DRESS AND DECORATION
OF THE
MIDDLE AGES

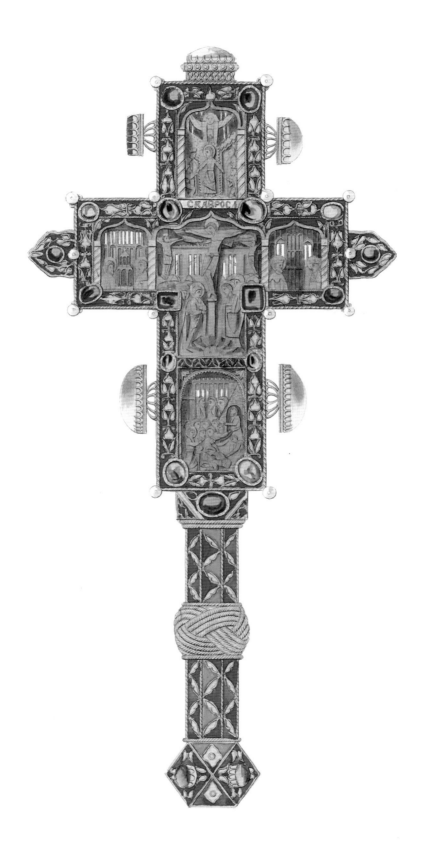

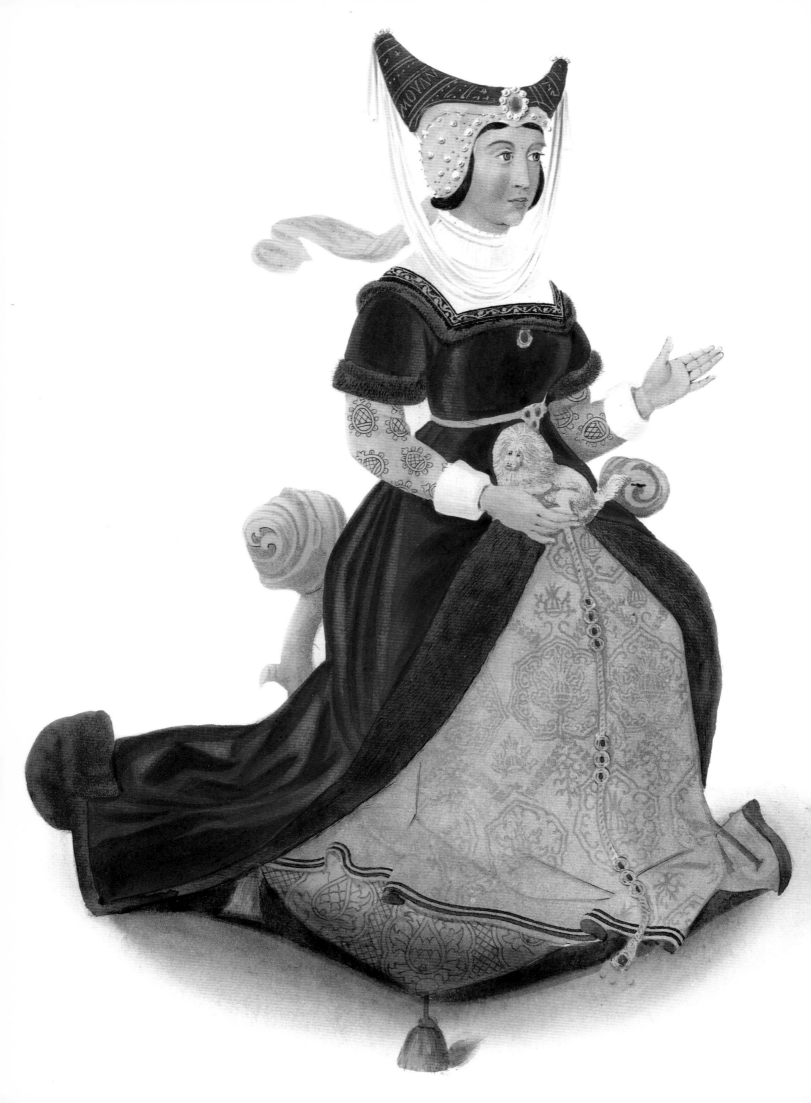

Dress and Decoration
of the
Middle Ages

⁂

Henry Shaw, FSA

Edited by William Yenne

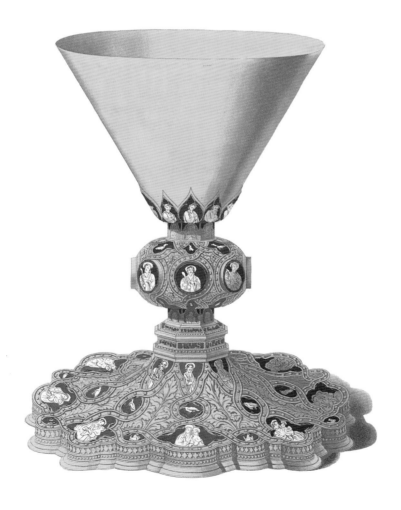

First Glance Books
Cobb, California

Published by First Glance Books, Inc.

© 1998 O.G. Publishing Corp.

Distributed by First Glance Books, Inc.
PO Box 960
Cobb, CA 95426
Phone: (707) 928-1994
Fax: (707) 928-1995

Produced by
American Graphic Systems, Inc.
PO Box 460313
San Francisco, CA 94146
Fax: (415) 285-8790

Design and artwork © 1998 American Graphic Systems, Inc.

ISBN 1-885440-24-3

Printed in Hong Kong

This volume is adapted from the original edition produced in 1858 by Henry Shaw. The 1998 edition
was designed by Bill Yenne, with design assistance from Azia Yenne, and based on the 1840-1858 illus-
tration and engraving work of Shaw and his collaborators. The latter included Albert Way, Director of
the Antiquarian Society, who contributed many beautiful drawings (along with their learned and accu-
rate descriptions); as well as the work of Charles Whittingham, whose mastery of the medieval art of
wood-block color printing is appropriately described as having thoroughly enhanced the original edition.
We are, of course, in debt to the draftsmanship of Henry Shaw himself, whose work in preparing the origi-
nal graphics reproduced herein is complementary to the high level of scholarship in his prose. Without him,
this book would never have existed.

The illustration on page 1 is of the cross from Mount Athos
(described at length on page 24).
The portrait on page 2 is of Constancia of Castile, Duchess of Lancaster and wife of John of Gaunt
(described at length on page 152).
The illustration on page 3 is of the ornamented chalice used by Pope Nicholas IV
(described at length on page 48).

The initial letter that opens Mr. Shaw's introduction on page 8 is taken from *The Durham Book*, a remark-
able manuscript in the British Museum that was written and illuminated in the latter years of the seventh
century on the Isle of Lindisfarne.

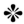

Table of Contents

Preface by William Yenne

HENRY SHAW WAS THE DEAN of medieval scholars during the British Gothic Revival Period of the mid-nineteenth century, and his immensely detailed study of the nuances of life during the Middle Ages will be as important a document in the twenty-first century as it was in the nineteenth. Indeed, much of the work he did in the nineteenth century was done with original source material which has been lost or is unavailable to scholars today. The rediscovery of this book, out of print for more than a century, is a milestone in our understanding of the Middle Ages.

Through Shaw's colorful prose — which is retained in this volume — we experience the essence of medieval civilization from the point of view of a scholar who had access to a staggering variety of original source material from England and Continental Europe. He approaches his study through a series of biographies of the major monarchs of the Middle Ages, discussing the details of court life and how style and sensibilities varied from country to country.

Originally written in the 1840s and published in 1858, Henry Shaw's work is an essential work for the study of the life and history of the Middle Ages. More than simply dress and decoration, Shaw presents intimate portraits of the important people — royal, political, and ecclesiastical — of the Middle Ages, as well as conveying an understanding of the popular tastes of the common people of the times.

Each illustration in this book is reproduced directly from Shaw's original hand-colored plates. He was a noted watercolor artist as well as a medieval scholar and a Fellow of the Society of Antiquarians, and this fact is clearly represented in the work contained in this volume.

Born in 1800, Shaw died in 1873 after a successful and rewarding life, in which he produced several books on manuscript illumination, as well as on medieval and Elizabethan art and architecture. Shaw not only worked closely with some of great collectors of the early nineteenth century, such as Robert Curzon in England and M. Sauvasgeot in Paris, he undertook lengthy and detailed studies at some of the most important libraries in Europe.

In London, his work took him to the Harleian Library at the British Museum, and into such collections as the Cottonian Manuscripts, Arundel Manuscripts, Sloane Manuscript, and the Burney Manuscript. At Oxford, Shaw studied rare works at the Bodleian Library and the Ashmolean Museum. He crossed the channel for lengthy investigations at the Bibliotheque du Roi (the Royal Library) in Paris, and at many other sources. The result was — and still remains, having survived the test of time — a work without compare.

His list of collaborators is like a veritable who's who of nineteenth century medieval scholars. On June 1, 1843, as he sat in his flat at 37

Southampton Row in London to pen his own preface to the original edition of his work, Henry Shaw specifically thanked a number of colleagues for whose support he was indebted. These included Albert Way, Director of the Society of Antiquarians, as well as several of the important members of the curatorial staff at the British Museum, including Sir Frederick Madden, Keeper of the Manuscripts; Antonio Panizzi, Keeper of the Printed Books; and Henry Josi, Keeper of the Prints.

Using Shaw's original text, we have organized this book as a series of two-page articles, each devoted to a specific topic, similar to the organization that was used by Shaw himself. The subjects are broad in scope and include fashion, arms and armor, jewelry, numerous examples of silver and gold work, stained glass, manuscript illumination, furniture, ivories, brasses, effigies, and scenes from tapestries.

Shaw has collected many important artifacts and documents, but his work is also valuable for its insightful scholarship. His research into the popular culture of the times gives us a peek into the medieval mind. For example, he tells us about the popular literature of the day, the "best-sellers" that formed the day-to-day notions of average people. We also learn from Shaw that the richly allegorical French poem *Roman de la Rose* (translated into English as *The Romance of the Rose*) was one of the most popular and important works in all of European literature from the beginning of the fourteenth century until the beginning of the seventeenth. Begun by the poet Guillaume de Lorris, who died in about the year 1260, *The Romance of the Rose* was initially published in 1305 by Jean de Meun, who also wrote much of the text.

Shaw also tells us how the "Four Stories of Antiquity" influenced the medieval perception of the classical era. Our current misunderstanding of the Middle Ages holds that Greco-Roman culture and literature was unknown in much of Europe until it was rediscovered by the Renaissance scholars. However, writing without the clouded glass of twentieth century revisionism, Shaw paints a clearer picture in which the Four Stories of Antiquity figure prominently in the backdrop of the medieval romances. Shaw tells us that the history of Thebes, with that of Troy, the wanderings of Aeneas, and the conquests of Alexander were all well-known and popular. The first three were considered as part of the same cycle, and as Shaw notes, the prologue to a medieval French manuscript of the story of Thebes describes it as, "*Li romans de Tiebes qui fu racine de Troie le grant.*"

There is no doubt that Henry Shaw's work is important in terms of its content and his scholarship. Beyond this, however, it is a beautiful work that is clearly the work of the hand of a master craftsman. A thing of beauty is a joy forever and Henry Shaw's work is truly timeless. �֎

Introduction by Henry Shaw

ERHAPS NO PART of the history of civilization is more interesting than the changes in dress and fashion of the era from the Norman Conquest of England to the sixteenth century. The different tribes who settled in the provinces of the Roman Empire after its final dislocation in the fifth century appear, in general, to have adopted the civil costume of the conquered Romans, while they probably retained with tenacity the arms and military customs of their forefathers. There was thus a general resemblance between the dress of the Anglo-Saxons, the Franks, and other nations of the West. Among the Anglo-Saxons, this style was preserved, with very little alteration, until the latest period of their sovereignty.

The dress of the Anglo-Saxons was simple and uniform in its character. It consisted, as far as we can gather from the allusions of medieval writers, and from the illuminations of manuscripts, of a shirt (called in Anglo-Saxon *syrce,* the origin of the more modern word *sark*), which was generally of linen; of breeches (in Anglo-Saxon *broc,* plural *brec,* the origin of the modern name), which appear also to have been commonly of linen; and of a tunic of wool or linen (called *rooc* or *roc*), which descended to the knee, and was bound round the body with a belt. Over this was

thrown a mantle (*mentel*), a short cloak which was fastened at the breast or on the shoulders with broaches. On the legs were worn hose (*hos*), which joined the breeches a little below the knee, which were frequently bound round with fillets, called *hose-bendas* (hosebands), *scanc-beagas* (leg-encirclers), *scanc-bendas* (legbands), or *scanc-gegirelan* (leg-clothing).

The form of the shoes, as represented in the manuscripts, is nearly uniform. They cover the foot to the ankle, are tied with a thong, have an opening down the instep, and are generally painted black, except in the case of princes and great persons, who had them frequently gilt or covered with gold. That gloves were not unknown to the Anglo-Saxons is proved by the circumstances that the name (*glof*) occurs in the earliest Anglo-Saxon poetry.

The form of the articles of dress was the same for all classes of society, differing only by the richness of the material or by the greater profusion of ornament. The leg-bands were used chiefly when the wearer was engaged in the more active pursuits of life, and particularly in traveling and in war.

Rich people, when in full dress, or on ceremonial occasions, wore a more ample tunic, descending to the feet. The sleeve of the tunic, between the elbow and the wrist, appears to be puckered up, and confined above the hand by a bracelet. Laborers and peasants appear frequently without stockings, and sometimes without shoes. Often, as we can see in the

illustrations in this book, all these articles of Anglo-Saxon costume were found in most of the different ranks of society. For example, it was common in England that all the persons seated at a festival meal would be wearing the large, ceremonial tunic.

A soldier's mantle might be similar to that of others, but ornamented by jagging at the border, somewhat like the fashion which became so prevalent in England during the reign (1377-1399) of King Richard II. In the illuminations, the Anglo-Saxons appear generally without hats, except when fully armed for war or traveling. They also contradict the assertion which has been made that the Anglo-Saxons universally wore long, flowing hair, for it is there generally cut short.

The dress of the Anglo-Saxon ladies cannot be described with the same precision as that of the men. The outer vest was a large, flowing tunic, which among persons of high rank was made of richly ornamented material. The Anglo-Saxon *cyrtel* is supposed to have been a shorter tunic, under this, and next to the skin was probably the *syrce* (shirt). The mantle of the ladies was also much larger than that of the men, and hung down before and behind. The head was generally covered with a long piece of silk or linen, which was also wrapped round the neck. The shoes appear to have been the same for both sexes.

During the Anglo-Saxon period, the common dress of the ecclesiastics does not appear to have differed much from that of the laity. The ceremonial robes resembled those of a later period, except that the miter was not yet in use. The tonsure was received among the Anglo-Saxon clergy early, though not without considerable opposition.

In the illuminations, the only addition to the dress of the warrior is his cap or hat, a kind of Phrygian bonnet, generally crested at the top. Perhaps the military tunic was made of thicker and less penetrable materials than that of the civil costume. Mail was probably used only by chieftains. The arms were an oval or round convex shield, made of wood, covered with leather, with the umbo and rim of iron; a sword; and a spear, or an axe. The Danes brought into more general use a double-bladed axe, which was long later known by the name of the Danish axe. The bow does not appear to have been used with much effect among the Anglo-Saxons. It may also be observed that the Anglo-Saxons always fought on foot.

The art of jewelry appears to have been extensively practiced among the Anglo-Saxons. People of rank and wealth covered their persons with bracelets, rings, broaches, and other ornaments, in precious metals and stones. Their ornaments were, in general, richer in the materials than in design. The Anglo-Saxons appear to have been devoid of taste in the arts; their drawings are, with a few exceptions, exceedingly rude and incorrect. The specimens given in this work are much superior to those which are found in

the great number of contemporary manuscripts. The general style of Anglo-Saxon ornament resembles that which was called Byzantine in the nineteenth century. The borders and initials in books are not dissimilar from those found in the earlier Greek ecclesiastical manuscripts. The borders of leaves in books are sometimes painted in a sort of mosaic work, and executed with considerable beauty. ✻

The Anglo-Norman Period

WHILE COSTUME AND THE ARTS of life had remained uniform among the Anglo-Saxons, they had, on the other hand, undergone a great change on the continent. Numerous and great political revolutions, and extensive interaction with Arabs and other foreign nations, had brought many modifications, even into the dress of the people, particularly of the higher classes. The Normans, when they settled in Neustria, adopted the costume and language of the Franks.

The military costume of the Anglo-Normans and Anglo-Saxons differed most widely at the time of the Norman Conquest of Britain by William the Conqueror in 1066. The Anglo-Norman soldiers were covered with the *hauberc* or *halberc*, a tunic of mail, either ringed, or network, or quilted. This article of dress was probably borrowed from the Arabs. It appears in the plate of Spanish Warriors of the eleventh century (page 27), who (with the exception of the round shield) are dressed exactly like the Normans in the Bayeux Tapestry. To the neck of this tunic was attached a cowl, which covered the head, and over which was placed the conical helm, with the long nasal guard descending in front.

The shield of the Normans was long and kite-shaped, and often bore the figure of a dragon, lion, or some other device. The Norman lance had a flag attached to it, and was called a *gonfanon*. The bow and the sling were also formidable instruments in the hands of the Norman soldiers. Before the end of the eleventh century, several changes had been made in the form and construction of defensive armor, and it sustained continual alterations during the twelfth century. The cowl of mail was preserved, but the helmet underwent a series of changes; the nasal defense was thrown away at the beginning of the twelfth century, and a pointed iron cap was adopted; and toward the latter part of the same century the helmet first took the form of a high cone, which later subsided into a flat-topped cap of steel, fastened under the chin with an iron loop. A long tunic was frequently worn under the hauberc, and the latter was partly covered with a surcoat, an article of dress supposed to have been borrowed from the Saracens during the Crusades. The kite-shaped shield continued in use until after the middle of the twelfth century, after which it became

shortened in form until it took nearly the form of a triangle, being semicylindrical instead of flat, as the kite-shaped shield had been. In England, under Richard I, who reigned from 1189 to 1199, the shield was charged with the armorial bearings of its owner. To offensive weapons was added, in the late twelfth century, the arbalest, or crossbow.

At first the civil costume of the Anglo-Normans differed not widely from that of the Anglo-Saxons. They wore the same tunic and mantle, and nearly the same shoes and leg bands, but the mantle was attached with cords and tassels. The Anglo-Normans wore long pantaloons with feet to them, which they called *chausses*. The head was sometimes covered with a flat, round cap.

Toward the end of the century the tunic was made fuller and longer, so that it sometimes trailed on the ground. The shoes were also constructed differently, and were profusely ornamented, as was every part of the dress. Knights and people of fashion wore long, pointed shoes, which were sometimes turned up at the points. In traveling, a cape, which covered the head, was added to the dress. The mantle, throughout the twelfth century, was very richly decorated. Under Henry II, who reigned in England from 1154 to 1189, a shorter mantle had been introduced, from which it is said that that monarch took the name of Court-manteau. The pointed Phrygian cap was the most usual covering of the head in all classes of soci-

ety, except when the cape was worn. The middle and lower classes of society typically wore a short tunic with sleeves, and chausses, with shoes, or sometimes short boots.

Under the Anglo-Normans the costume of the ladies was far more splendid and varied than under the Anglo-Saxons. Instead of the flowing tunic of the latter, the Norman women wore a robe which was laced close to show the form of the body. The head-covering was arranged more gracefully, and was thrown partly over the shoulders and back. It was called a *couvre-chef*. The hair of the ladies appears to have been frequently plaited in two or more divisions, which hung down behind or before. The information relating to the changes of fashion among the ladies during the twelfth century is defective. Toward the middle of the century, singular, long, hanging sleeves were in fashion.

This fashion appears to have been soon laid aside. The religious satirists, throughout the twelfth century, inveighed bitterly against what was then seen as the vanity, extravagance, and coquetry of the female sex. At the end of the century, Alexander Neckam, one of the best of the early Anglo-Latin poets, wrote numerous satires about the ladies of his time, in which he accuses them of covering themselves with gold and gems, of painting their eyes, of perforating their ears in order to hang them with jewels, of fasting and bleeding themselves in order to

look pale, of tightening their waists and breasts in order to mend their shape, and of coloring their hair to give it a yellow tint.

The most remarkable article in the dress of ecclesiastics during this period was the newly introduced miter. At first it was very low, resembling a stunted cap, as is shown in the plate of Ecclesiastics of the Twelfth Century (page 35), where the bishops carry a very plain pastoral staff. In the figures of ecclesiastics from Chartres Cathedral (opposite, and page 37), the clerics are bare-headed, but the archbishop has a miter which represents a plain, peaked cap. Thomas Becket's miter (page 39), although approaching more nearly the modern form, is still low. That of the archbishops at the end of the twelfth century, appear to be of the same form as that of Becket. In this era, the English ecclesiastics were remarkable for the cost of their apparel, and for their expensive and magnificent style of living.

We cannot perceive that the Normans, immediately after they settled in England, exceeded the Anglo-Saxons in skill in drawing or in taste for ornament; but after that event they progressed very rapidly toward perfection, and the twelfth century may be considered as the most brilliant period of the arts in England during the Middle Ages.

The drawings in manuscripts are generally spirited, and the outline tolerably correct, but they are much less highly colored than at a later period. The favorite kind of ornament during the twelfth century was scrollwork with foliage, which, in the initials and so forth, of manuscripts, as well as in enameled articles, vests, church windows, and so forth, is often extremely elegant. ✽

The Thirteenth Century

THE YEAR 1200 IS NOT a striking division in the history of costume or art, for the first years of the thirteenth century must be considered as a continuation of the last years of the twelfth. In England, the armor of the reign (1199-1216) of King John was nearly the same as that of the reign (1189-1199) of Richard I. In the course of the thirteenth century the quilted armor, then prevalent, began to be superseded by chain mail, which also had been borrowed from the Saracens. A new weapon came also into use, called the *martel-de-fer*, a pointed hammer, used for breaking the links of the armor. The helmet took the form of a barrel, and toward the end of the century it was surmounted by a heraldic crest.

In the time of England's King Edward I, who reigned from 1272-1307, the *aillettes*, for the shoulders, are said to have been introduced, although in one of the illustrations in this volume, of a much earlier period, a cross appears in the situation occupied

Right: A Twelfth Century Ecclesiastic from Chartres Cathedral (see page 36)

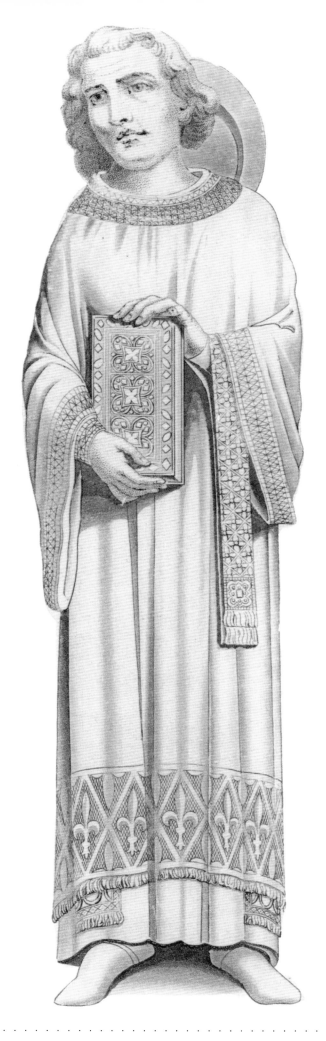

by the *aillette*. The plate on page 47 of knights fighting is taken from a continental manuscript, which may account for some apparent anomalies, particularly the kite-shaped shields, which were not used in England at this period.

Several new and rich stuffs were introduced early in the thirteenth century, brought generally from the East. The *siclaton*, which preserved its Arabic name, is supposed to have been a sort of fine, silky wool; the *baudequin*, a rich silk woven with gold, is said to have taken its name from Baldak, or Baghdad.

Siclaton, or siglaton, was chiefly employed in a super-tunic, or outward gown, which was known by the name of the material, and was frequently mentioned by the earlier poets. It was worn indiscriminately by persons of both sexes. Besides these, there were a great variety of costly furs, silks, and so forth, and we now find mention of velvet.

Among the items mentioned in the reign (1272-1307) of Edward I are *sendel* (which appears to have come from India or Persia), *sarcenet* (which is said to have derived its name from the Saracens), *tiretain*, or *tartan*, a.wool cloth of a scarlet color (its name derived by some writers from Tyre in what is now Lebanon), *gauze* (said to have been manufactured at Gaza in Palestine), and *burnet*.

The ladies of the time of Henry III (1216-1272) are most strongly distinguished from those of the previous reigns by their headdresses. The hair was

now gathered up, and confined in a caul or net of gold thread. The arrangement and shape of this caul appear, during the thirteenth century, to have been varied in almost every possible manner. From the satirists of the reign of Edward I, it would appear that it was then sometimes bound up in the shape of horns, a fashion which became much more famous in succeeding centuries.

The head was still covered with the head-cloth, or kerchief (*couvre-chef*), and the neck was enveloped with a wimple. In the Anglo-Norman romance of Tristan and Iseult, composed probably in the reign of Henry III, the following description is given of the costume worn by the young Iseult:

> The queen had clothes of silk,
> They were brought from Baldak;
> They were furred with white ermine.
> The mantle, the bliault, all train after her.
> Her locks on her shoulders are
> Banded in line on fine gold.
> She had a circle of gold on her head.

The *bliault* was a robe which fitted close about the body. One innovation during this century, which appears to have prevailed most in the reign of Edward I, was the long train of the ladies' robes, which dragged on the ground behind them, and did not fail to excite the remarks of contemporary satirists. A song of the reign of Edward I compares the women of his time to pies, and among other points of resemblance, says:

> The pie has a long tail
> Which hangs in the mud,
> on account of its weight;
> And a woman makes hers
> Longer than any tail
> of peacock or of pie.

The men's attire appears not to have undergone so many changes during this century as the costume of the ladies, although it was composed of equally rich materials. Under Henry III the men, in general, wore breeches and stockings, and over them a long tunic, open in front, sometimes as high as the waist. Over these they wore the siclaton. Writers of that century often speak of a fanciful, apparently jagged, mantle, named a *cointise*, which was used perhaps in place of the siclaton.

The shoes were long-toed, and among the rich they were very elaborately embroidered in fretwork. On the head people sometimes wore cowls, at other times round caps and hats, and, when on horseback, a coif attached under the chin.

Under Edward I there was no change in the general character of the dress, but the fretwork was transferred to the stockings, which were richly ornamented. The chief alteration in the dress of the lower orders (which had remained nearly the same since the time

of the Norman conquest) was the addition of a coarse outer garment resembling the modern smock-frock.

The only remarkable change in the ecclesiastical costume was the introduction of the different dress of the many newly-established orders of monks.

In artistic skill, the earlier years of the thirteenth century partake of the character of the twelfth. The illuminations of the middle and latter part of the century are less correct in outline, and deficient in spirit, but more elaborately and richly colored. Ornamental design was becoming gradually so varied and fantastic, that it is not easy to describe its characteristics in limited phraseology. ✱

The Fourteenth Century

THE REIGN OF ENGLAND'S EDWARD II (1307-1327) has nothing very decided in the character of its costume. It may be considered as a period of transition between the reign of Edward I and that of Edward III (1327-1377). The men's clothing style continued much the same as in the preceding reign, except that toward the end of this reign it began to be distinguished by the accumulation of finery, which became so obnoxious to the reforming lollards in the latter part of this century.

At the end of the reign of Edward II, and more universally in the beginning of that of Edward III,

the long garments of nobles and knights were changed for a shorter and closer vest, which was distinguished by the name of a *cotte-hardie*, from the sleeves of which hung long slips of cloth; and over the whole was worn a large, flowing mantle, buttoned over the shoulder, the edges frequently jagged, or, as it was then termed, dagged, and cut into the form of leaves and so forth. This mantle was, in general, thrown over the back, so as to leave the front of the body uncovered. The *cotte-hardie* was richly embroidered, and the whole costume was composed of the most costly materials and of the most festive colors. The "painted hoods" were the subject of many a popular rhyme. To the richness of the dress was added a profusion of jewelry and to increase the variety of color parti-colored dresses were now brought into use. The shape of the cap or hat, which was sometimes made of beaver, was frequently changed; one of its peculiarities, was the addition of a feather.

The middle classes of society soon began to vie with the courtiers in the extravagance of their apparel, and sumptuary laws were first enacted in the reign of Edward III, and were frequently repeated in succeeding times. It was during the time of Richard II, who reigned from 1377 to 1399, that the extravagance, which these laws were intended to repress, was carried to the greatest excess.

A host of contemporary writers inveigh bitterly against the vain foppery of the times. A writer of a

remarkable alliterative poem on the deposition of Richard II describes these costly fashions as the immediate causes of most of the misfortunes of his reign. Some idea of the costume of this time is shown in the plate on page 63 depicting courtiers of the time of Richard II, especially of the dagging of the edges of the mantle, or rather of the *gown*, for that was the name by which this part of the dress was now designated. Many fashions of this reign appear to have been brought from Germany, which is probably the source of the term "Dutch coats" that is applied to describe them.

The rest of the dress is thus described by a contemporary writer: "Their hoods are small, tied under the chin, and buttoned like those of the women, but set with gold, silver, and precious stones. Their tippets pass round the neck, and hang down before to the feet. They have another garment of silk which they call a paltock. Their stockings are of two colors (party-colored), or pied with more, which they tie to the paltocks with white latchets called herlots, without any breeches. Their belts are of gold and silver, and some of them worth 20 marks. Their shoes and pattens are snouted and piked more than a finger long, bending upward, which they called "crakowes," resembling the claws of devils, and fastened to the knees with chains of gold and silver."

Several articles of dress at this period were common to both sexes. Another contemporary moralist (printed in *The Reliquiae Antiquae, Volume I*, page 41) gives the following account of the dress of the men and women of the reign of Richard II: "Thus the devil fares with men and women: First he stirs them to pamper their flesh, desiring delicious meats and drinks, and so to hop on the pillar (of the devil's temptation) with their horns, locks, garlands of gold and of rich pearls, cauls, fillets, and wimples, and riddled gowns, and rockets, collars, laces, jackets, and paltokes, with their long crakowes, and thus the devil bears them up upon the pillar, to teach them to fly above other simple folk, and saith that they shall not hurt themselves, but he lies falsely, for unless they are as sorry therefore as ever they were glad, they shall leap down from the pillar into the pit of hell."

The women's costume in the first half of the fourteenth century differed little from that of the preceding age. They still wore the same style of coiffure, as well as the kerchief, and the gorget about the neck. The gorget and kerchief were commonly seen during this period.

In the reign of Edward III, the dress of the ladies made the same advances as that of the other sex. The cotte-hardie, sometimes with and sometimes without the long slips at the elbows, was worn by the women as well as by the men. Sometimes, instead of this vest, the ladies wore a tight gown or kirtle, very long, with long or short sleeves, and not infrequently with the same long slips at the elbows. At a later peri-

od a kind of spencer, or waistcoat, came into fashion, worn over the gown, reaching to the hips, and bordered with rich furs. This waistcoat came into more general use toward the latter part of the century. The hair was still bound up in a caul of fret or network.

Many of the festive women's fashions of the reign of Richard II are said to have been introduced by Queen Anne of Bohemia. A similar revolution in the same age was effected in France by the love of splendor and gaiety which was the characteristic of Queen Anne of Austria.

Ecclesiastics appear to have rivaled the laity in their love of finery. The splendor of the sacerdotal garments of ceremony was perhaps at its greatest height in the latter part of the twelfth and earlier part of the thirteenth centuries. Yet we can hardly imagine a dress much more rich than that represented in the plate of the incised slab seen on page 55.

Chaucer's description of his pilgrims is the best authority for the costumes of the different orders of society in the time of Richard II. His own portrait, seen on page 61, may be considered a good example of the ordinary costume of the time.

It would require a volume to give a minute account of all the changes in the military costume of people during the fourteenth century. One of the most remarkable innovations was the introduction of plate armor, which began to be used extensively in the reign of Edward II. The construction of the whole armor became more complicated. The helmet, in the reign of Edward II, took the form of an egg, more or less pointed at the top. The neck was covered by a guard of chain, called a camail. Crested helmets were used chiefly in tournaments. Aillettes were more universally worn. The shield took the shape most commonly represented in coats-of-arms, and was sometimes flat and at others semi-cylindrical. To offensive weapons were added the Turkish scimitar, and a new kind of poleaxe. During the reign of Edward III, the body of the warrior was completely encased in steel.

Many improvements at the same period were made in the helmet and the camail. A light jupon, embroidered with the arms of the wearer, and a rich belt, were first worn over the hauberk, then over it with the plastron, and then over the cuirass or "pair of plates," with an apron only, of mail.

In the time of Richard II many fantastical alterations were made in the form of defensive armor, in accordance with the general taste of that period, particularly in the helmet and visor, the latter often being shaped like a beak.

Ornamental design, during this century, was so varied that it would be scarcely possible to give a comprehensive account of it. The styles of drawings in illuminated manuscripts are extremely unequal, some beautiful specimens being found among much that is very inferior. The writings of manuscripts is less handsome, but more flowing, than in the preceding

centuries. The initial letters frequently possess great elegance and the international ornamental works that we have included represent French, English and other continental workmanship. ✤

The Fifteenth Century

AFTER THE ACCESSION OF HENRY IV to the English throne in 1399, various attempts were made to reform the extravagant fashions and expensive apparel of the preceding reign, and new and severe sumptuary laws were repeatedly enacted, but with very partial success. The dagged and slashed garments were especially forbidden, as were all garments "cut in the form of letters, rose-leaves, and posies of various kinds, or any such like devices."

Among the new names of articles of apparel which became common during the reigns of Henry IV (1399-1413) and Henry V (1413-1422), was a long tunic called a *houp-pelande,* which appears to have been most commonly of scarlet; a cloak of scarlet cloth and camlet called a *heuke;* and an outer garment of fur named a *pilche.*

The general character of the dress appeared, however, to have partaken largely of the fashions of the reign of Richard II, and the satirists continue to speak of the long *pokes,* or sleeves, sweeping on the

ground, and best fitted, as they said, for thieves who wanted a convenient receptacle for stolen goods. One of the "abusions" condemned by the poet Occleve was "A robe of scarlet, twelve yards wide, with pendant sleeves down on the ground, and the future thereon set, amounting unto 20 pounds or bet," for which, as he said, if the wearer paid, he would have "no good" left, "wherewith to buy himself a hood."

To this, he adds quaintly:
"Now have these lords little need of brooms
To sweep away the filth out of the street,
Since side sleeves of penniless grooms
Will it up lick, be it dry or wet."

With the reign of Henry VI, we come to a new period of the history of costume. The men's clothing styles of this period were again distinguished by every species of extravagance, and were almost infinitely varied. Among the principal characteristics were long, tight stockings, with feet, and sometimes short boots or buskins, and sometimes boots reaching to the middle of the thigh, called *galoches.*

There also might have been very long toed-shoes — with high fronts and backs that turned over each way — with a jacket or doublet cut short at the shoulders, and apparently an undervest, of which the sleeves passed through the armholes of the jacket. The mantle appeared in every fantastic variety of form, as well as the hat or cap, which was frequently

surmounted by a feather. The plates contain numerous illustrations of the state dress of this period.

The long-toed shoes, the hose buskins, and the galoches, with other articles of men's attire, continued under Edward IV and Richard III with little variation. However, the jacket was cut shorter, and was much stuffed and padded, and the sleeves cut open in slits, so as to show the rich shirts. The cap was sometimes made in a form nearly resembling that of the modern hat. The mantle during this period appears to have been less frequently worn.

The extravagance of dress in fifteenth century England appears at no period more remarkable than during the reign of Henry VII (1485-1509). Men of fashion wore very broad-brimmed hats or caps, with a profusion of large feathers. The sleeve of the jacket or purpoint was formed of two or more slips, attached to each other by points or laces, leaving openings through which the embroidered shirt was seen protruding.

The upper part of the stockings was sometimes slashed and puffed, while the mantle was sometimes elegantly bordered, or dagged. Sometimes the mantle was made of a square form, reaching hardly to the thighs, but with long, square sleeves which nearly touched the ground, and holes through which the arms passed. But the most remarkable characteristic of the latter part of the fifteenth century was the almost ridiculous broadness of the toes of the shoes, which suddenly usurped the place of the long, pointed toes of the preceding reigns.

The French writer, Paradin, describing the manners of this century, says that at first "the men wore shoes with a point before, half a foot long; the richer and more eminent persons wore them a foot, and princes two feet long, which was the most ridiculous thing that ever was seen; and when men became tired of these pointed shoes, which were called *poulains*, they adopted others in their place which were named duck-bills, having a bill or beak before that was four or five fingers in length. Afterward, assuming a contrary fashion, they wore shoes so very broad in front as to exceed the measure of a good foot."

The plates from *The Roman de la Rose* seen on pages 108 to 133, best describes the men's costume of the reign of Henry VII.

The women's costume also went through many changes during the fifteenth century. In the earlier years of the century, the dress of the ladies differs little from that of the reign of Richard II, except in the headdress. The hair was still gathered into a gold caul, but was stretched out curiously like two barrel ends, was flattened at the top, and appeared sometimes to be crowned with a garland, or covered with a kerchief or veil. This fashion seems not to have lasted very long, and we soon meet with the horn-shaped headdresses, a fashion which, in some form or other, had certainly existed more than a century before.

In addition to other allusions to the early use of the horned headdress — which has been too hastily stated not to have existed before the period which we are now treating — the subject was addressed in a late thirteenth century French satirical poem entitled *Des Cornetes*, which was printed in Achille Jubinal's *Jongleurs et Trouveres*.

The horned headdresses of the fifteenth century appear first in the shape of a heart, or of a broad miter placed sideways on the head. This fashion appears to have been brought from France. At first it was very fat, as in the figures in the plates of St. Edmund (page 60) and Christine de Pisan (page 83). In the latter plate we see another kind of horned headdress, which appeared in England a little later, resembling in some degree two butterflies' wings; it will be seen more strongly developed in the plate of The Lady of the Tournament (page 101).

It was succeeded about the middle of the century by the high tower, or steele-shaped, headdress, which had, generally, a long veil or kerchief hanging down behind. The cotte-hardie continued to be worn, and was laced very tight, in order to give a small waist to the wearer.

The common dress of the ladies through the reigns of Henry V and VI was a very long, narrow gown trailing on the ground, with hanging sleeves like those of the men. Under Henry VI the train of the gown was first made of an extravagant length, and soon provoked the criticisms of the satirists, who also accused the ladies of this time of having their dresses open so low before and behind as to expose to view the naked back and breast to an indecent extent. Toward the end of Henry's reign, and in that of his successor, the steeple headdresses were worn at an extraordinary height.

A French moralist, who wrote soon after the middle of the fifteenth century, gives us some curious traits of contemporary manners:

"Entering upon the subject of clothes," he explains with sarcastic wit, "One manner of spoiling and abusing one's vestments is, as to the form, which as regards women I consider in four parts. The first is in the head, which used to be horned, but is now mitered in these parts of France. And now these miters are in the shape of chimneys, and the more beautiful and younger the wearers are, the higher chimneys which they carry. The battlements to combat God above are the fine works of silk, the beautiful figures, the gold, the silver, the pearls, sometimes precious stones, and rich embroidery.

"The lances are the great forked pins; the arrows are the little pins. The shield is the large forehead stripped of hair. [It was the fashion in this century to pluck out the hair round the forehead, so as to make it appear larger.]

"The second evil is the great standard which they carry, this great, loose kerchief which hangs down

almost to their derrieres; it is a sign that the devil has gained the castle against God; for when the men at arms gain a place, they hoist their flag upon it. Another evil is in the body.

"By detestable vanity ladies of rank now cause their robes to be made so low in the breast and so open on the shoulders, that we may see nearly the whole bosom and all their shoulders, and much below down their backs; and so tight in the waist that they can scarcely respire in them, and often suffer great pain by it, in order to make their bodies small. And if it is said in their defense that, though they do not cover their breasts and necks with their robes, they cover them with something else. I answer that the covering is only vanity, for they cover it with a stuff so loose that one may see the flesh completely through it.

"The third evil is in the tail. They make them such long tails, that I see in them four *great* evils. The first of these is useless waste. What is the use of that great heap of cloth and fur and of silk which drags on the ground, and is often the cause of the loss of the robe, and of the time which must be employed to clean these long tails, as well as of the patience of the servants?

"The fourth evil is when they cause to be made for their feet shoes which are so small that they can scarcely walk in them, whereby they frequently have their feet lamed, sore, and full of corns."

Under Richard III a new headdress came into fashion, the hair being confined in a lower cap of gold net, projecting horizontally from the back of the head, and covered with a kerchief.

In the reign of Henry VII, the gown appeared fuller, and less tightly laced; the sleeves were full, sometimes slashed, and otherwise ornamented. The hair is now suffered to escape from under the cap or caul, and to hang loosely over the back. There appears, however, toward the end of the century, and in the beginning of the next, to have been no exclusive form of headdress among the fair sex, for we meet with an infinite variety in the pictures from this period of time.

The most prominent alterations in defensive armor in the first half of the fifteenth century were the introduction of the *panache,* or upright plume, on the helmet; some changes in the form of the helmet itself; the absence of the jupon and surcoat; and the addition of a skirt of horizontal bands of steel to the globular breastplate. Large, hanging sleeves of cloth were also sometimes worn with the armor.

During the reign of Henry VI the armor was highly ornamented, and frequently remarkable for the fantastic forms given to the different parts of the suit, of which several additional ones were now introduced. Handguns were added to the offensive arms of soldiers toward the middle of the century. From this time forward, the armor of the nobility was made

more and more splendid and costly. Elbow and knee pieces, in particular, took very fantastic forms.

The love of splendor naturally carried with it a taste for ornamental work and the fine arts. The latter were cultivated after the middle of the century with greater success than at any former period.

Artists of first-rate talent were employed in adorning manuscripts with delicate miniatures; and many of those preserved are works of art. The best school of miniatures was that of Flanders. The most elegant initial letters during this period are found in manuscripts executed in Italy. Cups, and similar articles, were also at this time ornamented in exquisite taste by excellent artificers. ✳

The Sixteenth Century

WITH THE REIGN OF HENRY VIII, who ruled England from 1509 to 1547, we enter upon an entirely new period of costume and of art, differing in every possible respect from the ages which preceded. Indeed, this era, which coincided with the period of the Italian Renaissance, can be said to mark the conclusion of the Middle Ages as we understand them. Meanwhile, the splendor and extravagance of the feudal baronage — an important feature of medieval society — was expiring, and the gorgeous pageantry of the Roman Catholic Church, which had contributed so much to medieval art, was on the point of disappearing from Britain.

The common men's costume of the higher orders and gentry during Henry VIII's reign may be best conceived by a reference to the illustration of the Earl of Surrey seen opposite and page 165.

As we can see, this fashion consisted of a full-skirted jacket or doublet, with large sleeves to the wrist, with a short, full coat over it, having frequently loose-hanging sleeves. To this was often added a broad collar of fur. A brimmed cap with an ostrich feather, close stockings, square-toed shoes, and an embroidered shirt, showing itself at the breast, and in ruffles at the wrists, completed the dress.

The upper part of the stockings were now slashed, puffed, and embroidered, and appeared as distinct from the lower part, or stockings. The gowns of the higher orders were very costly in material and ornament. Merchants and others wore them in the same form as those of nineteenth century masters of arts in the universities. During the reigns of Edward VI (1547-1553) and Mary I (1553-1558), the cap was often replaced by a small, round bonnet, worn on one side of the head; the shoes took nearly their present form; the puffed stockings (called trunkhose) continued in use; but the doublet was lengthened considerably at the bottoms.

This costume continued in use, with different changes in the details, until the reign of Charles I

Right: Henry Howard, the Earl of Surrey (see page 164)

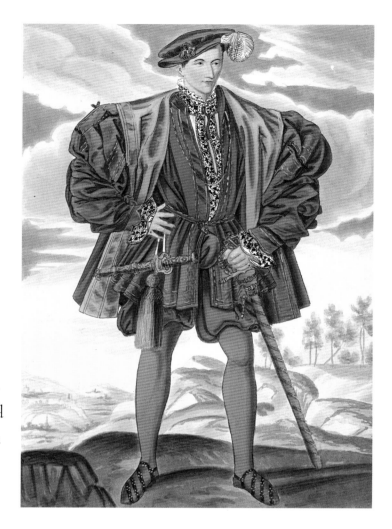

(1625-1649). The principal difference was in the enormous breeches, stuffed with hair like wool-sacks, which remained in fashion through nearly the whole duration of the reigns of Elizabeth I (1558-1603) and James I (1603-1625).

The different articles of women's costume were the same in the reign of Henry VIII as in the latter part of the preceding century, but from this time forward they went through so many changes of form and material that we could give no satisfactory description of them within the space allotted. The dresses of ladies of rank were rendered costly by the addition of a great quantity of jewels.

Early in the sixteenth century complete suits of defensive armor began to be less in use, except at tournaments and for ceremonious occasions, and then they were embossed and engraved in the most splendid and expensive manner.

Puffed and ribbed armor came into fashion in the reign of Henry VIII. Pistols (or dags), pikes, and long muskets were among the weapons in common use. In Elizabeth reign the armor was confined to the body and head, with the arms partly or wholly covered, but seldom descended below the hips. Among offensive weapons, we now find a considerable variety of different firearms. The increased use of firearms rendered defensive armor more and more unfashionable, until at last it was reduced to a simple breastplate and helmet.

The styles worn by Queen Elizabeth I and the ladies of her court are quite familiar and typical of the latter part of the sixteenth century. One of its most remarkable characteristics of the costume of her courtiers was the large ruff about the neck, which was common to all classes of society.

From the thirteenth century to the sixteenth, the age of the Renaissance — and of the great masters in painting and carving — Europe experienced a splendid period for every type of ornament and embellishment, distinguished by an infinite variety in style and character, and by beauty of execution. In the plates and small illustrations in this work, we present a few specimens of ornamented articles which will best illustration the grand scope of the dress and decoration of the Middle Ages. ✤

The Cross from Mount Athos

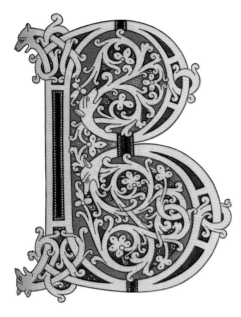

EFORE THE CHRIST-
IAN ERA, Mount
Athos was celebrated
for the length of its
shadow (*ingenti tel-
lurem proximus umbra
vestit*), which was said
to reach as far as the
Isle of Lemnos, for
the multitude of its
hares, and for having
been the scene of one
of the most wonderful exploits of the Persian hero
Xerxes, who in his invasion of Greece is said to have
cut a passage for his ships through the lower part of
this vast mass of mountains.

Since the time of the later Christian emperors of
Constantinople, it has been celebrated chiefly for the
number of its monasteries, on which account it
received the name of the Holy Mountain (or, as it
was called by the Italians, Monte Santo). These
monasteries are singularly interesting to the anti-
quary, because in them are preserved the manners and
the arts which characterized the monasteries of the
west of Europe, prior to the general introduction of
the Benedictine Rule.

One of these, the monastery of Caracalla, pos-
sessed for centuries the beautiful cross, a front view of
which is seen opposite, and a back view of whose shaft

is seen on this page. It was used by the bishops of the
Greek Church at the feast of the Epiphany, for the
purpose of blessing the water.

The cross is associated with the
name of one of the bravest princes
of the Lower Greek Empire, having
been given to the monastery of
Caracalla by the emperor John
Zimisces. He was an Armenian sol-
dier in the Greek army, and was
raised into power and influence by
becoming one of the numerous
lovers of the Empress Theophano.
Although he ascended the imperial
throne by the murder of her second
husband, the usurper Nicephorus, as
emperor he obtained the love of the
people by his rigorous execution of
justice, by his respect for the church,
and by his splendid victories over the
Russians and Saracens. After his
short reign, John Zimisces is said to
have been murdered by poison in the
year 969.

It is generally known that previ-
ous to that time the Byzantine style
was employed universally in the
buildings and ornamented articles of
Western Europe. Many of the latter

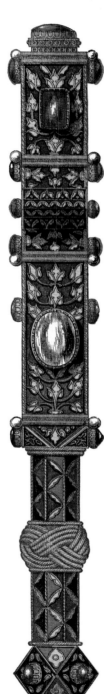

items were doubtlessly brought from the East. This particular Byzantine cross has thus a double interest for the English antiquarian.

In no remains of past ages can we trace so distinctly the prevalence of the Byzantine style in the West as in the earlier illuminated manuscripts. There is a splendid example in *The Durham Book* of the end of the seventh century; and we find numerous others down to a comparatively late period.

The initial letter opposite is taken from a fine manuscript from the tenth century, containing the Latin Gospels, with the canons and other articles which generally accompany them. Its illuminations are richly gilt on purple vellum, and consist chiefly of figures of the Evangelists, with one or two similar subjects, and ornamental initials. Some blank leaves (as far as regards writing) are covered with elegant mosaics, which remind us sometimes of the patterns found in Roman tessellated pavements. The canons at the commencement of the volume are written between columns supporting semicircular arches,

which we may be justified in considering as authentic specimens of the architectural ideas of the age. The capitals of the columns are especially curious, and the columns themselves probably show us the manner in which, at this early period, the architectural ornaments of churches were painted and gilt. In some instances there are evident representations of marble columns. These early manuscripts of the Latin Gospels, more or less illuminated, are by no means uncommon; and in some instances, appear to have been copied from one another, or from the same original. Dating from the same era as the cross, these manuscripts contain similar illuminations and mosaics, though somewhat ruder in their style of execution. On the outside of this volume is a relic of its ancient binding, an early carving in ivory in high relief, representing the crucifixion, surrounded by four compartments, containing the angel, eagle, and two animals, representing the four evangelists, and thus alluding to the contents of the book. ✽

VERY STEP WE TRACE back in the history of the nations of Europe brings us nearer to a uniformity of costume. Fashions in dress did not begin to go through that quick vicissitude of change which characterizes modern times until toward the thirteenth century.

We can trace little variation in the dress of the Anglo-Saxons during the whole period of their history, and not much between that of the Anglo-Saxons and the Franks. As people became more distinctly separated from each other by national jealousies, and long and obstinate wars, the new fashions adopted in one country were more slowly communicated to another, and thus the similarity of costume became separated by distance of date, while some countries became so entirely estranged from each other during a long period that the resemblance of costume and the simultaneous variation was altogether lost.

The figures which form the illustrations on the opposite page represent Spanish warriors of the latter part of the eleventh century, and are interesting on account of their remarkable resemblance to the Anglo-Norman soldiers on the celebrated Bayeux Tapestry. This resemblance is observable in the style of drawing, as well as in the costume. It is probable that the military habits of this period were, in part, borrowed from the Saracens, and this supposition is strengthened by the fact that Arabic inscriptions in Cufic characters are found among the ornaments of several robes still preserved, which belonged to German and Frankish barons of the tenth and eleventh centuries.

The manuscript which has furnished these figures is one of the most valuable of the treasures of that kind acquired by the British Museum. It is a large folio on vellum, in a beautiful state of preservation, containing a comment upon and interpretation of the Apocalypse, that fruitful source of design to the medieval artists. It was executed in the monastery of Silos, in the diocese of Burgos (Old Castile), having been begun under the abbot Fortunius, carried on after his death during the abbacy of Nunnus (Nunez), and completed in the time of abbot John, in the year 1109. This information we obtain from the manuscript itself; and as it thus appears to have occupied not less than 20 years in writing and illuminating, we may with propriety consider it as representing the costume of the latter part of the eleventh century.

This manuscript was purchased in 1840 by the trustees of the British Museum of the Comte de Survilliers (Joseph Bonaparte.)

The style of the drawings in this manuscript bears a clear Saracenic influence. The elegance of the ornaments contrasts strongly with the unskillful rudeness in the designs of men and animals, a circumstance which reminds us of the that in Arabic art, humans are not depicted realistically. This work is in many respects a valuable monument of art, and proves clearly the dialogue which existed between the Moors and the Christians in Spain.

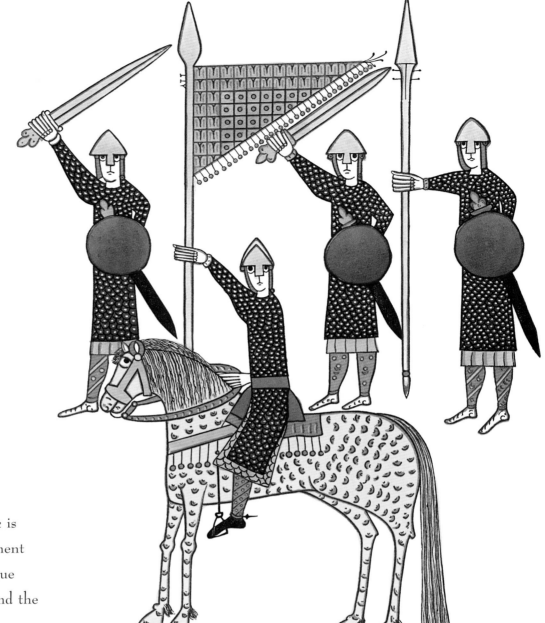

Throughout the volume the architecture of the buildings is altogether Moorish — the walls covered with arabesque ornaments, and the remarkable horseshoe arches, appear on almost every page, and show the accuracy of the term *Saracenic* adopted by architectural writings. The character of the ornamented initial letters, of which an example is given at the beginning of this article, bears a close resemblance to those observed in many of the Anglo-Saxon manuscripts of the tenth century.

One of the most interesting groups in this volume is that representing two minstrels, or jongleurs, seen on the facing page. They appear to be dancing on a kind of wooden stilts. There are many reasons for supposing that the character of the minstrel, as it existed in Christian Europe during the twelfth and thirteenth centuries, was of Arabian origin, as are without doubt many of the tales and stories which they were in the habit of rehearsing. These specific figures of Spanish jongleurs, so completely Oriental in their appearance, are a valuable addition to the materials for the history of that singular class of medieval society. ✳

Clovis I, King of the Franks

RANKISH KING CLOVIS I ruled northern France — including Aquitaine and Toulouse — from bases in Poitiers and Paris from 481 to 511. It was his unfulfilled ambition to unite all the Frankish kingdoms under his own rule. The statue pictured opposite — as well as that of his wife, Queen Clotilda pictured in the following entry — originally stood at the portal of the ancient church of Notre Dame at Corbeil, a town about 20 miles to the southeast of Paris.

For the preservation of this statue, as well as that of Clotilda, we are indebted to the zeal of Alexandre Lenoir, who placed them in his museum of national antiquities. Their companions perished when the church that they embellished was destroyed. These two figures are the only remains of its former magnificence. They were subsequently transferred from the museum to be placed at the entrance to the vaults of the magnificent church of St. Denis, the resting place of the

long line of sovereigns of whose power Clovis had laid the foundation.

It is, however, a mere conjecture which has given to these two statues the names of Clovis and Clotilda. A conjecture, too, which seems to have been made without any grounds to support it. Some antiquaries even went so far as to believe them to have been executed by the Merovingian princes. This is an evident absurdity. The church of Corbeil is said to have been founded in the latter part of the eleventh century; and the statues have every appearance of having been sculptured either then or early in twelfth century. We have no information as to the character of the four statues which are destroyed.

The initial at the beginning of this article is taken from a large manuscript Bible from the twelfth century, and represents a favorite subject in the illuminations of that period, the combat between David and Goliath.

The two musical instruments represented here date from the twelfth century and are typical of what would have been used at the court of Clovis and Clotilda. These illustrations were copied from the sculptures on the portal of the cathedral of Notre Dame at Chartres which were themselves carved during the twelfth century. ✤

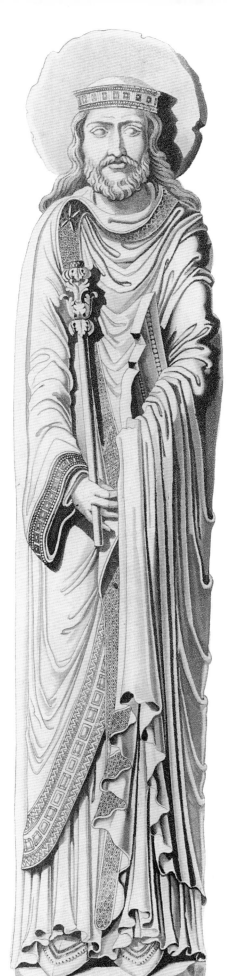

Clotilda, Queen of the Franks

AVING DISCUSSED THE STATUE of Clovis I in the preceding entry, we now present the companion statue of his queen. As with the image of Clovis I, this statue of Clotilda is taken from the ancient church of Notre Dame at Corbeil, which no longer exists. In this illustration of the statue seen opposite, we may note that the costume of the Frankish queen is simple, and the belt, with the pendent band before, became common in later regal monumental effigies, particularly of the twelfth century. The manner of binding up the long hair is remarkable, and may be intended for a traditional memorial of this distinguishing mark of royalty in the Middle Ages.

The drawings below represent chessmen of the twelfth century, carved in bone, and illustrate one of the favorite games of the princes of that remote period. One of the pieces here given represents a king. We meet with various early allusions to the game of chess, which seems to show that it was a favorite amusement of the norsemen, and that it was introduced by them into France and England. The king forms one of the large collection of chessmen discovered in 1831, in digging in a sand bank, in the parish of Uig in the Isle of Lewis (North of Scotland). It consisted of 67 pieces, comprising six kings, five queens, 13 bishops, 14 knights, and 10 rooks (or, as Sir Frederick. Riadden terms them, warders), forming the materials of six or more sets. The costumes of these figures are very clearly defined. The kings are represented with large, spade-shaped beards and with mustaches; their hair falls in plaits over the shoulders. They have low trefoil crowns on their heads; and their dress consists of an upper and an under robe, the former of which (the mantle, *clamys*) is thrown in folds over the left arm, and left open on the right side as high as the shoulder, where it is fastened by a clasp. Each of the figures holds a sword with both hands across his knee. They sit on chairs of a square form, with high backs, which are very elegantly carved. The queens are similarly seated on chairs, and crowned. One of them holds in her hand a drinking horn, a peculiar attribute of the queens among the norsemen, it being her office to serve the ale to the warriors of her husband's court. Of the bishops, some are seated, and others are in a standing posture. The knights are

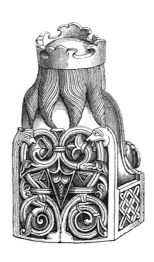 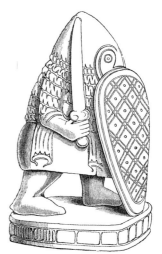

on horseback, while the rooks represent warriors on foot, with the singular, kite-shaped shields which were used in the twelfth century. One of these is cut out of a whale's tooth. Sir Frederick Madden, who has given a detailed and learned account of them, with many figures, in one of the volumes of the Archaeologia believes that they were made in Iceland. The originals are now in the British Museum.

The other figure is taken from a chessman of the same material preserved in the Cabinet of Antiquities at the Bibliotheque du Roi, in Paris. By comparison with those in the British Museum it would appear to be a rock. It represents a foot soldier, resting his kite-shaped shield before him on the ground. In the Cabinet d'Antiques there are with it four mounted knights, evidently belonging to the same set, with others which are different. They were, we believe, formerly in the Tresor of the abbey of St. Denis, and were represented as the remains of the "jeu d'echecs du Roi Charlemagne."

However, only one of that original set now remains, which is undoubtedly authentic, and bears a Cufic inscription. The monks seem to have added, from time to time, other ancient pieces which fell into their hands, to supply the defects of the set which had belonged to Charlemagne.

The initial letter at the beginning of this entry is taken from an illuminated Bible of the twelfth century preserved in the Public Library at Rouen. ✳

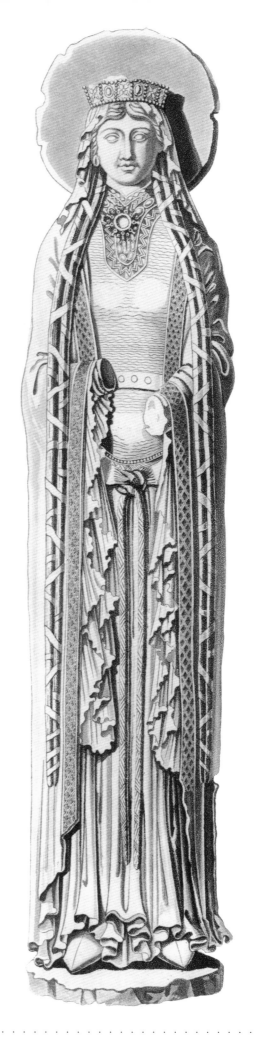

HE FIGURES ON the opposite plate are taken from illuminations in the Cottonian Manuscript Nero C.IV in the British Museum. They were probably executed sometime before the middle of the twelfth century. The subjects of the original drawings are taken from the New Testament. For example, the lady riding on a donkey represents the Virgin Mary on her way to Egypt.

These figures are chosen to present interesting examples of the women's costume among the English in the first half of the twelfth century, because, although the subject represented is from the first century, the costumes were updated to appear "contemporary."

The most interesting characteristic of this clothing was the long, hanging sleeves of the tunics, which, in some instances, were obliged to be tied up in knots when the wearers were moving about. This fashion is turned into ridicule in a droll figure of a devil given in the same manuscript and represented in the small illustration at the end of this article.

It has been observed that the dresses of the ladies at this time were unusually Oriental in their character; this style was probably introduced by the Crusaders, who, among the spoils of the Saracens must have brought home for their families many of the rich dresses of the Eastern ladies.

The long, plaited hair styling resembles, to some degree, that seen on the statue of Queen Clotilda from the church of Corbeil, in France, represented in the preceding article.

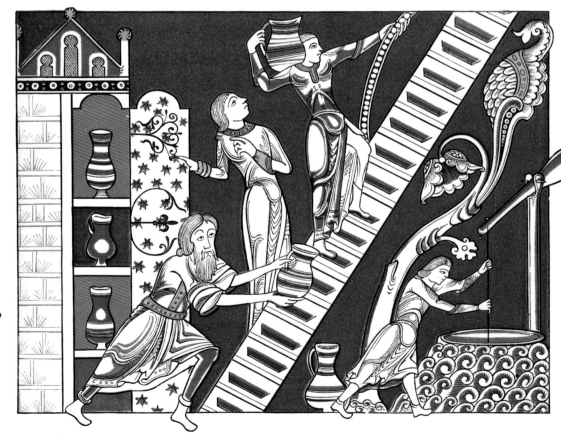

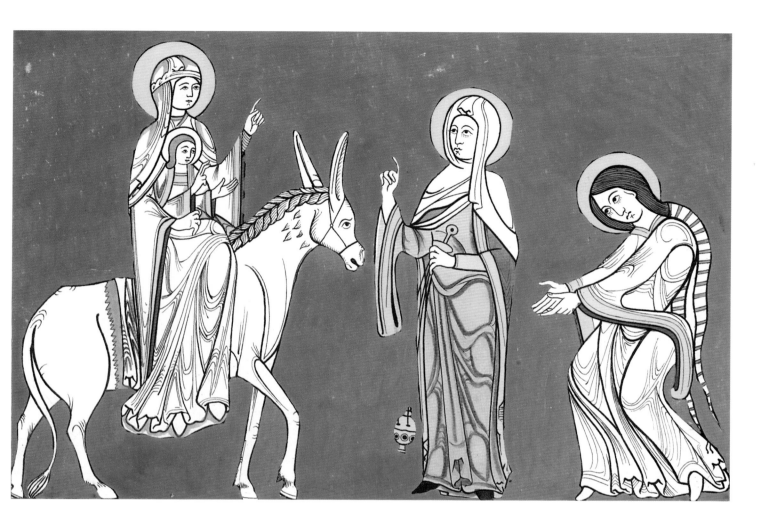

The illustration at the left is taken from the same manuscript. The subject of the whole illuminated page, of which this forms the lower compartment, is Jesus Christ changing the water into wine at the marriage at Cana. The upper compartment represents the wedding dinner, with Christ and the other guests at table. Christ is blessing the water, which he holds in his hand in a large drinking horn, the only vessel for liquids which appears on the table. In the longer compartment, represented in the small illustration, the servants appear, taking the water vessels from the cupboard, drawing the water from the well, and carrying it up stairs into the chamber where the guests are assembled at dinner. In the band separating the upper compartment from the lower we read in Anglo-Norman the words *Eci fist del eve din.*

The staircase has a very primitive form—it appears to be made of a solid piece of timber, with grooves cut in the wood in which to place the feet in ascending or descending. A platted rope attached to the side serves the purpose of a rail.

The initial letter opposite is taken from a splendidly illuminated manuscript Bible from the twelfth century that is preserved in the British Museum. ❈

O TYPE OF HUMAN FIGURE occurs so frequently in the illuminations of the earlier manuscripts as those of ecclesiastics of different grades. As the older illuminators were almost exclusively monks, we are justified in concluding that no other type of person is represented more accurately with regard to costumes and other characteristics.

The illustration at the top of the opposite page contains some very good figures of prelates from the earlier half of the twelfth century. They are taken from a series of curious scriptural illustrations accompanying a copy of the early Anglo-Norman version of the Psalter that is to be found in Cottonian Nero Manuscript in the British Museum.

This manuscript was probably written about the middle of the twelfth century, and possibly a little earlier. The bishops, who are seen here in their full dress, are remarkable as representing specimens of the low formed miter which was characteristic of the earlier pontifical costume.

These figures, besides affording good specimens of costume, are remarkable as embodying a little caustic satire on some of the ecclesiastics of the day. The particular illuminations from which they are taken compose a representation of the last judgment in four large pages. The two inner pages represent the Deity with his apostles sitting in doom. The first page of the four contains, in the upper part, a numerous group of heads of the different classes of mankind, from kings and queens to the lowest orders of the people, and beneath, a separate group of whole-length figures of bishops and monks.

In drawing all these figures, the illuminator has shown considerable skill in depicting the physical characteristics. On the right hand of God, the faces of the kings, queens, and higher orders are dignified and benign, and all have an air of conscious virtue. The bishops below are unshaven, with serious countenance, and bearing all the insignia of office, as being entirely absorbed in the discharge of their pontifical duties. The monks, in like manner, are thin and sedate, showing by their outward appearance that they rigidly

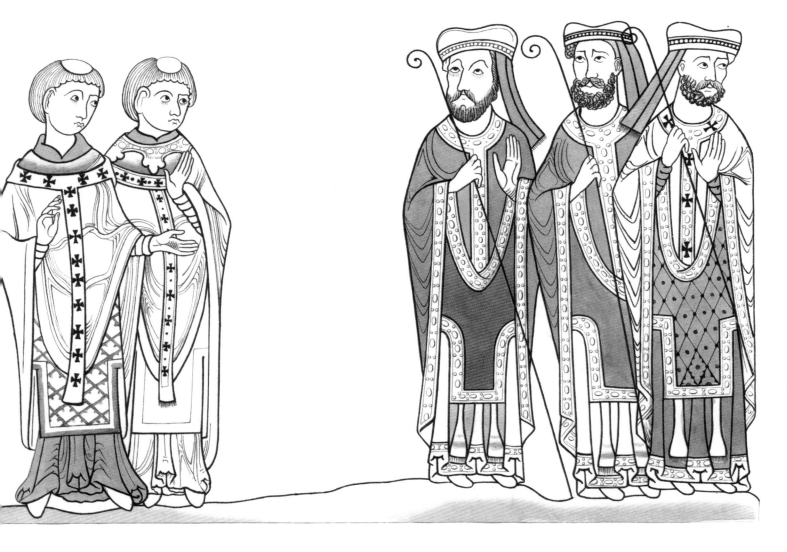

kept the rules of their order. On the other page, at the left hand of the judgement-seat, the physical character of the faces is entirely changed. The male heads, especially those which appear to belong to the lower orders, have features of a diabolical character; the faces of the kings and rulers are dark and gloomy; those of the queens are particularly effective, exhibiting a singular mixture of pride and voluptuousness. The clergy below are fat and sleek, with voluptuous and gluttonous looks; and some of the ecclesiastical dignitaries, as in the two given in the plate, while they bear their rich garments as objects of pride and ostentation, are without the principal insignia of their office, because they neglected their duties, and are

very fat, with their faces closely shaven. From what we know from history of the manners of the clergy of the age to which these drawings belong, we can hardly avoid believing that the illuminator intended to depict some of the sleek, worldly ecclesiastics of his time.

The handsome pastoral staff of the twelfth century, of which the upper part is shown opposite, is preserved in the collection of Monsieur Duguay in Paris. It is of copper gilt, and elegantly enameled.

The initial letter, which affords a curious illustration of early armor, is taken from a manuscript in the possession of Robert Curzon. The manuscript appears to have been written also about the twelfth century, or perhaps a little earlier. ✣

HARTRES IS ONE of the most ancient and interesting towns in France. Popular traditions carry the date of the foundation of the city back to the times of the deluge of Noah, and it was suggested by some of the medieval antiquarians that the splendid cathedral of Notre Dame de Chartres stands on the site of an ancient Druid temple.

The Cathedral of Chartres, founded in the earliest times of Christianity in the West, is remarkable for the many misfortunes it has sustained. In the 1820s, M. Lejeune, the librarian of the city, published an essay on this subject under the title, *Des Sinistres de la Cathedrale de Chartres*. According to Lejeune, in 770 the town and cathedral were entirely burned to the ground. In 858 the Norman invaders, having made themselves masters of the place, massacred the inhabitants, and again reduced to ashes the town and cathedral. In 962 or 963, this town again suffered the miseries of war, having been taken by surprise by Richard, Duke of Normandy, who burned the church and city. On September 7, 1020 the church was burned a fourth time, having been struck, it is supposed, by lightning.

Up to this time, the Cathedral of Chartres had been

built principally of wood, which had rendered the effects of the fire more fatal. In 1028, Bishop Fulbert laid the foundation of this edifice, but it required a large portion of three centuries to complete his design. The vast mass of statuary and sculpture with which it is adorned appears to be the work of the twelfth and thirteenth centuries. The portals appear to have been executed in the earlier part of the twelfth century.

After a period of nearly five centuries had passed since the disaster of 1020, in July of 1506 the tower of the cathedral was struck by lightning and the fire committed great ravages, but the most important and interesting parts of the building were happily saved.

In 1539, the tower was again set afire by lightning. Another fire was caused in 1674 by the imprudence of one of the watchmen. The last, and one of the most deplorable, of the modern disasters of the Cathedral of Chartres was the great fire which was caused by accident, on the June 4, 1836, when some workmen were employed in the tower. This calamity destroyed many important portions of the cathedral, but it spared some of the more ancient and ornamental parts. Among these not the least important are the interesting sculptures of the portals,

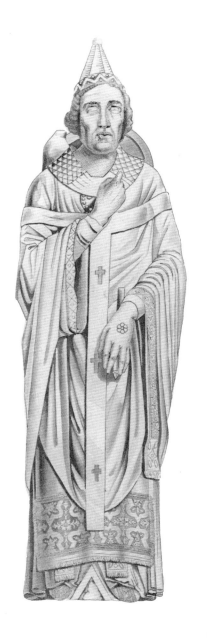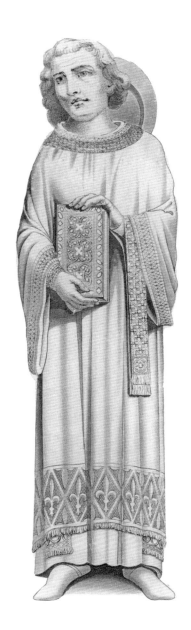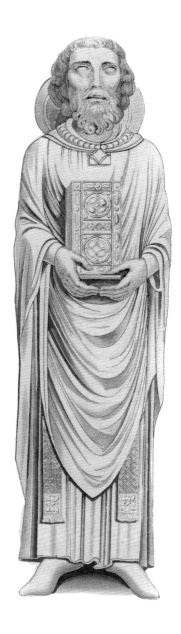

which, besides their excellence as works of art, are extremely valuable as specimens of the costumes of the period. It is from among these statues that we have taken the three figures of ecclesiastics shown above. The smaller illustration on the opposite page is of a carving which represents a portion of the Alb.

The first of the figures above represents an archbishop, and is singular on account of the form given to the miter, which bears a close resemblance to the tiara seen on the head of the pope in an illumination given by Gerbertus in *De Cantu et Musica Sacra*. The archbishop is giving his blessing with his right hand, while in his other hand he holds the crosier, the greater part of which has been destroyed.

The second figure is dressed as a deacon. He wears the *dalmatic*, with its large sleeves, which are not cut up the sides, but continuous. On his left arm he wears the *maniple,* sometimes called *fanon.* As it is his ministry to chant the gospel, he carries a beautifully bound evangelisterium in his hands. The two ends of the stole are seen under the dalmatic, and just over the alb. The third figure is a mere priest, holding the book of the Gospels on his breast; he wears the chasuble, stole, and alb. ✳

The Miter of St. Thomas Becket

URING THE TWELFTH CENTURY, the bishops and higher ecclesiastics combined in themselves the double character of temporal barons and ministers of the Church. What was then called "the Church" was a vast political power which claimed a feudal superiority of all the kings and princes of the Earth; and its bishops had their castles garrisoned by their armed dependents, and they led their armies into the field in the various contentions between the different orders of the state. Understandably, the kings and princes were often at war with that of the Church — it was, in fact, generally impossible that the two could live at peace together, and, according to the circumstances of the time, the Church defended itself openly by the sword, or by the no less (perhaps more) effective warfare of passive resistance.

The direct war between Church and state in England lasted more than two centuries. It began with William Rufus, who refused to acknowledge the temporal pretensions of the pope put forth in the person of Anselm, and continued with little interruption until Edward I forced the clergy to pay taxes. During this long period, the most extraordinary person amongst the great champions of the Church, in its claims to civil power, was Archbishop of

Canterbury Thomas (later St. Thomas) Becket (1118-1170), of whom a remarkable memorial is preserved in the series of vestments which are represented in this and the following plates.

Henry II, who reigned from 1154 to 1189, was one of the greatest monarchs who have occupied the English throne. Cast upon a period of extreme difficulty, among a powerful aristocracy which was breathing war and injustice on every side, he placed a strong hand upon the helm and did what lay in him to calm the storm. At the beginning of his reign he destroyed some hundreds of the castles which, during the reign of Stephen, had been so many dens of robbers. Many of these castles, and some of those which had been most mischievous, belonged to ecclesiastics; and thus, in his laudable efforts to weaken the oppressors of his country, and to clear away the greatest obstacles to peace, he found the Church opposed to him.

Becket was the man whom Henry II had raised from obscurity, and whom he had loaded with favors. Becket became the instrument of the Church in thwarting Henry's measures, and in destroying the work which the king had been so long laboring at. Becket was undoubtedly a very great man. We can only now see his character through the eulogies of his admirers and fellow ecclesiastics, but from all we can learn his private

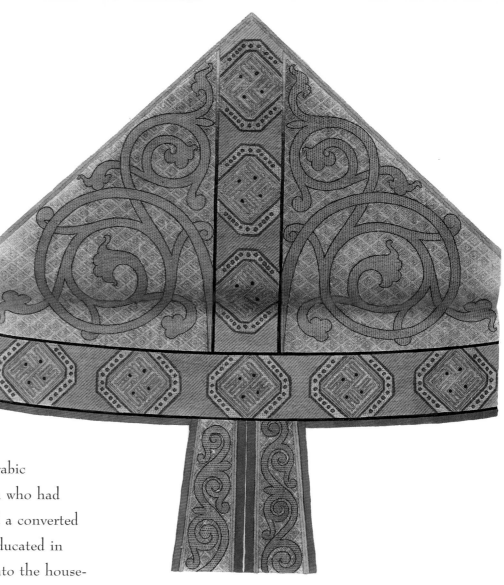

life was dignified and amiable. But we can hardly excuse him in public for being singularly proud and overbearing, for being intractable, unconciliatory, and even vengeful.

Thomas Becket was born in London on the feast of St. Thomas, from which circumstance he received his Christian name. He inherited from his parents a mixture of English and Arabic blood, his father being a London citizen who had been in Palestine and had there married a converted Arabian maiden. The son, after being educated in Merton College, Oxford, was received into the household of Theobald, Archbishop of Canterbury, and owed to him his first advancement. After being introduced by him to King Henry II in the earlier part of his reign, he became a great favorite with that monarch, who gave him all his confidence. He was with that king in his wars in France, and distinguished himself by his military skill and personal strength and courage. His attachment to his royal master continued unbroken until after he had obtained the archbishopric of Canterbury, the highest object of his ambition. He then found that he must choose between two masters, for Church and state were not only different, but opposite, services. He determined in the favor of the one in the ranks of which he ultimately obtained so high a stature. This step

was soon followed by an open breach with the king, and from that time we find the one continually opposing himself to the plans of the other, until, at the end of 1164, the prelate was obliged to flee from England and take refuge in France, where he remained until 1170. In this year, his temporary reconcilement with the king enabled him to return to his native country, where he soon afterward sealed with his own death, the cause in which he had fought so obstinately during his life.

While in France, Becket resided first at Sens, where he attended for a short time on the pope, and later at the abbey at Pontigny. It is at the former place that the ceremonial vestments of this celebrated martyr are preserved. ✳

King and Knight

RESS OF CEREMONY for solemn occasions, particularly with persons in exalted stations, suffer fewer changes in the course of time than those in common use. The illustration opposite represents a king from the latter part of the twelfth century. He is dressed in his robes of state, but we may probably take it as a good example of the regal costume during the twelfth and thirteenth centuries.

The costume of the king in this drawing bears a close resemblance to that presented in the monumental effigies of this period. He is clad in the long *dalmatica* (or tunic), and the royal mantle; the latter is thrown back loosely on the shoulders to exhibit the richness of the garment beneath, with its jewelled collar and belt. The *dalmatica* is here ornamented with fleurs-de-lys.

The dress and armor of the knight underwent much more frequent variations than those of the king. The one before us exhibits all the characteristics of a warrior of the age of Richard I, the Lion-Hearted, who ruled from 1189 to 1199. The crosses seem to show that this knight was a crusader. He is dressed in a coat and hood of mail and he wears over it a surcoat, probably of silk,

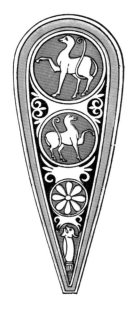

ornamented with crosses. This latter article of clothing first made its appearance about this time, and is supposed to have been brought from the Middle East. Its primary use seems to have been to hinder the armor from being too much heated by the sun's rays in a hot climate. This would not have been a serious concern in Britain.

The knight's legs are clad in the chausses, and the spur, a simple spike, is attached by a single strap of leather and a buckle. Beneath the coat of mail, we see, over the chausses, the chausson, or breeches, an article of the knight's dress which is less frequently represented in the old pictures. Even the *aillet* on the knight's shoulder has here the form of a cross. The helmet, which appears to be held by his armor-bearer, is also of that flat-topped, cylindrical form which came into fashion in the reign of Richard I. The *ventail*, or *aventaille,* moveable grating which protected the face in the hour of combat, is here represented as closed. At the period to which this figure belongs, the ventail was fixed by a hinge on one side and

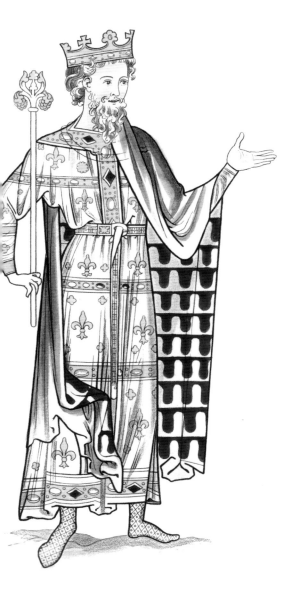

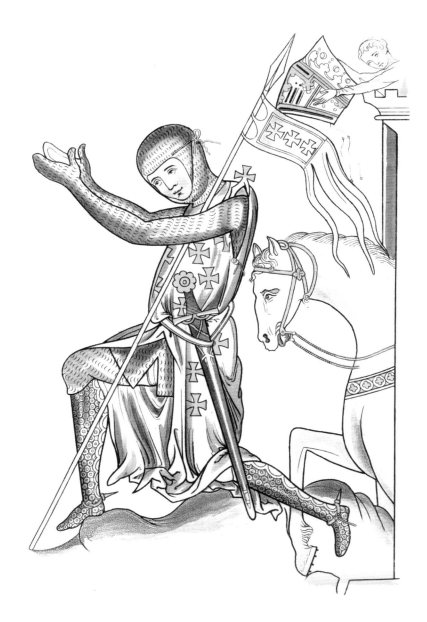

a pin on the other, and opened exactly in the same manner as a wicket, and, as the hinge was moveable, it might be taken off at pleasure.

The shield of the knight is not given in the picture, but we give two shields from other sources. The shield seen at the bottom of the opposite page is taken from a manuscript from the twelfth century in the Royal Library at Paris and is of that narrow, kite-like form which prevailed from the time of the Norman Conquest in 1066, until at least the reign (1154-1189) of Henry II of England. The form of the shield then underwent a gradual change, very similar to that experienced by the gothic window at later period; the bow became wider and wider, and the arch flatter, until at last it took the form which is still given to it in coats of arms.

The second shield is copied from a sculpture on the portal of the Cathedral of Notre Dame at Chartres, executed in the twelfth century, and is much broader in shape than the other example.

The initial letter on the opposite page is taken from Arundel Manuscript (Number 91) in the British Museum, and belongs to the same period as the king and knight illustration. ✽

An English Coronation Spoon and a German Scepter

THE ENGRAVING OPPO-SITE represents the spoon which has most probably been used in the coronation of English monarchs since the twelfth century, and which is preserved among the regalia in the Tower of London. Its style of ornament seems to prove that it was made at that period. It is of pure gold, with four pearls in the broadest part of the handle. The bowl, which is quite thin, has an elegant arabesque pattern engraved on its surface.

Unfortunately, the enamel has been destroyed, either accidentally or willfully. However, since the rough surface between the filagree work proves its former existence, it has been considered advisable to represent it in its original state. It is used to hold the oil for anointing the monarch at his coronation, and the bowl is divided by a ridge down the middle, into two hollow parts, in which the archbishop, when officiating, dips his two fingers. The ampulla, or vessel which contains the oil, is also of gold, in the form of an eagle, its head being loose and serving as a lid.

The object seen on this page is a small scepter, supposed to be from the latter end of the thirteenth century, which formerly belonged to the imperial abbey of Werden, but was in the possession of a Professor Muller in Wurzburg in the 1840's. It is made of bronze, gilt; the handle is surrounded by two spiral threads of silver, the space between them also being gilt. The knob at the bottom, as well as the dog's head at the top, are plated with silver, and ornamented with squares of black nielli. It has been observed that the dog's head is frequently found as the heads of staffs, and so forth, belonging to German ecclesiastics of the thirteenth century. Thus, it is said to be emblematic of the spiritual order.

It has been stated — and documents brought forward to substantiate the assertion — that the old regalia of England entirely disappeared in the troubled times of Cromwell, and that a new set was made in the time of Charles II. It appears, indeed, that the coronation of that monarch was obliged to be delayed on account of the absence

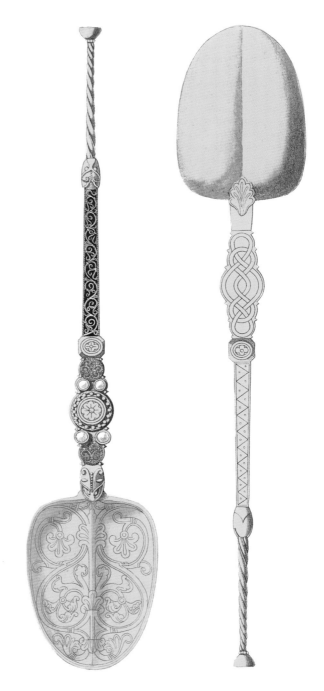

of these necessary articles belonging to the ceremony. Some of the old jewels, however, appear to have been recovered. We can have little hesitation in considering the spoon as having belonged to the ancient regalia. There can, of course, be no doubt of its antiquity; and it is not at all probable that an article of this kind should have been obtained from any other source.

The initial letter is taken from a manuscript collection of Saints' Lives, written in the twelfth century. The figures represent incidents in the legend of St. Caesarius. According to this legend, it was a custom at Terracina in Italy, under the Roman emperors, for a young man every year on the first of January to sacrifice himself to the gods as an expiatory offering for the prosperity of his native town. The victim was fed well and allowed every luxury of life for some months before the fated day; he then sacrificed an animal with his own hand to Apollo, and later armed himself, mounted a fierce steed, and rode headlong down a precipitous rock. Caesarius, happening to be a witness to this custom, preached against it, and was seized and carried before Leontius, who was consul there; by his exhortations and God's miraculous interference he converted the consul, upon which the superior magistrate Luxurius ordered them both to be enclosed in a sack and thrown into the sea. At the top of the letter we see first the victim offering up the sacrifice, and then riding over the precipice, while St. Caesarius is looking on with pity. To the right Caesarius appears to be addressing the pagans. The figures in the lower part of the stem of the letter probably represent Caesarius standing before Leontius. At the bottom, the men of Luxurius are throwing the two Christians into the sea, both enclosed in one sack. ✳

William Longuespee, First Earl of Salisbury

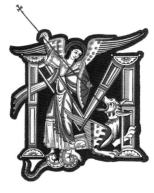

UCH IN THE WAY OF ROMANTIC interest is attached to the name of William Longuespee (or Longspee) (1153-1225). The first of Longuespee line, who is represented in the opposite illustration, was the son of King Henry II of England by his celebrated mistress, the Fair Rosamond (aka Rosamunde of Clifford).

William's wife Ela, Countess of Salisbury (1187?-1261), was also a heroine of romance. A woman of legendary beauty, she was the sole heiress of the powerful D'Evreux family in Normandy. It is said that she was discovered by a valiant English knight named Talbot, who found access to her in the guise of a minstrel, and, succeeding in carrying her away, presented her to King Richard I in London. In 1198, the English monarch gave her in marriage to his chivalrous kinsman William Longuespee, on whom he also conferred in her right the estates and title of Earl of Salisbury. They had one son, Stephen Longspee (1215-1260) and several daughters about whom little is known.

William Longuespee was actively engaged in the baronial wars during the reign of

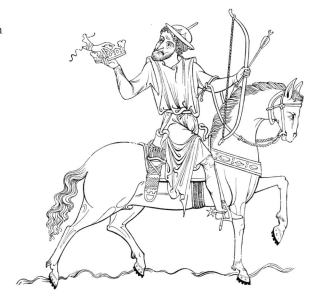

King John, of whom he was a devoted partisan. Early in the reign (1216-1272) of Henry III, William accompanied the Earl of Chester to the Holy Land, and was present at the Battle of Damietta, in which the Christians were defeated by the Saracens. He later was engaged in the Gascon wars. Upon his return to his native land an incident is said to have occurred which affords a remarkable illustration of the manners of that superstitious age. "There arose so great a tempest at sea, that, despairing of life, he threw his money and rich apparel overboard. But when all hopes were passed, they discerned a mighty taper of wax, burning bright at the prow of the ship, and a beautiful woman standing by it, who preserved it from wind and rain, so that it gave a clear and bright luster. Upon sight of this heavenly vision, both himself and the mariners felt confident of their future security: but everyone there was ignorant of what this vision might portend, except the earl: he, however, attributed it to the benignity of the Blessed Virgin, by reason that upon the day when he was honored with the belt of knighthood, he brought a taper to her altar, to be lighted every day at mass, when the canonical hours used to be sung, and to the intent

that for this terrestrial light he might enjoy that which is eternal."

William Longuespee died in 1225 (or possibly 1226), not long after his return from the Gascon wars. Son Stephen Longspee (1215-1260)

During his wanderings, the Countess Ela, like another Penelope, was pursued by the advances of a suitor — no less a person than Hugh de Burgh, who was later accused by some of having poisoned her husband. After the Earl's death Ela retired to the abbey of Lacock, which she had founded, and became abbess of that house, in which one of her daughters also was a nun.

The first William Longuespee was buried in the Lady Chapel in Salisbury Cathedral, whence his tomb, with his remains, was removed about the year 1790 to the place they now occupy, in the nave of the church. His effigy is a remarkably fine specimen of medieval sculpture. The coloring is very much obliterated on the more prominent parts, but a sufficient quantity of each pattern, or device, may still be traced to serve as authorities for a representation of it in its original state.

The initial letter on the opposite page is from the Arundel Manuscript (Number 91) in the British Museum, while the small illustration is from a thirteenth century illuminated manuscript concerning the Apocalypse, which is preserved in the Bibliotheque du Roi in Paris. ✳

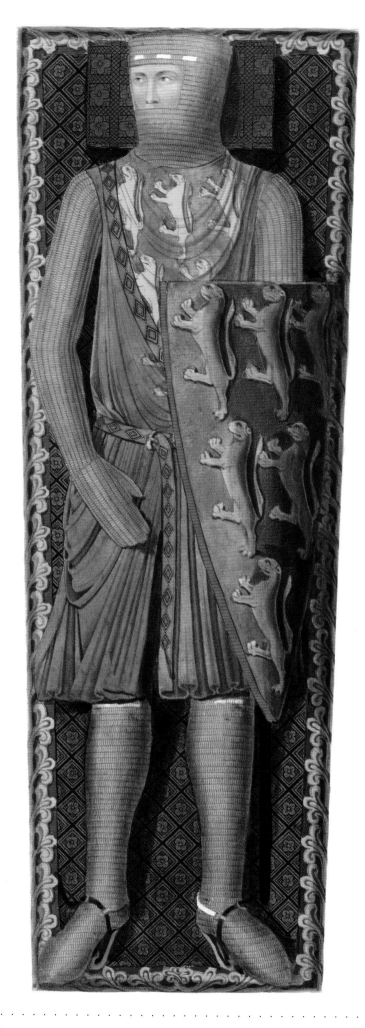

Knights Fighting

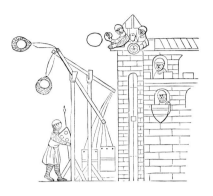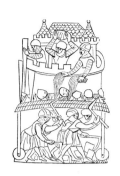

UIET AND PEACE WERE NOT among the most prominent characteristics of the Middle Ages. Unfettered by the sage power of judicious and efficient laws, people were taught to seek justice rather by their own strength than by the intermediation of others. At this time, the songs which sounded most musical to the ears of the iron-cased medieval barons were the romances that told of hard blows and doughty adventures, and the pictures most beautiful to their eyes were probably those such as the illustrations seen on the opposite page.

The volume from these are taken is a fine manuscript from the middle or latter half of the thirteenth century. It is well fitted for knightly eyes, as well as knightly ears, for it contains a large mass of the romantic history, adorned with a profusion of warlike pictures. In the margin, no less than in the text, the heroes of Thebes and Troy and other wor-

thies of ancient stories are represented combatting with all the arms and attributes of medieval knights.

The smaller illustrations represent some of the instruments used during the Middle Ages in carrying out sieges. In the picture below, a party is preparing to attempt the breach which has been made in the tower, while others are raised by means of a wooden machine to fight on an equality with the soldiers on the walls. On the other side of the picture similar expedients are adopted to raise the men in the ships.

The illustrations above are taken from a chronicle of France written at the end of the fourteenth century. One of them represents a machine used for throwing great stones at the walls, or into the castle; while in the other we see the assailants, under cover of a kind of shed which has been moved by wheels up to the walls, and which the besieged are attempting to destroy with stones, undermining the tower. This instrument was called, perhaps under different forms, by the different names of a *sow*, a *vine*, or a *cat*. The latter name was also given sometimes to a machine for

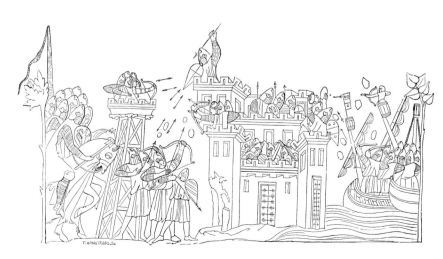

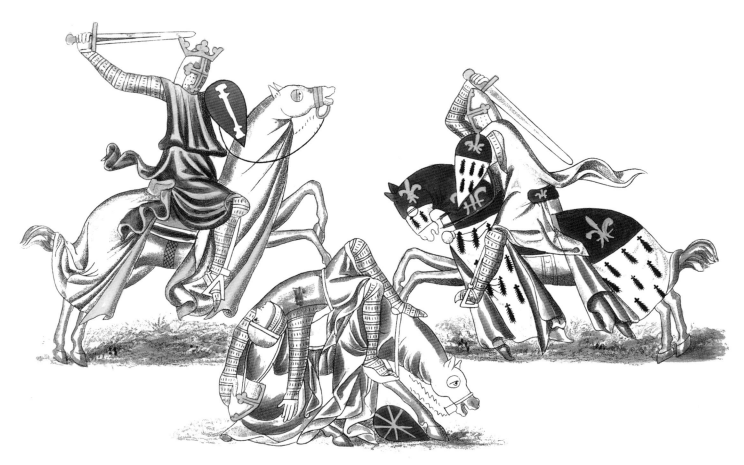

throwing stones. The warlike machines used during the twelfth, thirteenth, and fourteenth centuries seem to have been extremely numerous and complicated, and the knowledge of them was probably brought from Persia or China. Many descriptions of these machines are found in the old chronicles.

Strangely, their names were generally in the feminine gender. For example, William of Tudela, in his account of the war against the Albigenses, mentions, among others used by Simon de Montfort, the *ill neighbor* (*la mechante voisine*), the *lady*, and the *queen*.

The machine called *calabra* or *carabaga* was also used for throwing large stones. According to William de Rishanger, it was the second Simon de Montfort, son of the preceding, and so famous in English barons' wars of the thirteenth century, who introduced most of these machines into England.

At the siege of Rochester, garrisoned by the partisans of King Henry III, he used against the castle a machine which threw volleys of stones, each weighing upward of a hundred pounds.

The initial letter at the beginning of this article is taken from a thirteenth century manuscript in the Royal Library in Paris. ✳

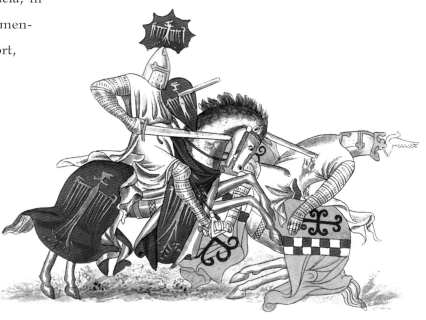

Ornamented Chalice and Font

MONG THE MOST BEAUTIFUL specimens of ornamented chalices is the one illustrated opposite, which was used by Pope Nicholas IV, and which was preserved at Assisi, Italy in the nineteenth century. It was crafted of silver gilt, and the stand is richly adorned with enamel and *niello* work (see page 134), representing figures of saints and others. The date of its fabrication and the name of the artist are preserved in two inscriptions in gothic capital letters around the stand, the letters being inlaid in gold on a blue ground. The first inscription on the chalice is *"Nicholas. Papa. Quantus."* The second reads *"Guccius manaie de Senis fecit."*

The translation is that it was produced for Pope Nicholas IV in Siena by a goldsmith named Guccio. Nicholas IV was pope from 1288 to 1292, meaning that this chalice is an authentic monument of Italian art in the latter half of the thirteenth century. Historians are not aware that there is any other account of the artist in Siena named Guccio. The last letter of the second name is

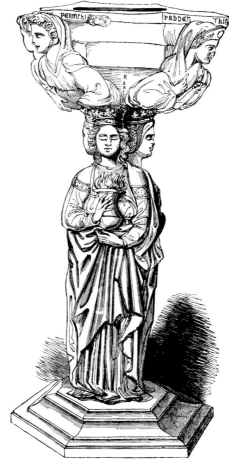

nearly destroyed, and it is not clear what it originally was. It appears not improbable, from the circumstance of his name being inscribed upon this chalice, that it was given to the church by Pope Nicholas.

The font, which forms the subject of the illustration on this page, is from about the same date as the chalice, and still remains at Pistoia, Italy.

The initial letter brings us from Italian to English art. It is taken from the Sloane Manuscript (Number 2435), a handsomely illuminated manuscript from the beginning of the fourteenth century, which has afforded us several other small illustrations for this work, and forms the initial to one of the chapters of an old French medical treatise, the subject of which chapter is the diseases of women subsequent to childbirth.

The doctor is seen here examining the breast of the patient. In the humorous figure above, the illuminator has amused himself with a little satire against the monkish orders, as he has again done in another initial included in this volume, where a monk is seen indulging in solitary and large potations in the cellar of the monastery. ✳

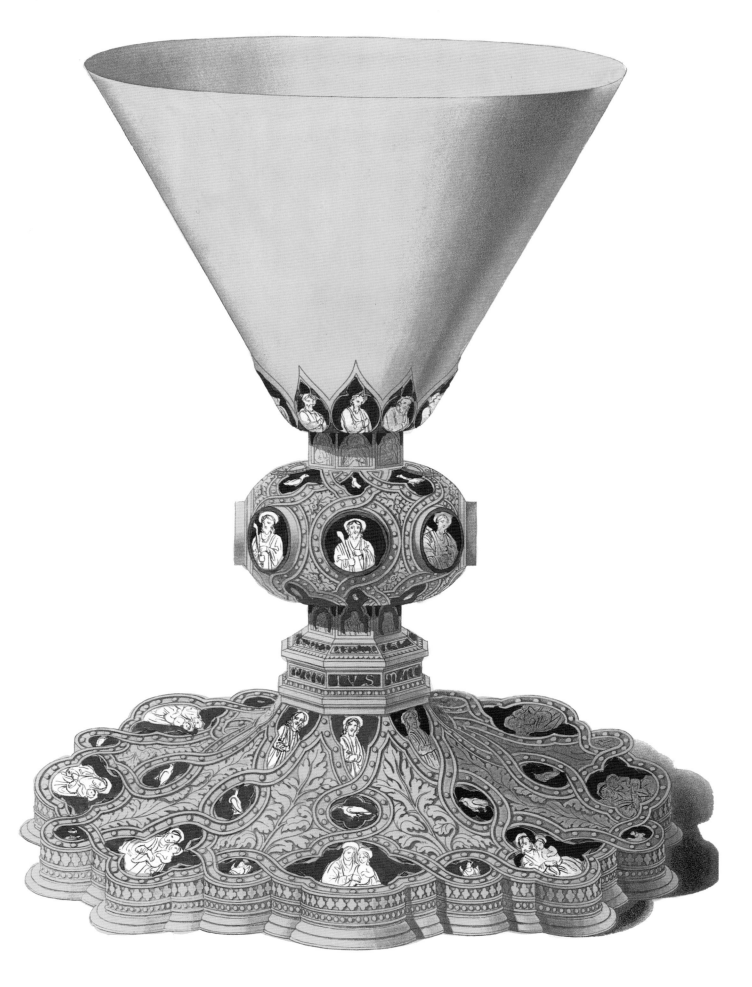

Ladies Playing on the Harp and Organ

OSTUME WORN through-
out northern Europe
during the thirteenth
and fourteenth centuries
was remarkably interna-
tional in character. One
would not have found a
striking difference between countries. Indeed, changes
in style and fashion were frequent — and often
remarkable — but the interplay of travel and com-
merce between England, France, Flanders, Burgundy
and the neighboring German-speaking states was so
constant that these changes in style were nearly
simultaneous in all regions.

When, however, we move to the south, and enter
the warm climate of the Italian states, we find that
the clothing worn by people at all levels of society had
an entirely different character. The costume of the
ladies, in particular, there was extremely light and
graceful. The illustration on the opposite page repre-
sents two ladies from Siena in the costume that is
characteristic of the beginning of the fourteenth cen-
tury. The fact that they are both playing musical
instruments is a reminder that music and dancing
were an integral part of Italian social life during the
Middle Ages.

The lady playing the harp is taken from a paint-
ing entitled *The Triumph of Petrarch*, which was pre-
served in the Academy of Fine Arts in Siena in the
nineteenth century. It is the work of A. Vanni, who
was active in the city during the fourteenth century.
The young lady with the accordion-like portable organ
is taken from a painting by Domenico Bartoli, who
lived in Siena at the beginning of the fourteenth cen-
tury at that place, and who was one of the first distin-
guished members of a family in which artistic talent
descended through several generations. This woman,
whose dress is remarkably graceful, is one of those
who attended festivals and parties to entertain the
guests by their performances. She has on her head a
characteristic crown or garland of flowers. The instru-
ment on which she is playing with one hand — while
she moves the bellows with the other — was very
common in Italy at this period. A similar organ can
be seen in the celebrated painting of St. Cecilia by
the great Renaissance master Raphael.

In the initial letter, we turn to the costume and
culture of northern Europe. It is taken from the fine
Sloane Manuscript in the British Museum, which
dates from the beginning of the fourteenth century,
and which contains the once popular poem by Gaulti-
er de Metz, entitled the *Image du Monde*. The illus-
tration represents the three classes, or castes, of soci-
ety acnowledged by the Middle Ages in England,
France, and Germany. These are the knight or sol-
dier; the clerk or scholar; and the husbandman or
laborer. The costume of each class is rendered in the
international style of the fourteenth century. ✳

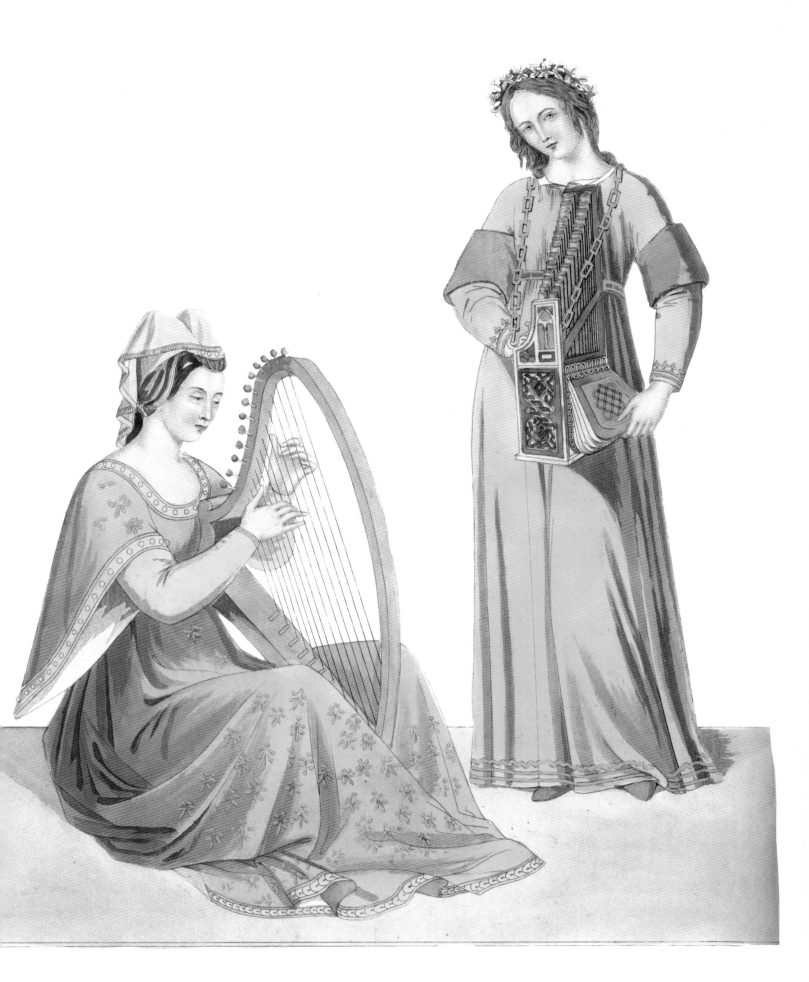

Gilbert de Clare, Earl of Gloucester

N THE OPPOSITE PAGE, we see an image of the third and last Gilbert de Clare of his lineage to hold the title Earl of Gloucester. This engraving is taken from a series of figures in the painted glass of the windows at the abbey church of Tewkesbury which represent members of the noble family of Clare, who were patrons of that monastic establishment.

The Earls of Gloucester of this family played important roles in the troubled events of the times in which they lived. The earlier members of the house were involved in the border wars against the Welsh, while Gilbert de Clare, the first Earl of Gloucester of the name, was one of the principal barons who took up arms against King John, and was one of the 25 appointed in 1215 to enforce the observance of the Magna Carta. After John's death, he remained staunch to the cause until he was taken prisoner at Lincoln, while fighting under the baronial banner. His son Richard de Clare was also a firm supporter of the Magna Carta, and a staunch adherent to the cause of the barons. He died by poison in 1262, and was succeeded by his son Gilbert de Clare. Probably the most celebrated member of the family, he was at first a partisan of Simon de Montfort. He fought at the battle of Lewes, after which he became jealous of the power and influence of Simon de Montfort, and swore allegiance to the king. His activity among the royalists is seen as having played a part in the disaster in the Battle of Evesham, in which he commanded a division of the king's army. He later returned for a short time to the cause of his old confederates, but he generally remained loyal to the crown through the reign (1272-1307) of Edward I.

His son, also named Gilbert de Clare and pictured opposite, was the last male heir of the family. He commanded the front of the English army at the disastrous Battle of Bannockburn in 1313, where he was slain on the field.

Although Gilbert was the last of the male line of the Clares, Earls of Gloucester, he had three sisters, and the descendants of one of them married into the royal line of the Plantagenets. Through them, the Clares were related — by way of the House of York — to the throne of England.

The windows at the abbey church at Tewkesbury were probably executed relatively soon after the death of Gilbert de Clare at Bannockburn, and the armor with which he is seen equipped is considered to be as a good and authentic example of the armor of the early fourteenth century.

The initial letter is taken from the fine Burney Manuscript in the British Museum, written and illuminated in the fourteenth century, and further described in the account of the Triumphal Chair of Don Martin of Aragon included in this volume. It represents a school, and is a good example of the costume of children in the fourteenth century. ❧

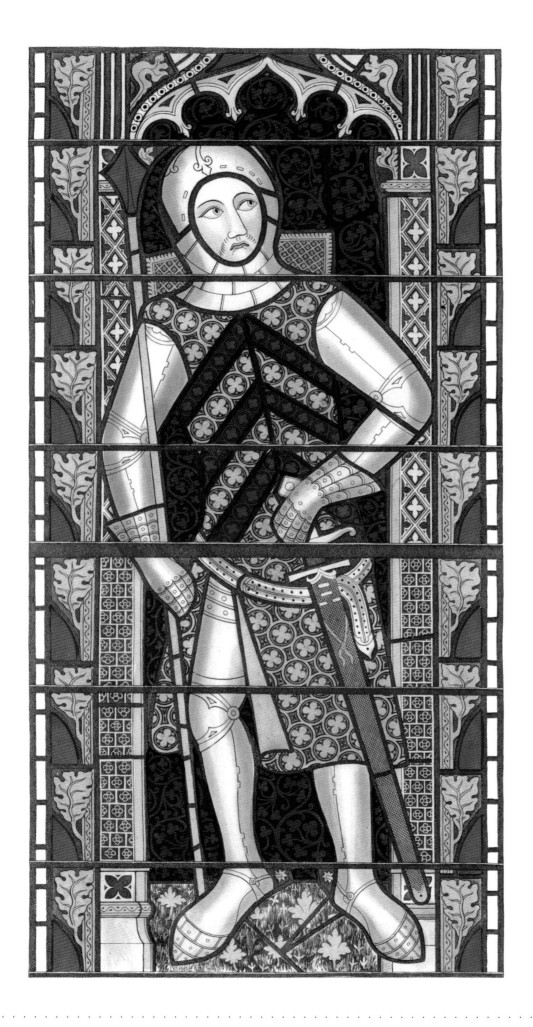

An Incised Slab Commemorating the Canon of Poitiers

MANY OF THE MOST richly decorated sepulchral memorials of France are incised slabs, which present the same general character of design as sepulchral brasses, and were probably executed by the same artists. Both had color introduced into the lines of the design and the lodgments which form the field, every portion of incised work being filled up with a resinous composition, either black or of various brilliant colors.

Brass plate was manufactured primarily in Germany, while in France, incised slabs of stone were used because they were less costly. On the continent, such plates and slabs were common from the thirteenth to the seventeenth centuries, but in England, incised slabs, usually of Derbyshire alabaster, occur rarely before the fifteenth century.

The fine specimen depicted opposite was located at the Abbey of St. Genevieve, where Millin, who was struck with its beauty, found it neglected and thrown out into a court adjoining the cloister. It had fortunately suffered little material damage, and was transferred to the Palais des Beaux Arts in Paris.

The man commemorated was the Canon of Poitiers and Chancellor of Noyon. He is seen vested in the alb, which has a rich bouquet of fleurs de lys and roses, and the chasuble, probably of cloth of Baudekyn, "embroudez avec mermyns de mier," or sirens (a common ornament in the fourteenth century) as well as with cocks, and lions. The maniple and stole are rich in decorations. On his head is the canonical vestment called the amyse, the furred lining of which is notable. Between his hands he holds the chalice and paten, and his feet rest on a dragon, from whose mouth and tail proceed a rose tree and a vine, forming an elegant diapering in the field of the central compartment. These Christian symbols refer to the triumph of Christianity over paganism and infidelity. Over the principal figure is seen the usual symbolical representation of the spirit of the deceased received into heaven. On either side is St. John the Evangelist, and St. John the Baptist, holding the Holy Lamb.

On either side are small figures of saints. St. Jullien appears with his Oliphant. St. Eloy, bishop of Noyon, where his relics were preserved, is represented with a hammer, because he was celebrated for his skill in working the precious metals. St. Michael, and a sainted abbot, whose name is illegible, appear on the opposite side. Beneath there are seen two relatives of the deceased, Jaquet and Isabeau: the curious horned headdress of the latter, apparently the same which is satirized by Jean de Meun, occurs in some contemporary instances in France. On a scutcheon in the margin on either side are, first and fourth, a human head couped; second and third, bouquets of fleurs de lys. By the heraldic usage of France, ecclesiastical dignitaries quartered the bearing of the see, instead of impaling it, as was usual in England. ✽

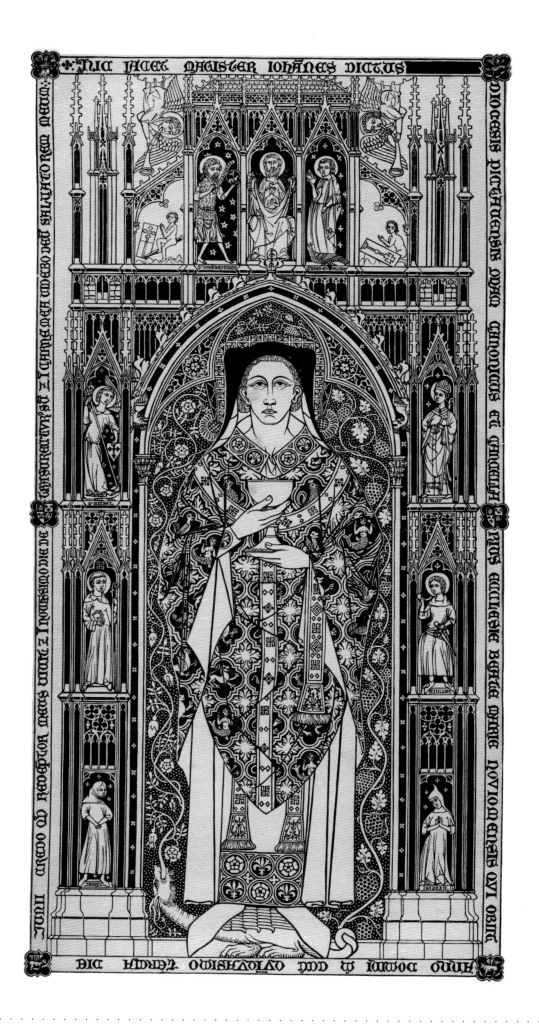

Edward III, King of England

AMONG THE MOST INTERESTING discoveries connected with the ancient palace of Westminster in London were those of the paintings on the walls of St. Stephen's chapel and of the room which, from this characteristic, has always been known as the Painted Chamber.

Frequent discoveries made during the first decade of the nineteenth century combine to show how much painting was used in the Middle Ages for architectural decoration, particularly in churches. Numerous pictures in the illuminated manuscripts exhibit the magnificence which appeared in the decorations of the interiors of palaces.

The image opposite was adapted from a painting found at the east end of St. Stephen's Chapel. Here the wall was painted with religious images, as well as with figures of St. George, Edward III, and his five sons. Each image was painted with an arched canopy such as is seen here. In the image of St. George, he is represented as leading the king to present him to the Virgin Mary.

The image on the opposite page is probably a tolerably accurate portrait of the king, who was born in 1312, and who ruled from 1327 to 1377. This portrait was probably done in about 1355, the date of the birth of his fifth son. The figures, if erect, would be in the original, about 18 inches high. Edward is represented in full armor. His crown is embossed and gilt; the helmet is silvered, with its rim gilt. The mail also was embossed and gilt. The surcoat is quartered with the arms of England and France, the lions being embossed and gilt on a red field.

The illustration on this page is of a cup of silver gilt from the era of Edward's reign. It was preserved at Pembroke College, Cambridge, where it was still being used on festival days five centuries later. The

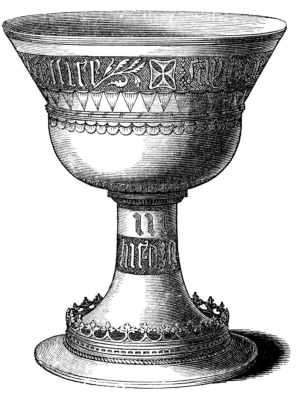

cup was presented to the college by its founder, Mary de Valencia, Countess of Pembroke. The college was founded in 1347, and the cup may date from that year.

Around the bowl of the cup runs the following inscription: "Sayn Denes yet as me dare, for his lof drink and make good cher." Below is inscribed: "M. V. God help at ned." M. V. are the initials of the donor's name, Mary de Valencia. ❁

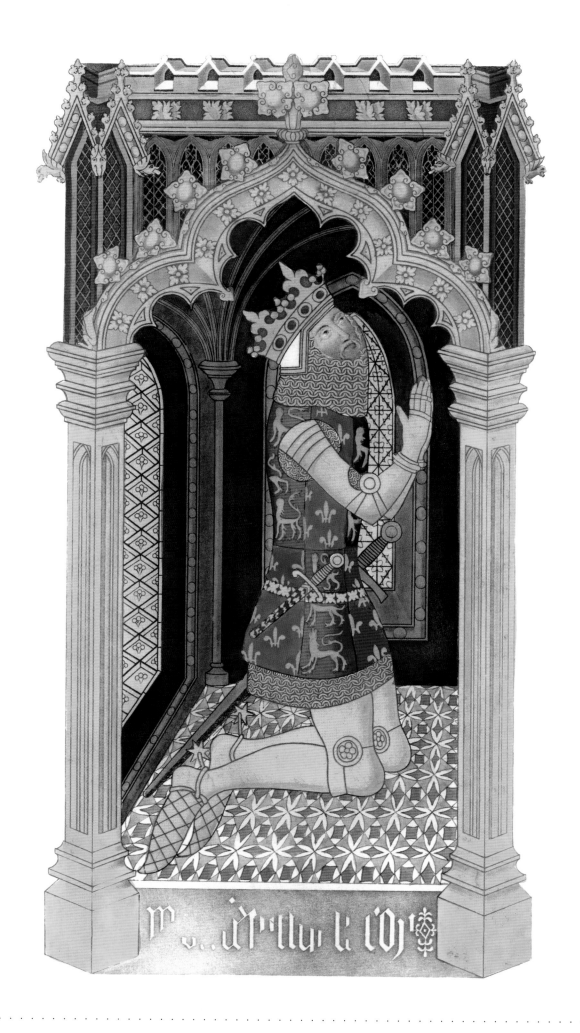

The Black Prince

THE LEGENDARY BLACK PRINCE — Prince Edward — was the eldest son of Edward III of England. In August 1346, when he was just 16, he was celebrated as the victor in the Battle of Crecy. It was here that Prince Edward first adopted the crest of the ostrich feathers with the motto *ich dien* (I serve) that has been used ever since by the Prince of Wales. These were in fact the spoils of King John of Bohemia, who was slain in the battle. Meanwhile, he earned the appellation of "Black Prince" by wearing an all-black suit of armor.

In 1356, Edward achieved another important victory at the memorable Battle of Poitiers, in which the king of France was taken prisoner and brought by the prince to England. A few years later, the prince went to Castile, where he successfully reinstalled Pedro IV on his lost throne, thus adding another victorious campaign to his exploits. In the war in 1372, however, Edward was compelled by sickness to return to England.

During the peace, which lasted through the remainder of his father's reign, he increased the love which the English people had ever borne toward him by advocating popular measures of state. The sorrow is said to have been great and universal when their favorite prince died on June 8, 1376, at the age of 46. He never was to become king. When his father, Edward III, died a year later, Richard, the 10-year-old son of the Black Prince, ascended to the throne.

The Black Prince was buried with great pomp in Canterbury Cathedral, where his monument and effigy still remain. The portrait seen opposite is taken from a painting on the wall at St. Stephen's Chapel at Westminster adjacent to the portrait of Edward III seen on the previous page. Prince Edward occupies the compartment of the picture immediately behind that of his father, and is, like him, represented kneeling in adoration of the Virgin, who in the original is seated in a larger compartment above.

This portrait was probably done at about the time of the Battle of Poitiers, when the prince was 26, and he is, accordingly, represented as a beardless youth, bearing strong traits of resemblance to his father. His helmet, surrounded by a coronet, resembles that on the effigy at Canterbury.

In other respects, his armor varies little from that of King Edward. It is not, however, the all-black uniform which he wore at Crecy and Poitiers. It is believed that he wore the black armor in battle, but not on occasions of state, when he would have worn the uniform in which he is represented here.

Only three letters from the end of his name are preserved at the foot of this picture, reminding us of the mutilations that were made after completion to this and to many other paintings and statues from the fourteenth century and before. It is remarkable that we have as complete a first hand record of the Middle Ages as we do. ❉

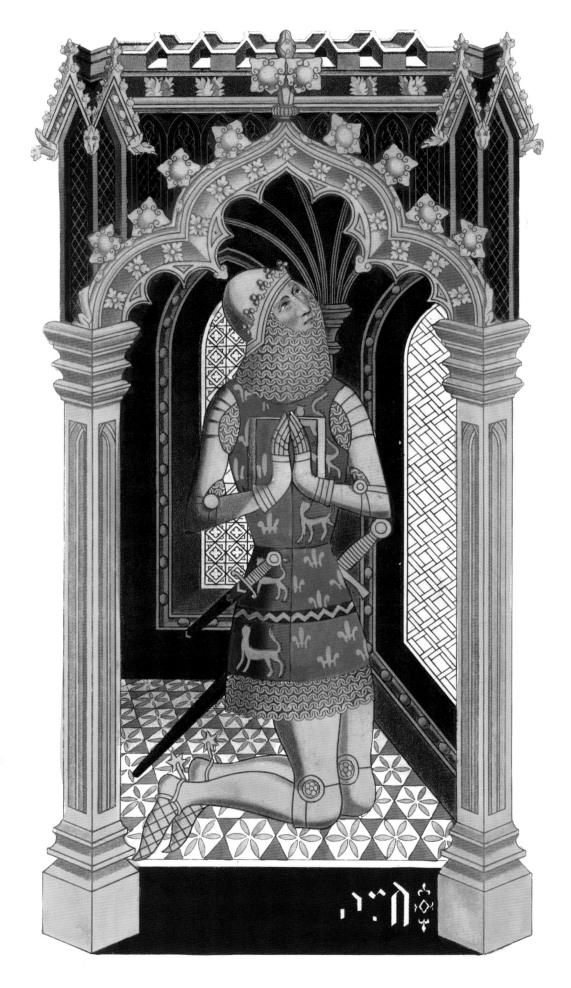

Richard II, King of England

ERHAPS NO MONARCH under the same circumstances ever enjoyed so great a share of the sympathy of posterity as the ill-fated, though at the same time — it must be confessed — ill-deserving Richard II. This is perhaps to be attributed in great measure to the mystery which involved his last days. Brought to the throne in 1377 at the age of 10, this weak prince had been led astray by the vanities and luxuries which were thus placed in his grasp before he had learned to estimate the duties which belong to a crown.

During his reign, the kingdom was governed by favorites of most unworthy character. On the eve of a mighty revolution in the minds of his countrymen, the king was urged by his own inclination, and by the evil counsels of his favorites, to *increase* the number of abuses. While the kingdom was ruled in a disgraceful and inglorious manner, the people were loaded with new taxes to support the extravagance of the royal household. As a finishing stroke to the general dissatisfaction, Richard's greedy entourage even alienated the king from the nobility. He seized the property of John of Gaunt, fourth son of Edward III and banished John's son Bolingbroke, who returned to England and imprisoned Richard II. When Richard died under mysterious circumstances, Bolingbroke assumed the throne as King Henry IV.

Meanwhile, Richard's reign was an era popularly famous as the age of Jack Straw and Wat Tyler. In religious history it is connected with the name of the reformer John Wycliffe (1320-1384), while in literature it boasts the name of Geoffrey Chaucer (1340?-1400). The era also furnished to future ballad-singers the never-to-be-forgotten rhymes of Chevy Chase.

There are two original paintings of King Richard II, of which the most curious is represented on the opposite page. Preserved at Wilton House, the seat of the Earl of Pembroke, it is a small piece. Also included, but not pictured here, are his patron saints, John the Baptist, St. Edmund the King and Edward the Confessor before the Virgin and Child, attended by angels. The date of this painting is stated to be 1377, and it has been cited as an example of painting in oil previous to the supposed invention of that art in 1410 by Jan van Eyck (1370-1440). On closely examining it, however, it appears to be merely executed in distemper, and washed with some kind of varnish which has given it somewhat the appearance of oil. It is painted on a bright golden ground, and the colors are extremely fresh.

The small illustration at the left is taken from a manuscript from the latter half of the fourteenth century.

The initial Letter is taken from a handsome manuscript in the British Museum, written early in the fourteenth century, or perhaps at the end of the thirteenth. In the original it begins the chapter of an old medical book which has as its subject the diet and dress proper to each of the four seasons of the year. The four compartments of the letter represent the manner of dressing in each season. The first compartment shows the costume proper for spring, where a light robe is thrown over the tunic, of such make and materials as to be neither too hot nor too cold.

In autumn the same dress is recommended as in spring but the outer garment is here left loose and open, and the cloth is recommended to be a little colder. The figure in the fourth compartment, closely muffled up, represents the winter dress. ❋

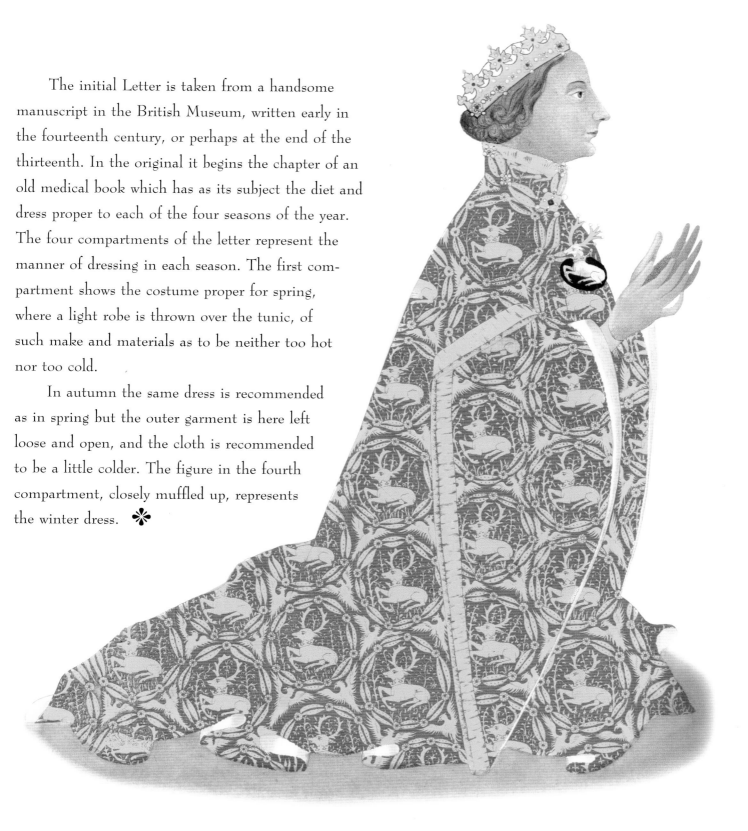

Courtiers of the time of Richard II

DESPITE THE POLITICAL CORRUPTION of the royal household, the reign of the weak Richard II was remarkable for the variety and festivity of its fashions. The satirists and reformers of the day were zealous and loud in their outcries against the extravagance of the higher classes.

Geoffrey Chaucer, who wrote during this period, in declaiming against the "superfluitee of clothing" which prevailed around him, blames "the cost of the embroidering, the disguising, indenting, or barring, pounding, paling, winding, or bending, and semblable waste of cloth in vanity; but there is also the costly furring in his garments, so much poisoning of chesel to make holes, so much dagging of sheers, with the superfluitee in length of the previously mentioned garments, trailing in the dong and in the mire on horse and eke a foot, as well of man as of woman, that all the like trailing is verily (as in effect) wasted, consumed, thread-bare, and rotten with dong, rather than it is yeven to the pour, to great damage of the foresaid poor folk, and that in sundry wise."

The garments worn both by men and women during the late fourteenth century — and alluded to in this passage by Chaucer — are shown in the opposite illustrations.

The rich, albeit quite effeminate, gown of the knight at the lower part of the page, as well as that of the person who is making obeisance to him, will explain what Chaucer means by "poisoning and dag-ging." The edges of the sleeves, hoods, and so forth were punched and dagged (or cut in shreds) into the form of leaves, and sometimes gave the costume a very grotesque appearance. Among the nobility, the gown was often enriched with a profusion of jewelry. The man above apparently has a collar of small bells about his neck.

These two figures are adapted from an illustration of the *Song of Solomon* in the Harleian Manuscript, which is well known as containing an interesting contemporary narrative of Richard II's expedition to Ireland in May 1399, and his demise shortly thereafter at the hands of Bolingbroke, who would succeed him as Henry IV.

The story is written in French verse by a French gentleman who accompanied a Gascon knight on the expedition, and who was therefore present at most of the circumstances which he relates. The figures are portraits of the Gascon knight and the author, neither of whose names are known. The latter is paying his respects to the knight, who had sent for him to accompany him to England.

"Five days before the first day of May," he writes in a caption to the illustration, "when every one ought to quit sorrow and trouble, a knight whom I love cordially, said to me with much gentleness, 'Friend, I pray you affectionately, that you will come with me joyously into Albion [England]; I intend to go thither shortly.' " ❊

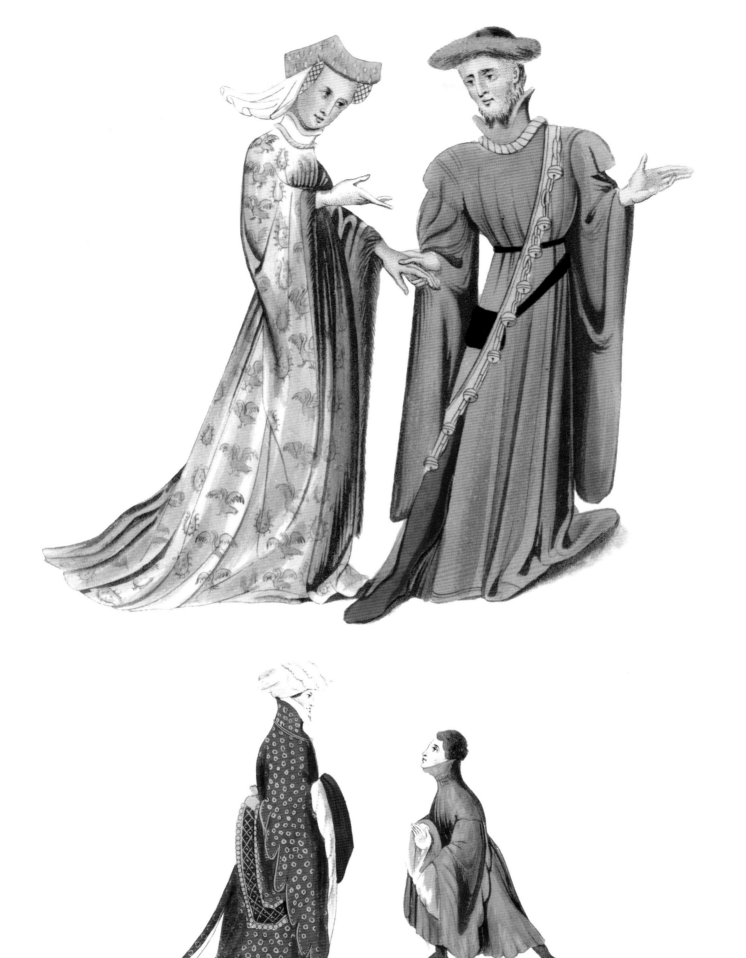

LEGANCE AND GRACE, which had seldom exhibited themselves in the horned and peaked headdresses of the ladies of the fifteenth century, began again to show themselves in the various headdresses of the beginning of the sixteenth. This was especially visible in France, which, then as now, took the lead in the fashions of dress. In England, during the reign of Henry VIII, many of the forms of women's costume bore a close resemblance to those which were continuing to appear, even in the early nineteenth century.

In the illustration opposite, the two first heads and the fourth are taken from the Lavalliere Manuscript (Number 44), preserved in the Royal Library in Paris. This manuscript, written at the beginning of the sixteenth century, consists chiefly of proverbs, adages, and similar matter. Among these are a series of imaginary portraits of celebrated ladies from ancient history or fable, drawn in sepia, and represented in the costume of that age, under the classical names "Hypponne, Penelope, Lucretia, Claudia, Semiramis, Ceres, Porsche and Romaine."

With each of these heads is a brief character in French prose of the person that is represented. The three shown

here are identified by the names Lucretia, Penelope, and Hypponne.

The caul, under which the hair is gathered in the first two of these figures, is frequently mentioned as an article of attire in England during the reign of Henry VII. At her coronation, his queen, Elizabeth of York, wore her hair hanging down her back with "a caul of pipes over it."

The band on the fourth head, running round the temples, and ornamented with jewelry, appears to be the "template" spoken of by Olivier de la Marche, in his *Parement ou Triomphe des Dames*.

The third figure on this plate is a portrait of one of the wives of Francis I of France who reigned from 1515 to 1547 and sent the first French expeditions to America. It may be Anne of Brittany, but it is more probable, however, that it portrays Francis' first wife, the beautiful Claude de France, who bore his heir and successor, Henri II.

The illustration at left is from a manuscript written in the fifteenth century, and now preserved in the extensive collection at the library of the Arsenal in Paris. It represents a religious vessel such as cibory (*ciboria, ciborium*) or reliquary, in which were placed sacred relics. The ornamental mounting is gilt, while the cup itself appears to be made of glass. ❀

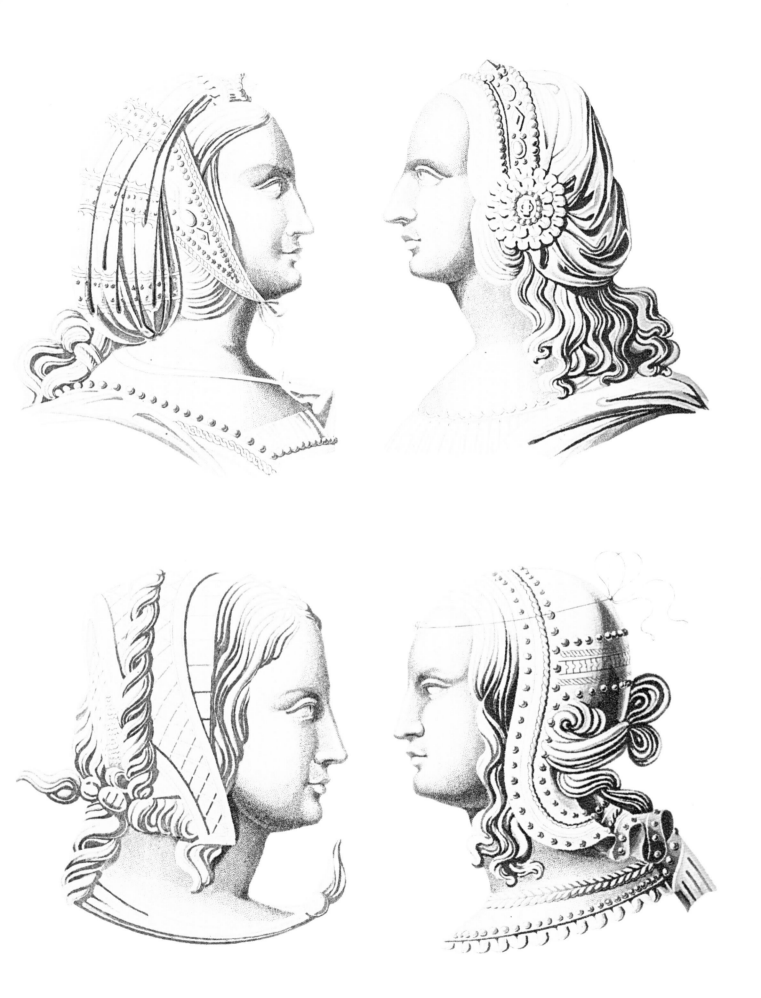

The Processional Cross of Lianciano

On the shores of the Adriatic Sea, in the Italian town of Lianciano, one may see the beautiful processional cross illustrated on the opposite page. This plate shows the front of the cross. The reverse is shown and described on the following pages.

Dating from approximately 1360, this cross stands about three feet high, independent of the stem, and is made of wood, plated all over with silver, embossed or chased and gilt. The figures are in very high relief, and silvered, to contrast more strongly with the gilt ground of the cross. The stem of the cross is of brass gilt, and is much inferior to the cross itself in design and execution. It has more of the Venetian forms in its design and execution, particularly in the niches and in the gables and foliage of the under part of it.

The ornament at the head represents the Resurrection, while the right arm represents the Virgin with the other two Marys. On the other side are three of the disciples as mourners, and at the foot is the representation of the disciples committing the body of Christ to the tomb. In the center the body of the Savior is extended on the cross.

This cross escaped the rapacity of the French, when they had possession of the town in the time of Napoleon. The monks built it up in a recess in the tower of the

church to which it belongs, or it would doubtlessly have suffered the fate of so many other church ornaments which perished during that melancholy period.

After the fall of Napoleon Bonaparte in 1815, and the subsequent restoration of peace to Europe, this cross was taken from its hiding place, and during the nineteenth century. it was still being carried in Catholic ceremonial processions.

There was once another rich cross belonging to the same church, larger than this one, but it had not the same good fortune as the other. It was entrusted to the keeping of the sacristan and a priest, whose cupidity was excited by the value of the silver with which it was covered, and which they stripped off and sold before destroying the cross.

The illustration at left which provides a good view of the armor of the middle part of the fourteenth century was taken from Sloane Manuscript. It is part of a series of illustrations of Scripture history, as set forth in a Latin metrical paraphrase of the Bible composed in the twelfth century by Peter de Riga.

An Englishman by birth, de Riga was a clerk of the church of Rheims in France. In his poem, entitled *Aurora*, he expands and elaborates on the stories of Sacred Writ, and frequently indulges in typical and allegorical interpretations. ❁

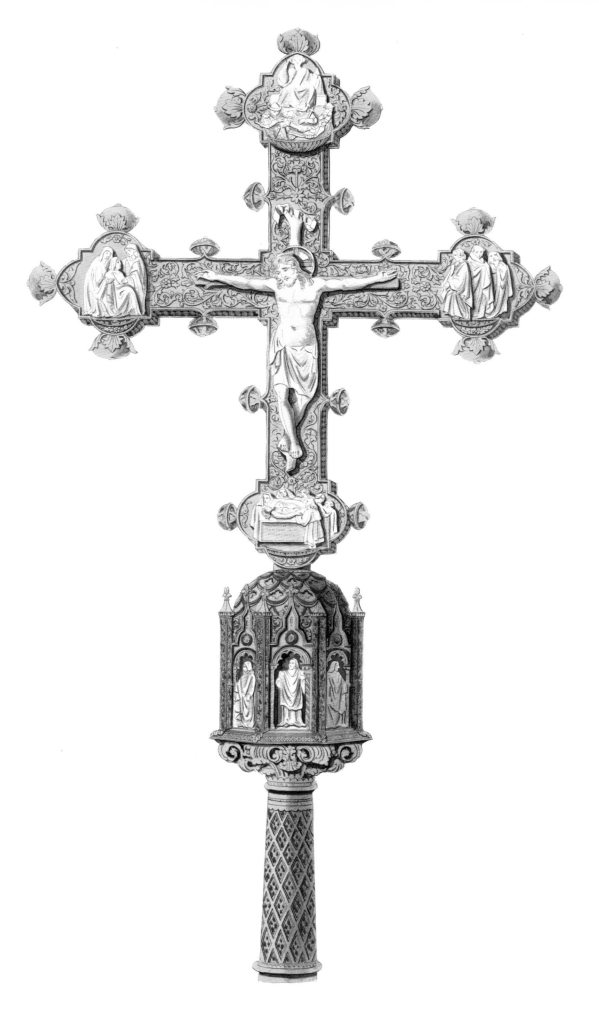

The Processional Cross of Lianciano (Reverse)

ONTINUING the account of the splendid Processional Cross of Lianciano begun on the preceding pages, we offer the illustration of the reverse side of this splendid object. In the plate opposite, we see the figures on the back, which are by no means inferior in beauty to those which adorn the front.

The figure in the center appears to he intended to represent Christ teaching. Around him are four raised enamels of the four Evangelists. At the top is represented the crowning of the Virgin. The two Marys appear again at the extremities of the arms of the cross, and at the bottom is a representation of the administering of extreme unction.

The figures below are taken from a fine manuscript from the celebrated poem of Piers Ploughman that is preserved in the Library of Trinity College, Cambridge. Written around 1377, at about the end of the reign of Edward III or at the beginning of that of Richard II, it gives us a very good idea of the mode of plowing with a pair of oxen during the fourteenth century, as well as of the kind of instruments and equipment that were then in use, and of the costume of the man and woman who are at work here.

One of the beams of the plow is inserted the plow-mell, or mallet, frequently mentioned in old writings. The drawing is accompanied by the old popular saying, which calls upon God to speed the plowing and provide corn as the fruits of the labor.

The illustrations that are seen on the opposite page are taken from the Bodley Manuscript (Number 264) preserved in the Bodleian Library at Oxford, and containing the *French Romance of Alexander the Great*. It was written in the year 1338, as we learn from the following entry at the end: *"Romans du boin roi Alixandre, qui fu prescript le xviii. jor de Decembre, l'an m.ccc. xxxviii."*

The initial letter at the beginning of this article is taken from Queen Mary's Psalter. ❉

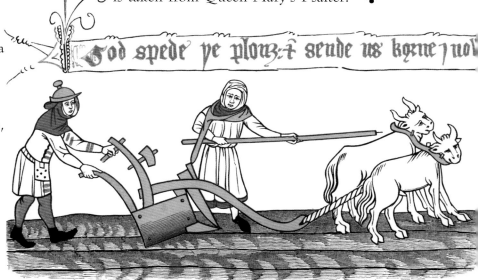

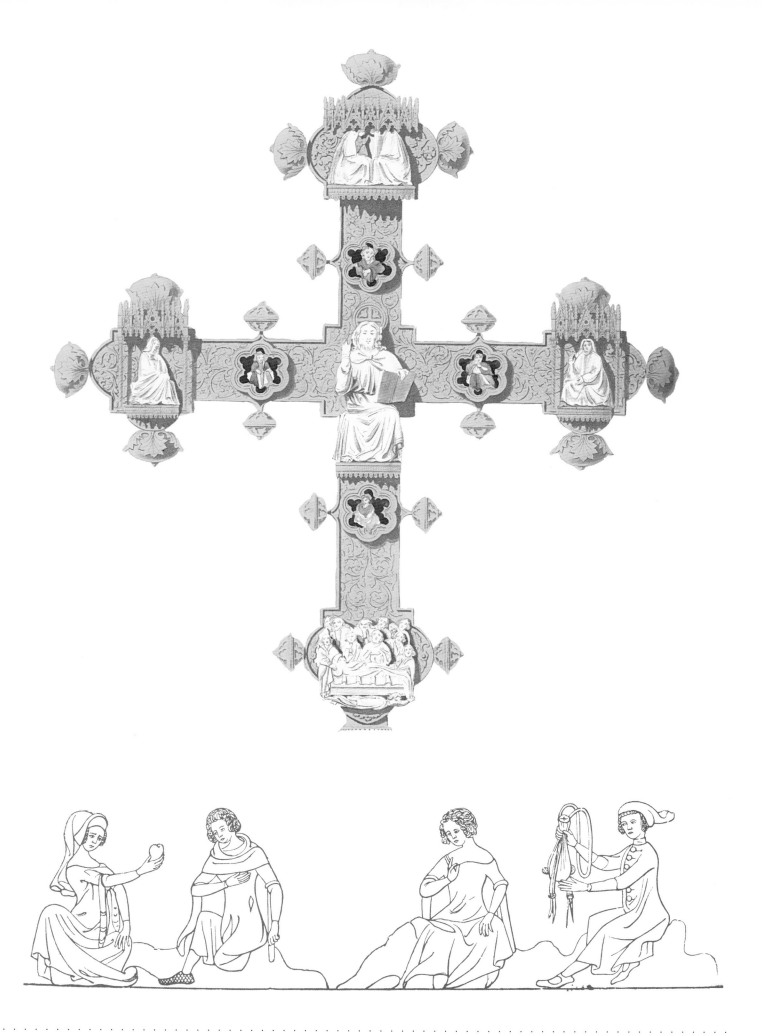

The Triumphal Chair of Don Martin of Aragon

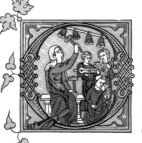 N THE OPPOSITE PAGE, we see the image of a very richly ornamented chair or throne, made of solid silver, still preserved in Barcelona, Spain. Tradition points it out as the chair of Martin, King of Aragon. When Martin succeeded to the throne of Aragon in 1395, he was actually in Sicily, where he was preoccupied in suppressing the rebellion against his son and daughter-in-law, then the sovereigns of that island.

Having reduced the Sicilians to obedience, and establishing the power of his son, he returned to take possession of his own dominions. He landed at Barcelona in 1397 and made a triumphal entry that was received with great festivities. It was on this occasion that he used the chair of silver depicted here.

The two small illustrations on this page are taken from a fourteenth century manuscript ornamented with beautiful miniatures and now preserved in the British Museum. The figure on the left represents St. Jude writing his epistle, but actually shows a scribe of the fourteenth century. Such scribes wrote on vellum in quires, which was bound into volumes after being finished. The quire is here represented as held

in place by a piece of lead suspended on a string. One page is already written, while the other is prepared. In one hand the writer holds his pen, and in the other a scraper, to erase mistakes from the vellum. On one side of his seat are three ink-horns, to hold the different colored inks. The box within the chair contains his writing implements.

The other small illustration represents the Biblical King Amaziah sick in bed, and awaiting the return of his messengers — whom he had sent to consult Baalzebub, the god of Ekron — and to know if he were destined to recover (2 Kings, chapter 1). At the end of the fourteenth century people had not yet laid aside the custom — rejected in the early nineteenth century — of going to bed naked.

The initial letter is taken from the very fine large fourteenth century Burney Manuscript in the British Museum. It contains some of the principal scientific treatises of Priscian, Boethius, Euclid, and Ptolemy. It is full of handsome and interesting illuminated initials. This one represents a party of musicians. One is playing bells, once a favorite instrument of ecclesiastical music. The use of them still remains in English church chimes. In medieval manuscripts King David is often seen playing bells. ❈

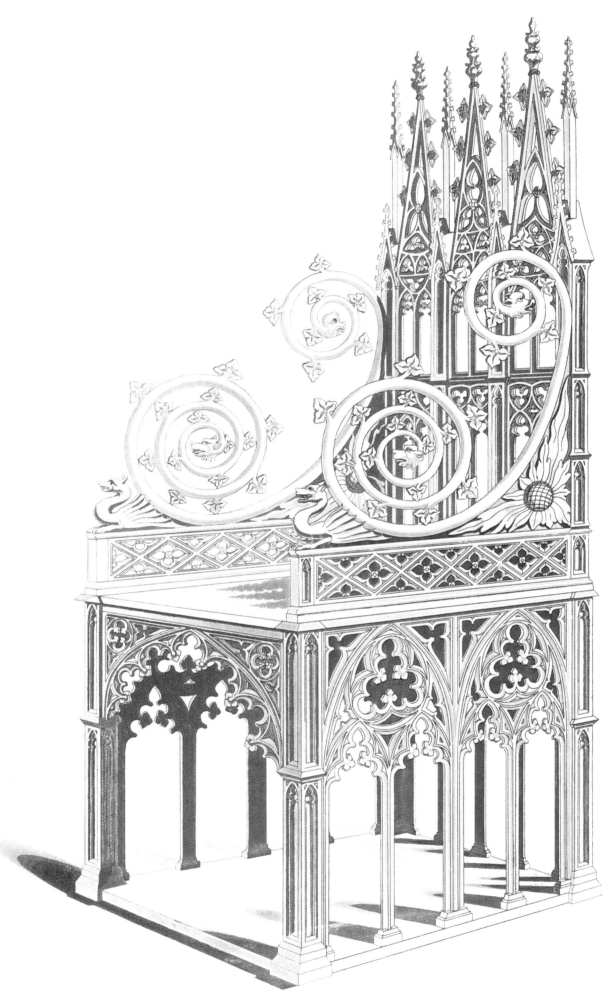

Geoffrey Chaucer

AN CHAUCER, as he is termed by some of the older British writers, is the popular representative of the earlier period of English poetry. Indeed, he may be considered the poet *par excellence* of the English Middle Ages. In spite of the antiquated character of his language, *The Canterbury Tales* will never cease to be generally read.

However, in spite of his great fame, which was already established during his lifetime, many of the most important parts of his life are covered with mystery. We have no memorials left of his birth or of his parents, and the rank or condition of the latter has been a subject almost as much disputed as the celebrated question of the birthplace of Homer. The date of Chaucer's birth has been placed in 1328, and we have his own authority for stating that it took place in London. The place of his education has also been a matter of controversy, but it seems probable that he studied in Cambridge. Speght, his biographer and editor, informs us that there was a record of his having been "fined two shillings for beating a Franciscan friar in Fleet Street." In the records of the reigns of Edward III and Richard II (spanning the years from 1327 to 1399), we find evidence of his having held various government jobs, including being sent by the king as envoy to Genoa. He returned to England imbued with a taste for the beauties of the Italian poets. He died on October 25, 1400.

Chaucer wrote at a period when the English language was influenced by the introduction of Norman French words, yet he was certainly the first writer, since the breaking up of the Anglo-Saxon language, who gave absolute elegance and smoothness to the English tongue. It is certainly remarkable that he not only stepped into a place infinitely above those who had gone before him, but that for nearly two centuries after nobody could put in a claim to rival him.

He was, to speak figuratively, the sun of the firmament, whose light overwhelmed the twinkling of the smaller stars around him.

There are several portraits of Chaucer. Contemporary poet Thomas Hoccleve (1370-1450) commissioned the opposite view for his book, *De Regimine Principis*, which he presented to Henry V. Under the drawing he inscribed: "Although his life be quaint, the resemblance; Of him that hath in me so fresh liveliness; That to put other men in remembrance; Of his person, I have here the likeness; Do make, to the end, in soothefastness; That they that of him have lost thought and mind; By this picture may again him find."

Copies of this portrait are found in one or two manuscripts of Hoccleve's book, and one of them was engraved to illustrate Tyrwhitt's edition of *The Canterbury Tales*. The resemblance which these different portraits bear to each other leaves no room to doubt that the likeness is correct. ✽

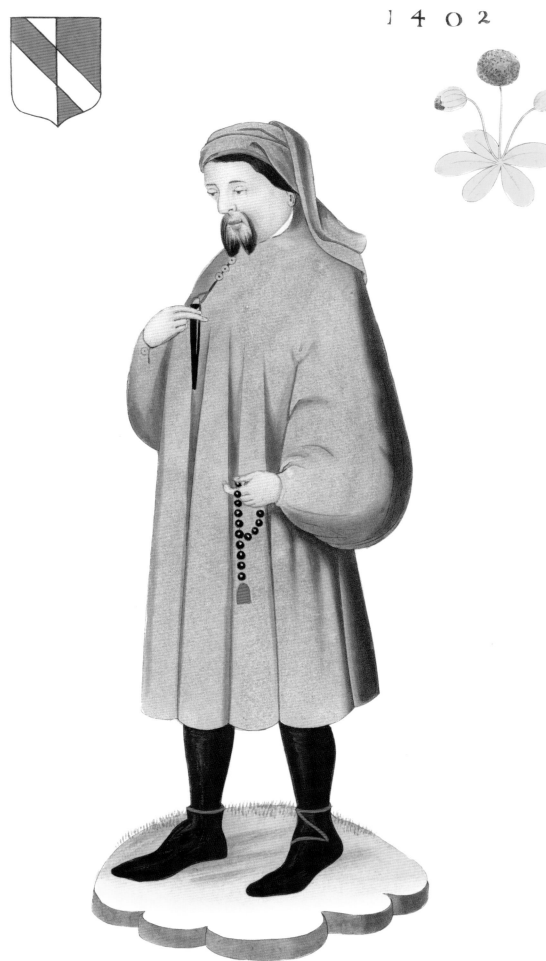

1402

The Limerick Miter

ROM A CURIOUS passage in the ancient "Ceremonial" of the Catholic bishops, it appears that each prelate was expected to possess three different miters, the precious (or superb) miter (*pretiosa*), formed of plates of gold or silver, adorned with gems and precious stones; the miter of orfrais (*auriphrygiata*), also ornamented, but much less richly, and without the plates of gold or silver; and the simple miter (*simplex*), without any rich ornament to distinguish it.

The precious miter seen opposite was used by the bishop of Limerick, Ireland, on occasions of great ceremony. Its date is established by the inscription round the rim. From the space occupied by the part of the inscription erased, and the known period of O'Deagh's pontificate, there can be no doubt that this date is 1408. Another inscription, in a small compartment, has preserved the name of the maker: *Thomas O'Carty artifex faciebam.*

The body of this miter consists of thin silver laminae gilt, and is adorned with flowers composed of an infinite number of small pearls. The borders and ornamental panel — or style — down the middle, on both sides, is of the same substance, but thicker, being worked into mouldings and vine leaves. It is enriched with encased crystals, pearls, garnets, emeralds, amethysts, and other precious stones.

The infulae, or pendant ornaments, which hung down the back of the bishop (not shown) were 21 inches long, and consisted of silver plates, gilt, and in a like manner are ornamented with numerous small pearls, disposed in the form of leaves and flowers.

It has been supposed that the Episcopal miter, in its present form, open and double pointed, was not introduced before the ninth or tenth century. Even then, it seems to have been much lower in shape than at a later period. The miter of William of Wykeham in the fourteenth century is 10 inches in height, while the Limerick miter measures 13 inches. By the sixteenth century, the height had been increased to 18 inches.

It was during the eleventh century, that popes began to grant to abbots and priors the privilege of wearing the miter. At a somewhat later period a regulation was made that the mitered abbots, who were exempt from Episcopal jurisdiction, should be restrained to the orfrais miter, and that the non-exempt abbots and priors should use the simple miters. It does not, however, seem certain that this decree was always strictly observed.

The initial letter that is seen on this page is taken from the Burney Manuscript (Number 175) from the fifteenth century. Now in the British Museum, the Burney Manuscript also contains a copy of *The Noctes Atticae of Aulus Gellius*, written between the years 1479 and 1494. ✤

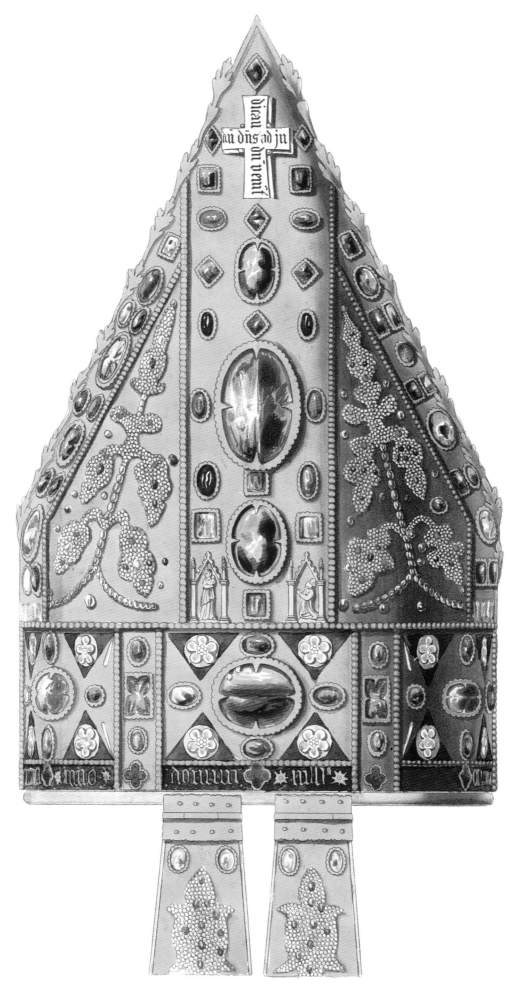

IXTUS IV holds a place among those popes who were most celebrated for their patronage of literature and the arts, though his pontificate was a brief one. He was raised to the papal chair in 1471 and died in 1484. He interfered little in the affairs of Europe, although at the beginning of his reign he was occupied by the issue of wars with the Turks.

Though obstinate in his opinions or measures, he was remarkably easy in dispensing his favors, and gave promotions and places to petitioners without discrimination. He spent great sums of money erecting splendid buildings, and is said to have been the first pope who ordered his image to he placed on coins. He will always be remembered among scholars as being the chief founder of the Library of the Vatican, although this library is said to have been first erected by Pope Nicholas V, who occupied the papacy from 1447 to 1455.

During the short pontificate of Calistus III (1455-1458) the books collected by his predecessor were dispersed, but the library was reestablished by Sixtus IV, who appointed Platina to be librarian. It was again destroyed in the sixteenth century because of the sacking of Rome by

the army of Charles V. It was finally restored by Sixtus V, who occupied the papal chair from 1585 to 1590, and who enriched it with great numbers of books and manuscripts.

The portrait opposite is taken from a painting by the celebrated Renaissance master painter Piero della Francesca (1420-1492) that is preserved in the Vatican Museum. The pope is dressed in a cape of scarlet cloth bordered with ermine. The rochet, or tunic, is of linen, and the *soutane*, or cassock, of white wool. His shoes are red, with crosses of gold. The chair is of classic form, with a cushion of crimson velvet, with a fringe of red wool mixed with threads of gold.

Piero della Francesca was a native of Tuscany, and was employed by Pope Nicholas V to ornament the Vatican with frescoes. According to *The Biographie Universelle*, he became blind in about 1457. However, if he painted this portrait of Sixtus IV, this date — which is founded only on conjecture — must be altogether wrong.

The ecclesiastical ring seen at the left is preserved in the Museum of the Louvre in Paris. The monstrance that is seen on the opposite page adjacent to the portrait of the pope, is taken from an engraving by Israel van Meekin. A monstrance is a vessel used to hold the host in Roman Catholic ceremonies. ❋

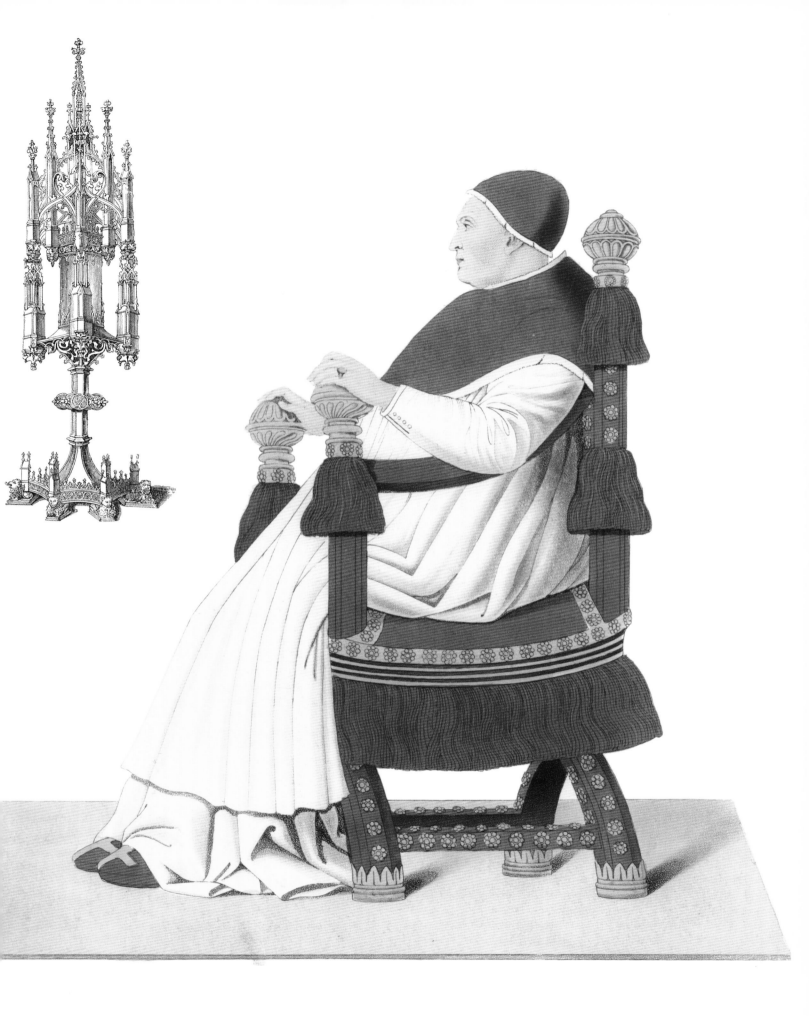

MANY ILLUMINATED MANUSCRIPTS contain drawings representing an author presenting a book to his or her patron. These furnish us with portraits of the authors — as well as of the kings and princes — in cases where otherwise we would have no reminder of them.

In the illustration from the Arundel Manuscript on the opposite page, the standing figure is an accurate and carefully executed portrait of Henry V, the conqueror of France and the hero of Agincourt, drawn when he was Prince of Wales. The other figure is, without doubt, an equally good portrait of the poet Thomas Hoccleve (1370-1450), who was also known as "Occleve," and whose poems are contained in the Arundel Manuscript. Found in the British Museum, Arundel Manuscript Number 38 is the identical volume which the poet is seen presenting to his patron.

Occleve is generally considered as having flourished about the year 1420, but this book must have been written some years before that time, as Henry became King of England in 1413.

Little is known of the personal history of this poet, and few of his works have been printed. In the picture he is represented in the dress of a gentleman, and we know that his profession was the law. He tells us in his own poems that he had learned poetry of his "master" Geoffrey Chaucer, writing:

My dare master, God his soul quite,
And fader, Chaucer fayne would have me taught,

But I was dull, and learned light or naught.
Alas! my worthy master honorable,
This londis verray tresor and riches,
Death by thy death hath harm irreparable
Unto us done; his vengeful duress
Despoiled hath this land of the sweetness
Of rhetoric, for unto Tullius
Was never man so like amongest us."

These few lines are sufficient to show that Occleve's style is not without merit. They have, indeed, much of the harmony which had been introduced by Chaucer into the English poetry. However, the subjects he chose were not as favorable for poetry, and he has too much of the flatness which characterizes the writings of John Lydgate (1370-1451).

Occleve's chief work was a metrical version of the celebrated treatise of Egidius, *De Regimine Principum*, a work on the education and government of princes, which he dedicated to Prince Henry. Many of his minor poems are to be found scattered through different manuscripts.

The poets of the sixteenth century and the early seventeenth were quite enamored with Occleve and Lydgate. In fact, the pastoral poet Thomas Browne, borrowed a story from Occleve for one of his elegies, and he speaks highly of the earlier poet.

The initial letter is taken from the same manuscript which furnished the subject for the plate. ❧

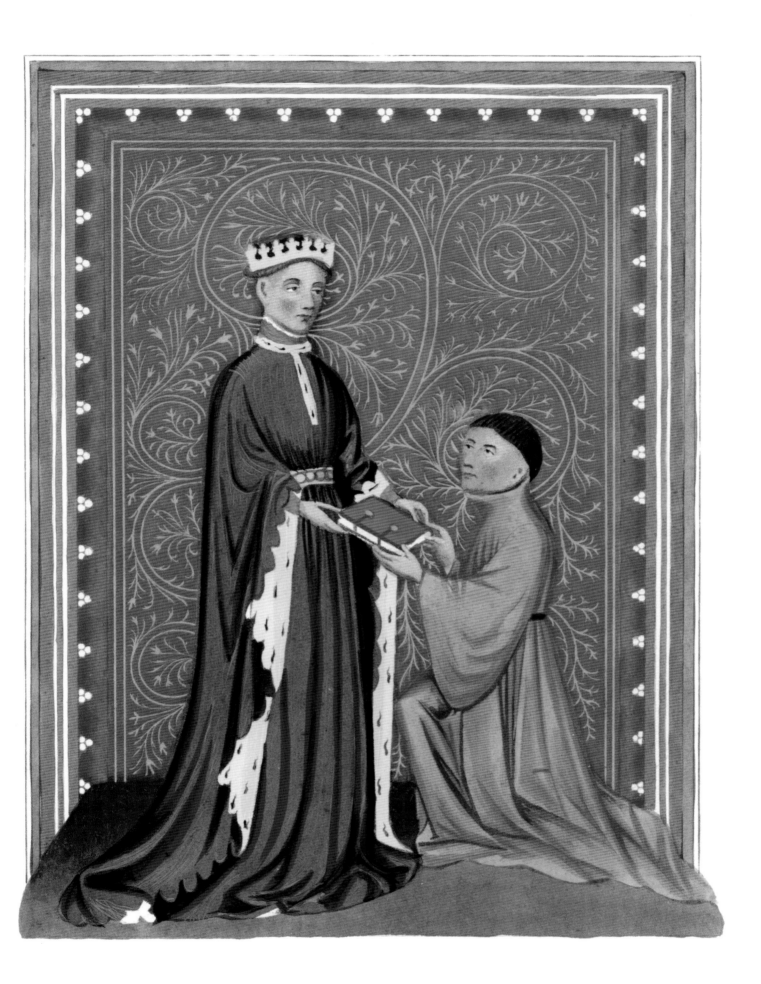

Pyrrhus Receiving the Honor of Knighthood

ACHILLE JUBINAL, in his splendid book on the subject of early tapestries, identified the plate on the opposite page as being the design of a fifteenth century tapestry. It consists of three compartments, all taken from the then popular subject of the Trojan Wars. The first compartment in this tapestry represents the city of Troy, with the arrival of Panthesilea, Queen of the Amazons, to succor the Trojans. The second represents a battle in which Aeneas, Polydamas, Diomedes, and Panthesilea are engaged in combat. In the third, which forms the subject of this illustration, we see Pyrrhus, the son of Achilles, under a rich tent receiving the honor of knighthood, with all the ceremonies practiced in the Middle Ages.

Here we see Ajax and Agamemnon dressed in the uniforms typical of the fifteenth century. Ajax is buckling the belt of the young hero, Pyrrhus, while an esquire is fastening his spur to his boot.

It is possible that the ornamental work in this tapestry may owe something of its detail to the imagination of the original artist; yet a comparison with other monuments of the time is sufficient to convince us that the

costume and armor may be considered as very fair specimens of what was worn by sovereigns and princes during the fifteenth century.

The history of this tapestry is remarkable. It is believed by Jubinal to have once belonged to the famous French military hero, Pierre Terrail Seigneur de Bayard (1473-1524). Indeed, it would remain in the castle in which he was born — an edifice seated on the summit of a hill which commands the banks of the river Isere — until the beginning of the eighteenth century.

When the castle was ravaged during the French Revolution, this tapestry was overlooked, and escaped destruction by a mere accident. In 1807, it was discovered in the chateau by a distinguished Lyonnaise artist, M. Richard, who bought it from the proprietor and thus saved it again from imminent destruction, this time through general neglect. From Richard it passed, in 1837, to Jubinal, who presented it to the Bibliotheque du Roi in Paris.

The adjacent illustration represents a 7.5-inch iron door knocker that dates from the fifteenth century, and which was known to be in the possession of M. Dugue of Paris in the 1840s. ✼

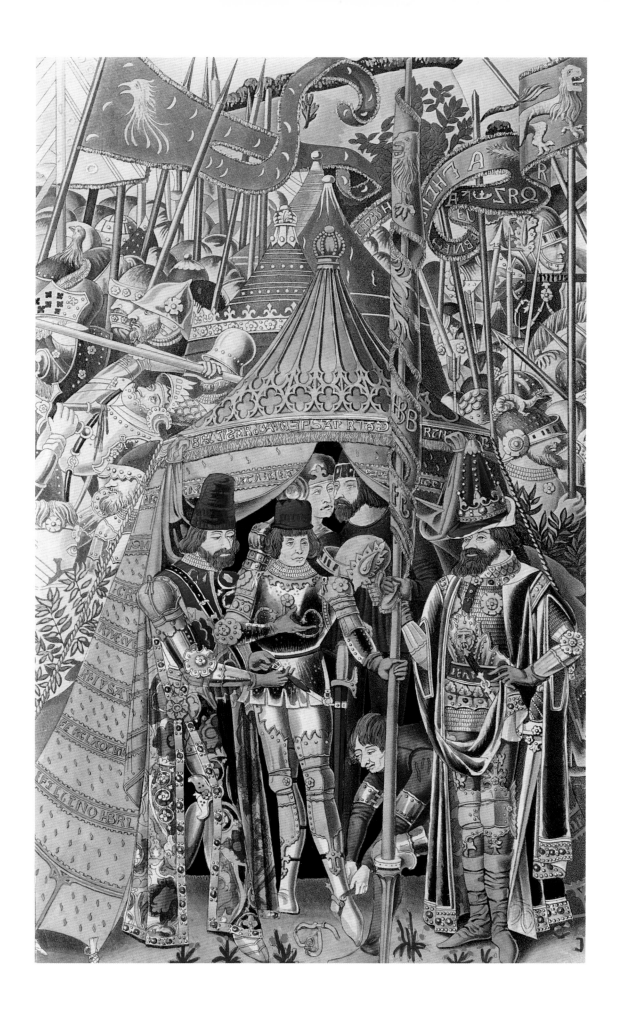

THE ILLUSTRATION on the opposite page is taken from a splendid fifteenth century illuminated volume which contains a large collection of the writings in prose and verse of the great poet, Christine de Pisan (1363-1430). The picture contains the portraits of two celebrated women, Christine de Pisan, and Isabella of Bavaria, the Queen of France, to whom Christine is represented as presenting the volume from which the illustration is taken. The first in this book — to which this picture forms the illustration — is specifically addressed to the queen.

The picture is valuable in another point of view in that it contains a remarkably interesting representation of the interior of a room in a royal palace of the beginning of the fifteenth century. The ceiling supported by elegant rafters of wood, the couch (of which we have few specimens at this early period), the carpet thrown over the floor, and several other articles, are worthy of notice.

Christine de Pisan was one of the most remarkable women of her time. She was the daughter of Thomas de Pisan, a famous scholar of Bologna, who, in 1368, when his daughter was five years of age, went to Paris at the invitation of Charles V, who made him his court astrologer. Thomas became rich by the munificence of his royal patron, and Christine, an eager scholar like her father, was educated with care, and became herself celebrated as one of the most learned ladies of the age in which she lived. She married a gentleman of Picardy named Etienne (Stephen) Castel, whom the king immediately appointed one of his notaries and secretaries.

The great prosperity of this accomplished family was short when Charles V died in 1380. The pension of Thomas de Pisan ended with the life of his patron, and, reduced to comparative poverty, he died brokenhearted. Etienne Castel died — possibly of the bubonic plague — a few years later and Christine was left a widow, with three children depending upon her for their support. However, she dedicated herself to literary compositions, and her talent obtained her patrons and protectors.

She eventually retired to the tranquility of a convent, but was thrown on troubled and dangerous times. Though a woman, she did not hesitate to employ her talent in the controversies which then tore her adopted country. On one side she took an active part with the celebrated Chancellor Gerson in writing against the *Roman de la Rose*; while on the other, by her political treatises, she attempted to arrest the storm which was breaking over France in the earlier part of the fifteenth century.

Her contemporaries compared her eloquence with that of Cicero and her wisdom with that of Cato. Prompted by necessity she wrote incessantly, both prose and poetry. She declares herself that in

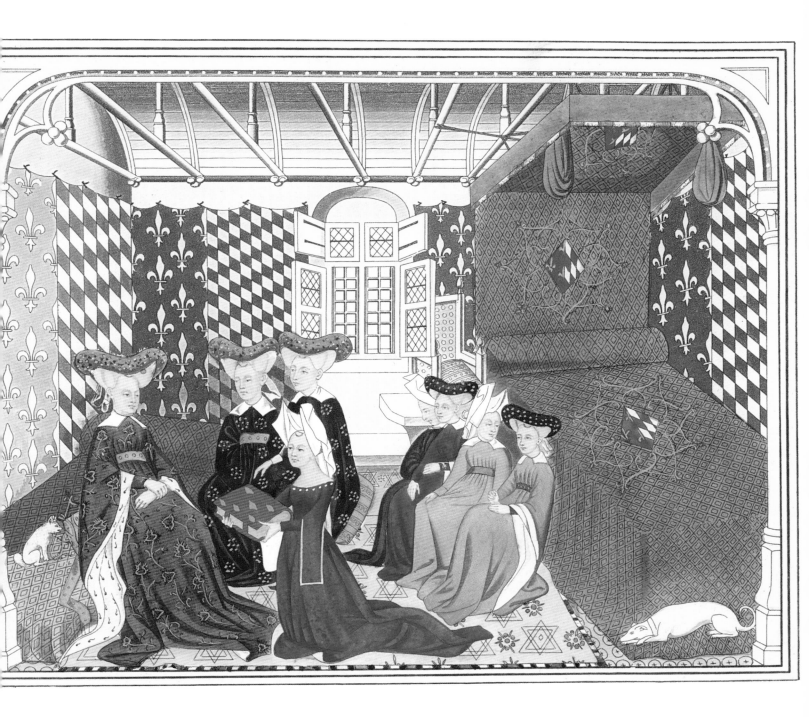

the short space of six years, between 1397 and 1403, she wrote fifteen important books, and many minor essays, which, compiled, make seventy larger books. Among her works in prose are *Le Livre des Faitz et bonnes Moeurs du Saige Roi Charles*, an elaborate biography of Charles V, written at the solicitation of Philip of Burgundy, who was rearing her eldest son as his own child. This book is full of moral lessons, but its merit is somewhat impaired by a useless display of erudition and a diffuse style. She wrote *Le Livre de Paix*, a treatise dealing with the education of princes, who, according to the author, should be trained in honesty. An important work was her *Trésor de la Cité des Dames*, about a city dedicated to great women or art and politics.

The initial letter on the opposite page is taken from the same volume by Christine de Pisan which furnished the illumination. ✳

John and Henry I, Kings of England

N ONE OF THE COTTONIAN MANU-SCRIPTS, a brief metrical chronicle of the kings of England attributed to John Lydgate is illustrated by a series of singular and bold drawings of the monarchs whose reigns it commemorates. Two of these figures are given on the accompanying plate, and represent King John (left), who reigned from 1199 to 1216 and King Henry I (right), who reigned from 1154 to 1189.

Why the two are pictured together is uncertain, as their tenures on the throne were not contiguous, being separated by the ten-year reign of Richard the Lion-Hearted. John was, however, a young man of 22 when Henry died.

As seen here, the costume of King John is rather remarkable, particularly the high clogs which he has on his feet.

The poem which these figures illustrate is curious, and appears to have been very popular, because of the numerous copies which are found in manuscripts dating from the fifteenth century. This particular edition was printed by Thomas Hearne, in the appendix to his publication of *Robert of Gloucester*.

An extract or two from the descriptions of the reigns of the two kings shown here will convey to the general reader an idea of its style and character.

Of King Henry, the writer tells us:

He made statute, with good rede,
That thevis though hanging should be dede.
Another he made anon right,
That money makers should lose his sight.

The characteristics of John's reign were the interdict and the civil war:

In John's time, as I understood,
was interdicted alle England.
He was full wrath and gryme,
For prestis would not singe before him.

In his time was a great dirthe,
Pens an half-penny loaf was worth.
Than he made a parliament,
And swear in angre verament
That he would make such a sauwte.
To fede all England with a spawde.
A monk anon thereof heard,
And for England was sore aferde ;
A poison than he ordained anone,
So was he poisoned, and died right sone.

John's greed led to a historic curb on a monarchy by its subjects. The general gloom of John's reign can be seen in his finally being forced by the nobility to sign the Magna Carta in 1215.

The initial letter is taken from a copy of Jenson's edition of *Pliny* (1476). ❈

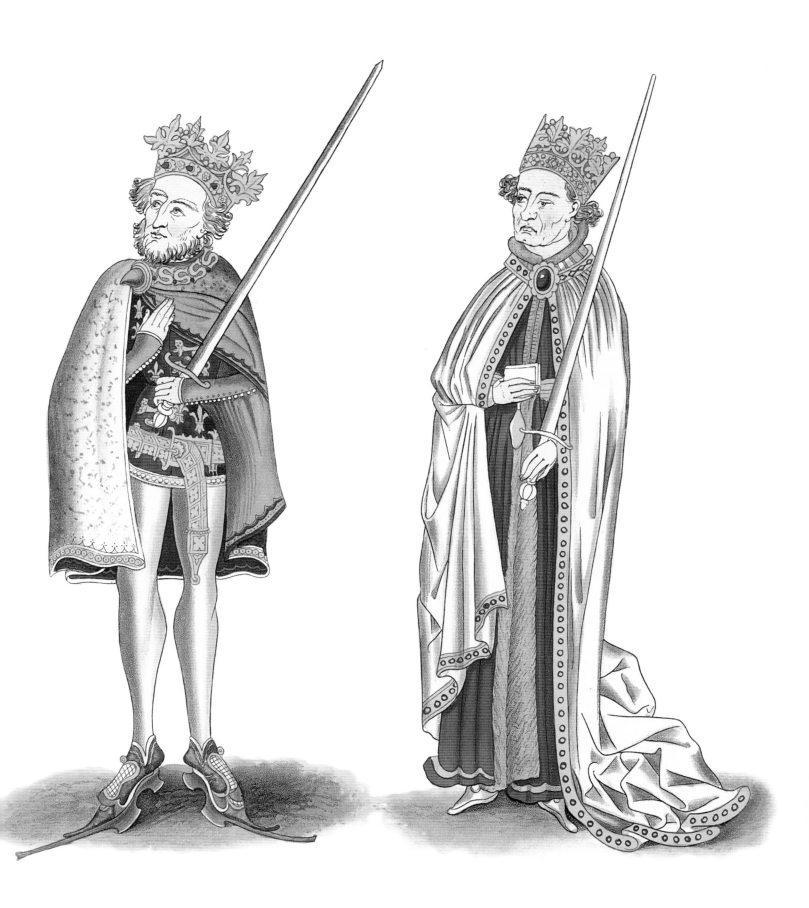

Margaret, Queen of Henry VI, and her Court

ONG AND FREQUENT visits to Coventry made King Henry VI and Queen Margaret great favorites with the people of that city, even in the midst of their misfortunes. The memory of their 1422-1461 reign is still preserved in Coventry in the traditions connected with a tapestry, a portion of which is represented in the opposite illustration. It is placed at the north end of the dining room of St. Mary's Hall, Coventry, above the dais, occupying a 30 x 10 feet space beneath the windows. A portion of the tapestry in the middle appears to have represented God, with other sacred objects.

On the right of the tapestry, as seen on the facing page, Queen Margaret and the ladies of her court are represented in prayer. As we see here, Queen Margaret is represented as a tall, stately woman, dressed in a rich, flowing robe, with a chain of gold round her neck. The lady kneeling behind the queen is identified by tradition as being the Duchess of Buckingham, but we cannot place much confidence in such authority. The patron saints of this group of ladies are represented above them in the tapestry. The king is represented on the left of the tapestry (see the following pages) along with men of his court.

St. Mary's Hall, which is one of the most remarkable buildings in Coventry, owes its foundation to the guilds of merchants, which here, as well as at Chester, are known for the mysteries and miracle plays they performed on their festival day. The hall itself was built in the earlier part of the reign of Henry VI, and his coat of arms is frequently represented among the numerous paintings and architectural ornaments with which it is profusely decorated.

The illustration below is taken from an illumination in a manuscript in the British Museum and represents a coach from the years of Henry VI's reign. The manuscript contains a French translation of Valerius Maximus dedicated to Charles V of France, although it was not written during his reign. The type of carriage represented here — very similar in form to a nineteenth century covered wagon — is frequently seen in manuscripts from the fourteenth through the sixteenth century. It appears to be covered with figured silk, supported upon brass rods. ❋

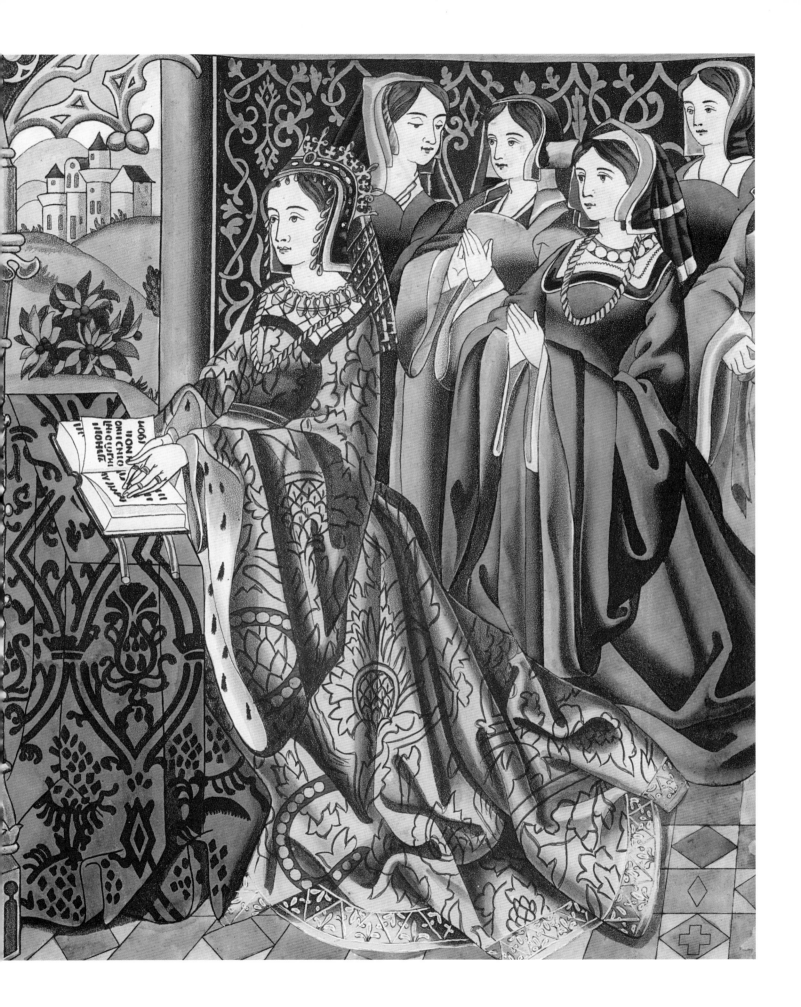

Henry VI, King of England, and his Court

O N THE OPPOSITE PAGE is a representation of the left compartment of the tapestry in Coventry that is described in the preceding article. Henry VI is seen at the right, while the nobleman with the flowing beard is said to be "the good Duke Humphrey," and the person in the hat behind the king is his uncle and rival, Cardinal Beaufort. The tapestry must therefore have been made before 1447, the date of Duke Humphrey's death.

This group has a peculiar interest for readers of Shakespeare, since it shows several of the persons who figure prominently in *King Henry VI*. Humphrey presents much of that character which is so vividly painted by the bard. Henry is the man loved by the people, and respected by the good among the nobles:

"The common people favor him, Calling him, Humphrey, the good duke of Gloster; Clapping their hands, and crying with loud voice, *'Jesu maintain your royal excellence, God preserve the good duke Humphrey!'*"

We can hardly contemplate the rival nobles of Henry's court thus assembled together before our eyes. The parties of Beaufort and Gloucester occupy their places in the same court a few months before the death of their two leaders.

Yorkists and Lancastrians met amicably under the same roof, just a few years before the outbreak of the bloody civil wars which devastated England — without calling to mind the jealousies which were already rankling in their bosoms, and the intrigues in which they were already engaged. In the picture, the face of the cardinal is characteristic of the ambitious and cunning prelate, as well portrayed by the pen of the poet.

The words of the Earl of Salisbury present themselves forcibly to our mind:

I never saw but Humphrey duke of Gloster
Did bear him like a noble gentleman.
Oft have I seen the haughty cardinal —
More like a soldier, than a man o' th' church,
As stout, and proud, as he were lord of all —
Swear like a ruffian and demean himself
Unlike the ruler of a common-weal.
— Warwick, my son, the comfort of my age!
Thy deeds, thy plainness, and thy housekeeping,
Hath won the greatest favor of the commons,
Excepting none but good duke Humphrey.
—And, brother York, thy acts in Ireland,
In bringing them to civil discipline;
Thy late exploits, done in the heart of France,
When thou wert regent for our sovereign,
Have made thee feared and honored, of the people:
Join we together, for the public good;
In what we can to bridle and suppress
The pride of Suffolk, and the cardinal,
With Somerset's and Buckingham's ambition;
And, as we may, cherish duke Humphrey's deeds,
While they do tend the profit of the land. ✻

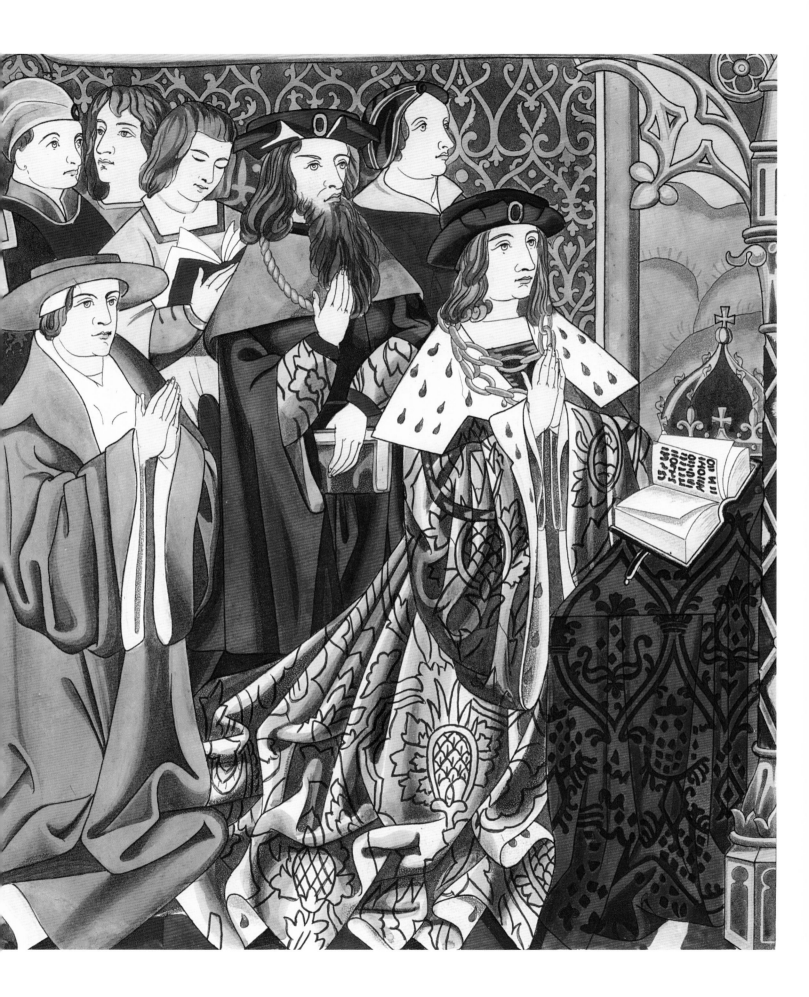

DURING THE FIFTEENTH CENTURY, few gifts were more acceptable or more frequently offered among princes and nobles (for only they were capable of giving such expensive articles), than a richly illuminated book. *The Shrewsbury Book* (Royal Manuscript 15E.VI) was made by order of John Talbot, Earl of Shrewsbury, the "warlike and martial Talbot" of Shakespeare It was presented by him to Margaret of Anjou, after her marriage to King Henry VI of England.

At the beginning of the volume is a superb miniature, reproduced opposite, which represents Talbot, dressed in the robes of the Order of the Garter, presenting the book to Queen Margaret, who is seen seated beside the king, her husband. It is accompanied by a dedication in French verse, in which Talbot, among other things, says that the volume was made for her instruction and entertainment, and that it was written in French, so that "after she had learned English, she might not forget her native tongue."

The contents of this volume consist chiefly of the poetry and prose romances of "Chivalrie" which were then so popular. Among the works were *Tree of Battles*, by Honore Bonnet; *the Book of Politie*, written by Frere (Brother) Gille de Romme; an unedited *Chronicle of Normandy*; *the Breviary of Nobles* (in verse);

and the *Livre des faits d'armes et de Chivalrie*, by Christine de Pisan.

The illustration below is also taken from one of the numerous miniatures in *The Shrewsbury Book*, specifically from the beginning of the *Livre des faits d'armes*. It represents King Henry VI, attended in court by his nobles, delivering to the gallant Talbot the sword which he knew so well how to use. We may imagine this picture to be an illustration of the scene in Shakespeare's *Henry VI* where Talbot delivers his sword to the king:

> I have awhile given truce unto my wars,
> To do my duty to my sovereign:
> In sign whereof this arm — that hath reclaimed
> To your obedience 50 fortresses,
> Twelve cities, and seven walled towns of strength,
> Besides 500 prisoners of esteem,
> Lets fall his sword before your highness' feet. ✤

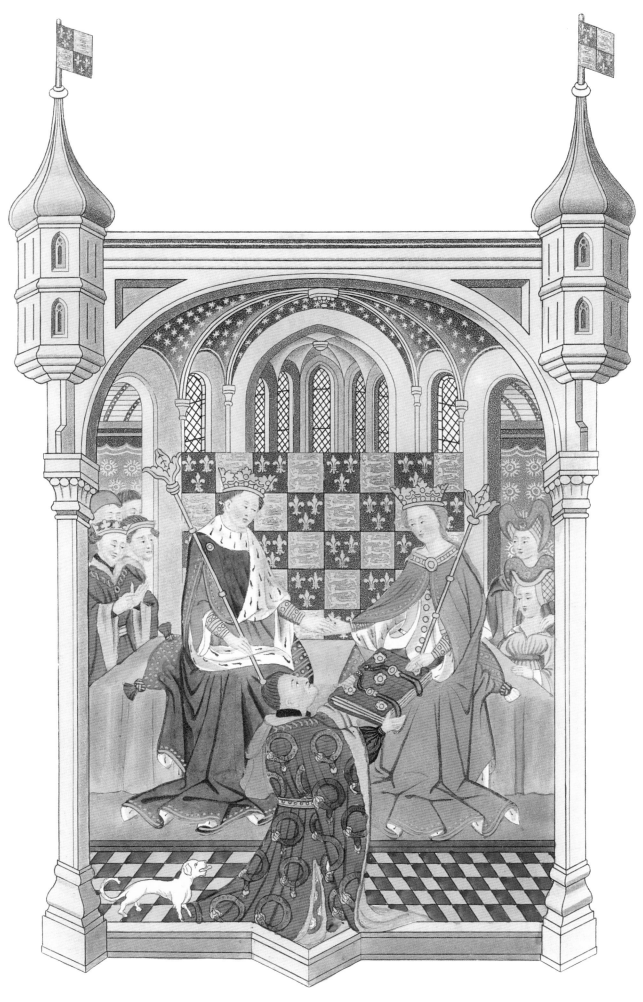

As discussed in the preceding article, John Talbot, Earl of Shrewsbury (1413-1460) was a renowned patron of the literary arts, and few books commissioned by him are of such lasting importance as *The Shrewsbury Book* (Royal Manuscript 15E.VI). As noted previously, the Earl of Shrewsbury presented the book to Margaret of Anjou, after her marriage to King Henry VI of England, and because French was her first language, he had it written in French. However, the illustrations were subtly English and the book also included references to the House of Shrewsbury.

The illustration on the far right of the opposite page represents a herald bearing a banner, which depicts the surcoat of the arms of John Talbot and of his alliances. Marshalled in a very unusual manner, they are his own, impaling those of his first wife, both of which are surmounted by an escutcheon containing the arms of the grandmother of his second wife. The rampant lion represents Talbot. The three lions seen *passant gardant* are the arms of King Henry VI, the husband of Margaret. The fringe colors — specifically white, red and green — are the colors of Queen Margaret herself.

The banner at the left of the facing page, bearing the arms of England — represented by Henry VI — and France — represented by Margaret, is also taken from *The Shrewsbury Book*. This banner is important because of the variation on the well known motto, which is here written *Dieu est mon droit* (God is my right), instead of *Dieu et mon droit* (God and my right).

Both Queen Margaret and Talbot figured in the closing acts of the Hundred Years War between England and France. In the 1420s, Talbot participated in the English conquest of northern France as the English possessions were expanded in a series of campaigns culminating in Bedford's victory at Verneuil in 1424. By 1429, English and Burgundian government extended over nearly the whole of northern France above the Loire, but in June, the French triumphed at Patay, capturing Talbot himself.

It was in 1444 that a truce in the war between England and France was achieved by the arrangement of a marriage — which occurred in 1445 — of Henry VI and Margaret, who was the niece by marriage of France's King Charles VII.

In 1449, however, an attack by English mercenaries based in Normandy against a town in Brittany gave Charles VII a welcome excuse to start the war again. Having defeated the English in Normandy, Charles VII turned his attention to Gascony. Bordeaux fell in 1451, and efforts to recapture it led to Talbot's last expedition, which ended in his death at the Battle of Castillion. In 1452, centuries of rule by the kings of England in France — through the Duchy of Normandy, the Duchy of Aquitaine, and a claim to the French Crown — were at an end. ✳

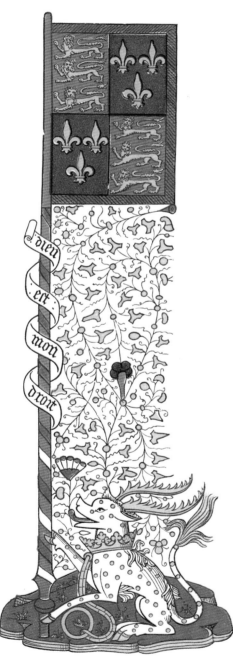

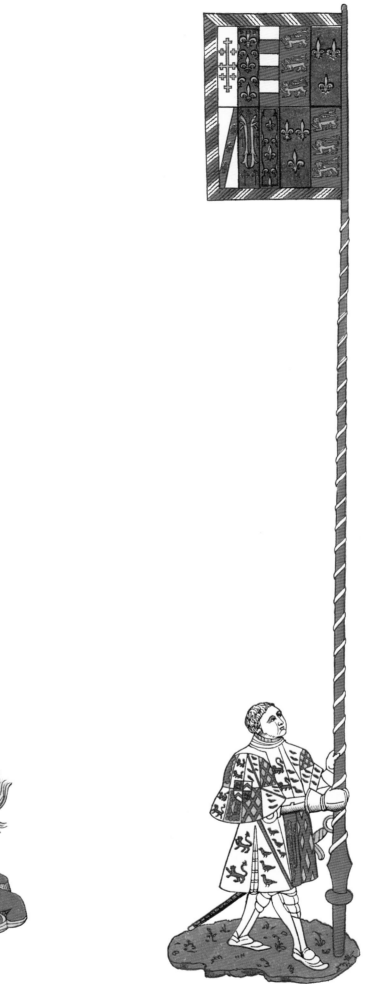

The Effigy of Sir Richard Vernon

EFFIGIES ARE AMONG the most interesting of the features of decoration with which medieval sepulchral memorials were enriched. They provide — during a period comprising upward of four centuries — illustrations of every description of costume, contributing to our understanding of the circumstances of history.

From the times of the earliest introduction of effigies until the fifteenth century — comprising the period of the greatest interest in and perfection of works of this nature — many hundreds of sepulchral figures were produced throughout Western Europe. Of the numerous effigies preserved in England, few possess a more attractive character than that represented opposite. Sculpted in pure alabaster, it is located at the church of Tong in Shropshire.

Sir Richard Vernon took possession of the castle of Tong in 1410 through the alliance of his ancestor with the heiress of Sir Pule de Penbrugge. Sir Richard was a distinguished knight in the wars of Henry V, and he held the post of treasurer of Calais, a position of no small importance. He was chosen Speaker of the Parliament at Leicester, and appears to have died in 1452. He espoused, it seems, his cousin Benedicta, daughter of William Ludlowe, and her effigy reposes by his side.

The costume of this knightly figure marks the period when plate armor was used almost exclusively, with mail being only occasionally introduced as gussets for the protection of the joints. An orle encircles the helmet, enriched with chased work and pearls, which rendered it ill suited for the purpose for which it was originally intended. The helm here appears under the head of the figure, decorated with crest and mantlings. It was indispensable for the protection of the face when the helmet was worn, as in tournaments, without a visor. A plate gorgiere protects the neck, which, for greater freedom of movement, is attached on either side to the helmet by strong rivets. These serve as hinges, and the lower part of the face has an additional defense described as a barbiere, or barbet piece.

The espaulieres are dissimilar, the lower plate on the right side being cut out under the armpit, to allow the free use of the lance. The cuirass, which is strengthened by a demi-placate, has appended to it a skirt of taces, around which is girt the splendid cingulum of goldsmith's work. On the fastening is a figure of St. George.

The sword is attached by a transverse belt, and its scabbard bears the sacred monogram IHS, according to the spirit of the times, when religious feeling was inseparable from the spirit of chivalry. Every plate of this fine armor was edged with a band of gold, and enriched partly with borders of impressed or engraved ornament. The sculpture is chiselled with such care that it may be studied with almost as much advantage as the actual armor. ❊

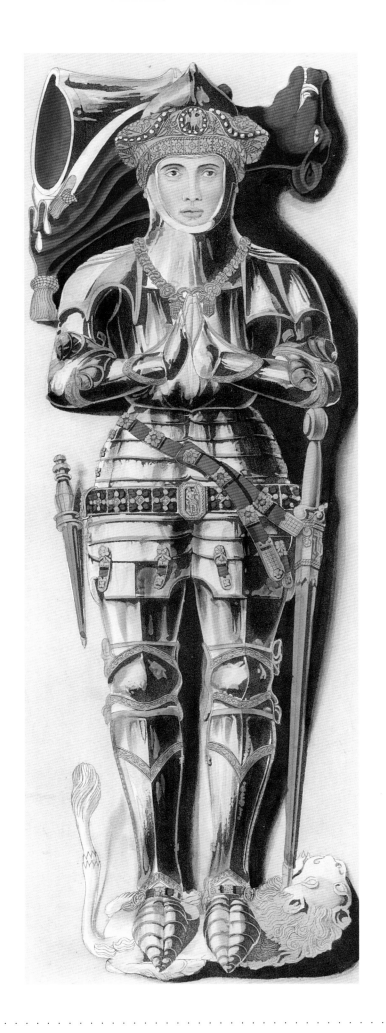

N SOME NATIONS during the Middle Ages, the amusements of peace partook at least of the forms of war. The nations of antiquity often adapted warlike activities as parts of their games and ceremonies, but in the age of chivalry, these games took a more refined and more splendid form as tournaments and jousts. These terms for such games appear from their names to have been first introduced in France.

Military combats of this kind are said to have been practiced in France at the end of the ninth century, under Louis de Germanie and his brother Charles, although they could hardly bear the name of tournaments until many years later. The laws which regulated these combats were compiled a few years before the middle of the eleventh century.

In spite of all the efforts of kings and churchmen to put a stop to them, tournaments continued to be popular until a very late period. As early as the twelfth century, the kings made vigorous efforts to suppress them, for they were usually accompanied by numerous and serious disorders. They were also frequently the catalyst for family feuds, which were not appeased until much blood had been shed. Tournaments also served, at times, the purpose of seditious meetings at which the turbulent barons assembled to conspire against the king.

The celebration of a tournament was important in the context of chivalry and knighthood. A tournament was preceded and accompanied by many acts and ceremonies, which were exactly defined and determined by a regular code of laws. It was announced long before the time appointed for its celebration, in a ceremonious manner, in all the civilized states in the west of Europe, in order that all knights who stood high in chivalric fame might have the opportunity of attending.

Among the numerous treatises on the laws and customs of tournaments, no one is more interesting than the *Traite des Tournois* of King Rene. This prince was born in 1408, and became Duke of Anjou in 1434. Jeanne II, Queen of Naples, declared him her heir in 1435, but he was driven from his new kingdom by Alfonso I, King of Aragon, who had previously been adopted by the same queen. After several fruitless attempts to recover this inheritance, Rene renounced his claims to the crown of Naples in 1473, and retired to his own hereditary dominions, where he was beloved by his subjects. He died at Aix en Provence in 1480.

Rene was distinguished among his subjects by the title "The Good." He was a great patron of chivalry, as well as of literature and the fine arts, in all of which he himself excelled. His court was fre-

quently gratified with splendid tournaments, and he is supposed to have composed his famous *Traite* about the year 1450.

Several manuscripts of this work are preserved, and the one from which the illustration on the following page is taken — and which is now in the Bibliotheque du Roi in Paris — was Rene's own personal copy. It is further said that the illuminations were drawn by his own hand. The drawings are interesting not only as vivid pictures of the manners of the time, but they are also valuable as specimens of medieval heraldic costume.

In King Rene's book the forms and ceremonies of the tournament are not only declared in writing, but they are represented to the eye by a series of spirited illustrations of a tournament between the Duke of Bourbon and the Duke of Brittany.

We know from *Traite des Tournois* that the king of arms of the dukes involved would preside over arrangements and that the poursuivants, or attendants, would proclaim the tournament and distribute

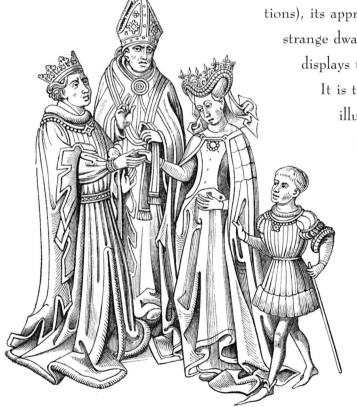

shields to those knights and esquires who intended to take a part in the tournament, as well as the shields of arms of the *juges-diseurs*, or umpires of the field.

The illustration on this page represents a royal marriage. While the theme of the illustration may be dissimilar to the theme of the tournament, the underlying notion of family association and loyalty — not to mention of chivalry — are essential to both.

Royal marriages were alliances between houses and families, just as tournaments represented rivalries between houses and families. The doctrine of chivalry affected and governed both.

With its stern-faced king and bishop (with the crown and miter of their respective stations), its apprehensive young bride and strange dwarf, this drawing accurately displays the costume of the period. It is taken from a splendidly illuminated French manuscript discussing the life and times of St. Catherine, that was executed in the fifteenth century. This work originally belonged to the library of the dukes of Burgundy, but later found its way into the Bibliotheque du Roi in Paris. ✸

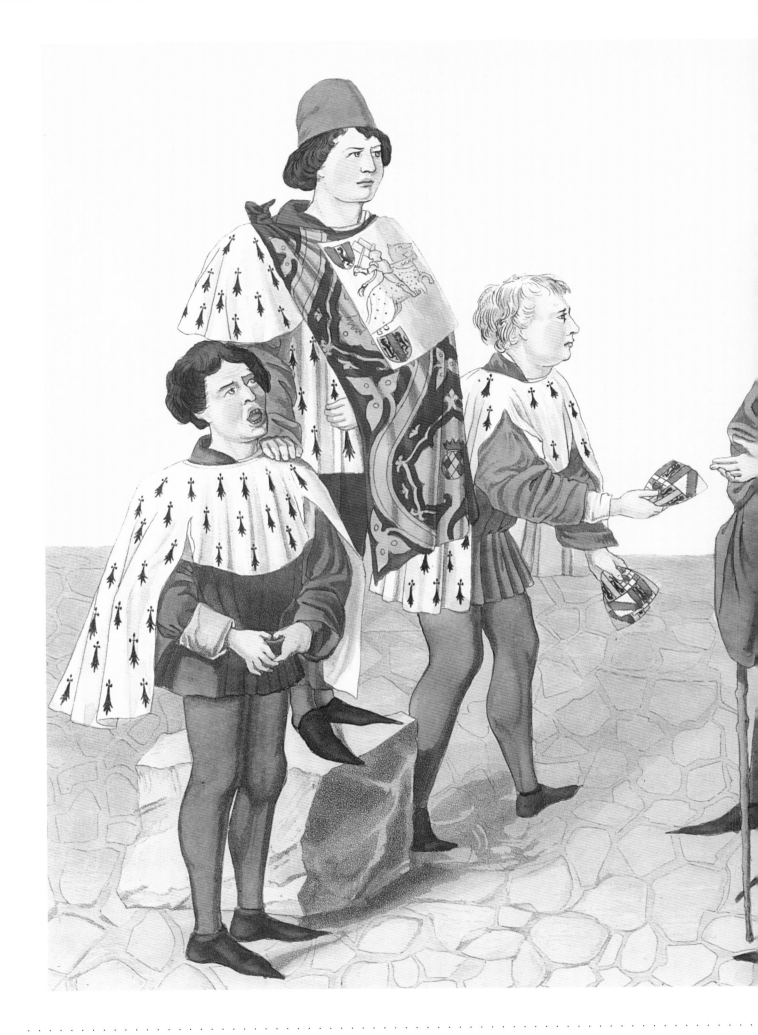

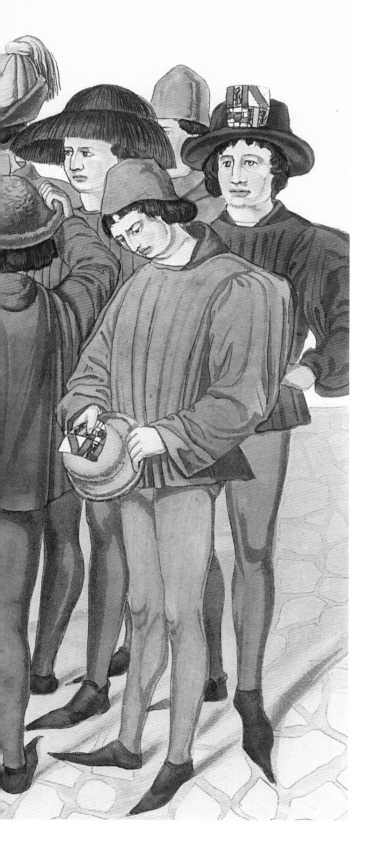

The Proclamation of a Tournament

AS NOTED on the previous pages, the illustration at the left is from a treatise on the laws and customs of tournaments published in about 1450 and entitled *Traite des Tournois*. It was written by Rene the Good (1408-1480), who was the duke of Anjou and, briefly, the king of Naples. As noted in the previous article, the luckless Rene was promptly evicted from Naples by his adoptive half-brother, King Alfonso I of Aragon.

This illustration, possibly by Rene himself, records preparations for a tournament between the duke of Bourbon and the duke of Brittany and is the fifth in order of a series of drawings. The person standing on a block between the two poursuivants is the king of arms of the duke of Brittany. On this occasion he has added to his ordinary costume two yards of gold cloth or velvet, in the manner of a small mantle, with a parchment attached, on which are figured the two combatants ready for the fight.

His two poursuivants, covered with the ermine of Brittany, are employed in proclaiming the tournament, and in distributing to those knights and esquires who intend to take a part in the tournament the shields of arms of the four *juges-diseurs*, or umpires of the field. ✤

The Lady of the Tournament Delivering the Prize

D URING THE TOURNAMENT, the scaffolds surrounding the field were crowded with ladies, who encouraged the combatants by their smiles. They not infrequently gave to some favored knight a glove or a handkerchief, which he was to defend against the field.

To a lady also was reserved the office of delivering the prize to the victor in the tournament each day. The opposite illustration representing this ceremony forms the last of the series of drawings by Rene the Good from his *Traite des Tournois*, discussed in the preceding four pages. In this work, we have special directions relating to awarding the prize at the conclusion of the day's amusement. When the *juges-diseurs*, or umpires, had given their judgment, the king of arms announced it to the knight who had been decided the victor in the day's contest, and, attended by the heralds and poursuivants, conducted him to the Lady of the Tournament. The lady was attended by two damsels of her own choice, and she carried the prize carefully covered. When the victor in the tournament was brought into her presence, she uncovered it and delivered it to him, and he received it graciously and kissed her. He was allowed "to kiss her two damsels like-wise, if it were his pleasure" (*et semblablement les deux damoiselles s'est son plaisir*). Then the king of arms, heralds, and poursuivants cried aloud in the hall that the prize of the day had been adjudged and delivered. After this, the knight led the lady to the dance as his partner; and the judges, knights of honor, king of arms, and poursuivants conducted the two damsels with all ceremony back to their places. The rest of the day was spent in joyous festivities.

The small illustration seen here is of Marie, Duchess of Burgundy and daughter of Charles the Bold, who was married in 1477 to Maximilian of Austria when she was just 20. The life of this innocent princess was a constant series of sorrows and misfortunes. In her youth she was persecuted by strangers, and rudely treated by her own subjects, who took advantage of her. A short life filled with troubles was ended by a violent death. In 1482, while she was riding, her horse made an effort to leap over a fallen log. In so doing, the girths broke, the saddle turned and the duchess was thrown with considerable force against the log. She was carried home severely wounded, but no fears were entertained for her life. It is said, however, that from feelings of modesty she would not allow the physicians to take proper care of her wounds, which became worse, until, after languishing three weeks, she died. �֍

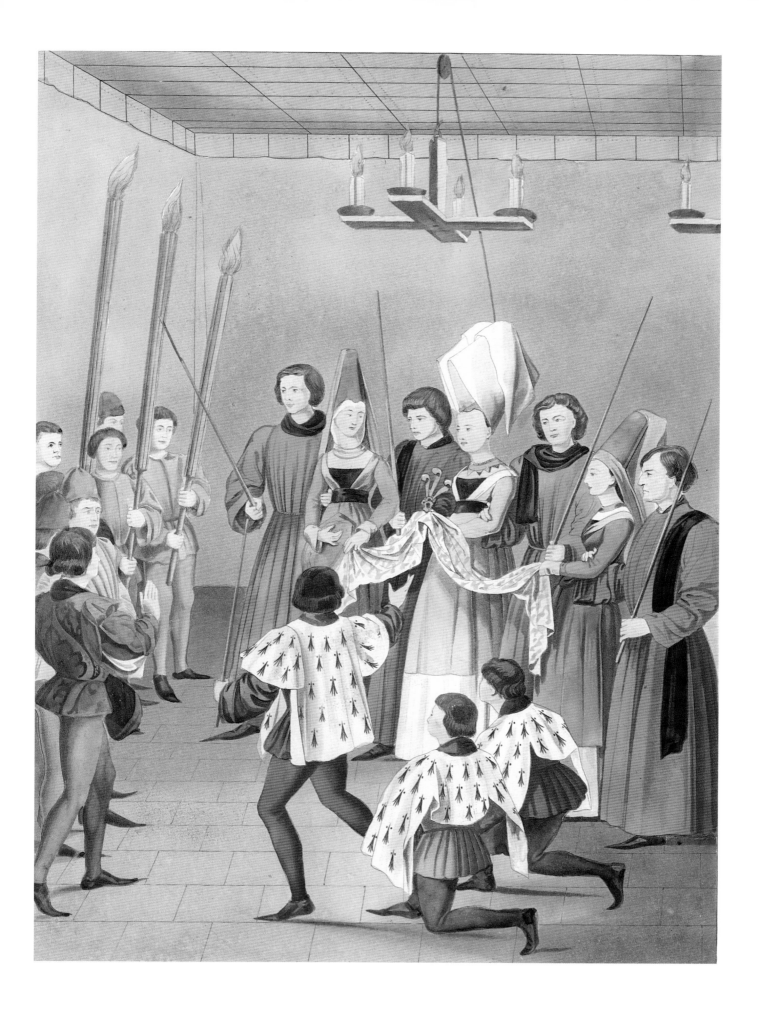

Philip the Good, Duke of Burgundy

CONTEMPORARY writers speak in glowing terms of the power and magnificence, the greatness and magnanimity of the "good" Philip of Burgundy. Born in 1396, he was the ally of England's Henry V in his French wars, and as the steady partisan of the English interests, until the bad policies of Henry VI drove him to join the opposite party.

His portrait, shown opposite, is taken from a manuscript in the Harleian Collection, containing the laws and minutes of the celebrated order of the *Toison d'Or*, or Golden Fleece, of which he was the founder and first sovereign. According to the legend, Philip established this order to honor the golden locks of one of his mistresses, but it seems more probable that it was intended to be emblematical of the staple of the commerce of his Dutch and Flemish subjects. The Harleian Manuscript is an important historical document, for it contains the minutes of all the "feasts and chapters" of the order from its first institution in 1429 at the Flemish city of Brugge (Bruges), to that held at Bois-le-duc (s'Hertogenbosch) in Brabant, in 1481.

The chapters appear to have been held always at towns within the "good" duke's dominions, and the day of meeting, fixed at first on St. Andrew's Day, was, in 1445, changed for the convenience of the knights to the second day of May. The names of many noble persons occur in these minutes. At the tenth chapter, held in 1440, Charles, Duke of Orleans and Valois, was elected a knight. At the fifteenth, in 1445, King Alfonso of Aragon was elected, and in 1461, his successor John of Aragon and Navarre was named.

In 1467, Philip of Burgundy died at Brugge, in Flanders, and his son Charles succeeded him as sovereign of the order. At the same chapter in which the new sovereign was nominated in May 1468, Edward IV, King of England, was also elected as a knight. Charles of Burgundy himself died in 1473, and was succeeded as chief of the order by Maximilian, Archduke of Austria.

Philip of Burgundy was a munificent patron of literature and the arts. For example, the celebrated collection of tales by the Queen of Navarre, that are known as the *Cent Nouvelles Nouvelles*, was written at his court.

It is difficult to fix the exact date at which the picture on the facing page was made. A note at the beginning of the Harleian Manuscript shows that it was written some years after the election of the King of Aragon at Gent in 1445. If we take as a middle date between this and the last chapter recorded in it (1481), the year 1460 for that of the portrait, we would, perhaps, not be far from wrong.

The initial letter on this page is from an edition of the *Biblia Moralis* of Peter Berchorius, printed in folio at Ulm, in 1474. ❊

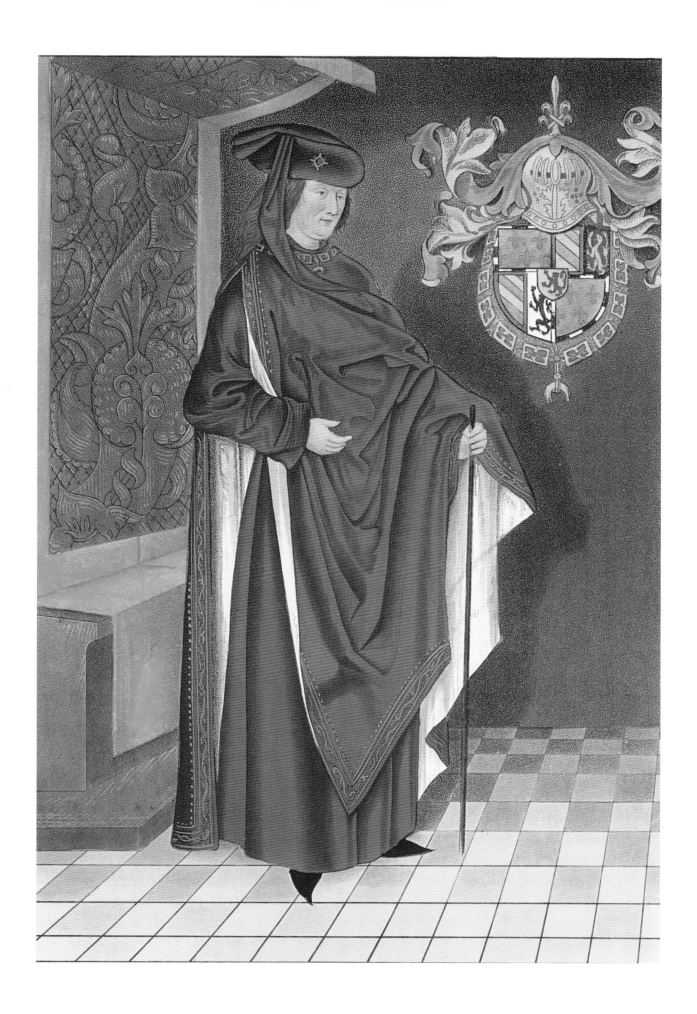

Knights of the Garter

F THE VARIOUS ORDERS of knighthood which originated in the chivalrous culture of the Middle Ages, few have continued to hold so high a rank as that of the Garter. It was founded originally by one of the most warlike of the English monarchs, and numbers among its members, the greatest names to have figured in several centuries of history.

The Order of the Garter was founded by King Edward III in the year 1344, on the occasion of solemn festivities held by that monarch at Windsor Castle. Among the first members of the order were the Black Prince and many of the heroes of the French wars. The patron of the order was St. George, who is also the patron of England.

A popular story explains the adoption of so singular an emblem as a blue garter to represent the order. At a ball given by Edward III, the fair Countess of Salisbury, to whom he was paying his addresses, had dropped her garter on the floor. The monarch took it up and offered it to her, observing in answer to the smiles of his courtiers and in the language then used, *Honi soit qui mal y*

pense. This expression which has since been adopted as the device of the order, although the tale appears to have no good support in history. Many things combine to render it at least extremely improbable. Various theories have been stated — and many incidents seized upon — to take the place of the one just mentioned, but with no very apparent success. It would be perhaps a vain labor to attempt to find reasons for what may have been little more than the caprice of the moment.

It has also been suggested that the garter may have been intended as an emblem of the tie or union of warlike qualities to be employed in the assertion of the founder's claim to the French crown. Thus the motto would be a retort of shame and defiance upon anyone who should think ill of the enterprise, or of those whom the king had chosen to be the instruments of its accomplishment. The fourteenth century taste for allegorical conceits, impresses, and devices may reasonably warrant such a conclusion.

The picture on the facing page illustrates the costume of a Knight of the Garter at about the time of Edward IV (1461-1483) or Richard III (1483-1485), and is taken

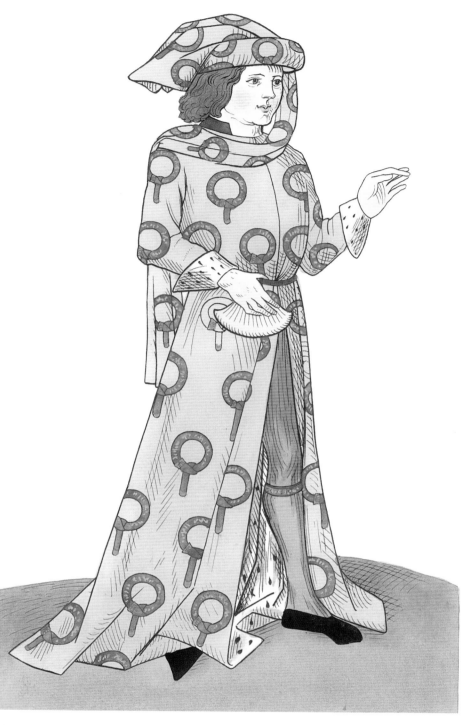

from a fifteenth century manuscript that was in the possession of Thomas Williment in the 1840s. This manuscript appears to have been written in England for a Pole or Russian, and on one of its leaves is the inscription *Vincislai et amicorum*. It contains a treatise on heraldry, and a copy of a set of the statutes of the Order of the Garter.

Since the first foundation of the order, various slight alterations have been made in the costume. Originally, it consisted of a mantle of woolen cloth (the staple manufactured item of England) on a blue ground, lined with scarlet cloth. The garters of blue cloth or silk were embroidered with gold, having on them the motto of the order in letters of gold. The buckles, bars, and pendants were of silver gilt. A surcoat, also of woolen cloth, narrower and shorter than the mantle, was fastened to the body, and the color was to be changed every year. The hood was made of the same materials as the surcoat.

The initial letter on the opposite page is taken from a fine early printed edition of *The Commentary on the Gospels* of Thomas Aquinas (1225-1274). It is hardly necessary to say that the figure within the letter represents one of the evangelists.

The engraving at the bottom of the facing page represents a leather case for a religious book that dates to the time of Edward IV in the fifteenth century. It was purchased in Venice in about 1830 by the noted collector, Robert Curzon, Jr. ❁

Tobit the Apocryphal

FINE MANUSCRIPT of the French translation, by Guiart de Moulins, of the *Historia Scholastica* of Peter Comester, has furnished the subject of the accompanying plate. It was intended to represent a scene in the history of Tobit the Elder, who was a popular subject for artists and story tellers — both Christian and Jewish — during the Middle Ages. *The Book of Tobit*, one of the books of the Apocryhpha, portrays the lives of Tobit and his son Tobias (Tobit the Younger) in allegories of love, prayer, fasting, and family life.

In the illustration opposite, Tobit is represented on his couch, blind and sick. He has just dispatched his son Tobias to the City of Rages. In the manuscript there is another compartment which represents young Tobias going out of his father's house to his guide, the angel Raphael, who is properly booted for the journey, but is distinguished from his companion by his wings. The lady, who is cooking, was no doubt intended to represent Tobit's wife Anna. The picture itself is a good representation of the interior of a room in the fifteenth century. The hanging behind the couch seems to serve the purpose of a window-curtain. The type of jack on which the cooking utensil is suspended is often seen in the illuminations of medieval manuscripts. The buffet, with its cups and pitchers, is similar to one seen in another illumination in the same volume, this representing the feast of Balthazar, when he beheld the portentous writing on the wall.

The manuscripts of the work to which this picture forms an illumination are very numerous, and generally embellished with pictures. This manuscript, which is preserved in the Royal Library in the British Museum, is a very large volume in folio, containing only a part of the book — a second volume being lost — and was written in the year 1470, during the reign of Edward IV of England. At the end, the volume is inscribed, in the hand which executed the whole of the volume, *"escript par moy, Du Ries."*

Peter Comestor was pseudonym of a French scribe whose real name was either Mangeur or Mangeard. He was a native of Troyes in Champagne, and was a long time chancellor of the University of Paris, famous for his learning and eloquence. He died in 1179 in the abbey of St. Victor, where he was buried. His epitaph in Latin verse — which was visible on his tomb before the destruction of religious monuments which occurred during the French Revolution — was an important specimen of the taste of the age in which it was composed. It read, in Latin: "Petrus eram quem petra tegit; dictusque Comestor Nunc comedor. Vivus docui, nec cesso docere Mortuus, ut dicat qui me videt incineratum, Quod sumus iste fuit, erimus quandoque quod iste."

Peter Comestor compiled a paraphrase of Bible history, which for a time became more popular, and

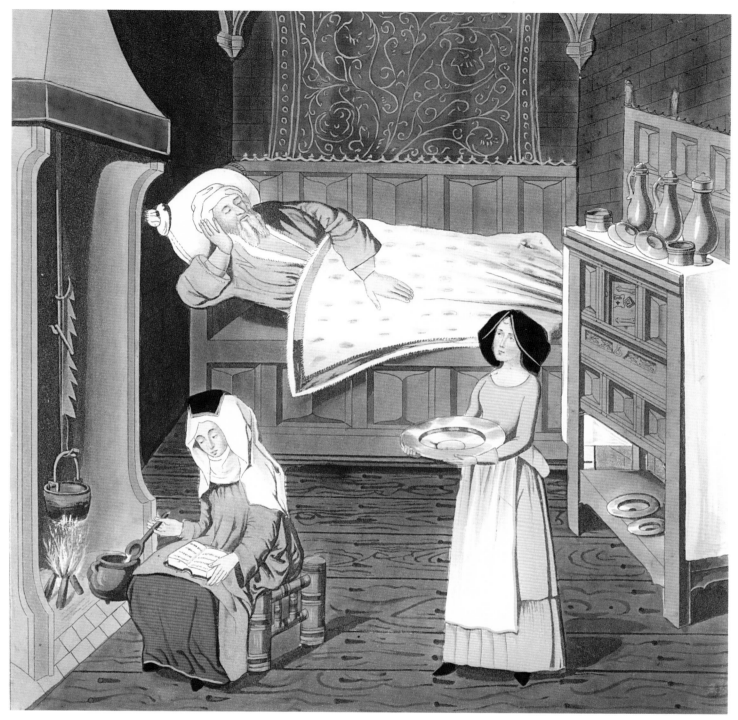

was more generally read, than the Bible itself. This work was translated into French more than a century after it was originally composed by Guiart des Moulins, who informs us in his preface that he was born in 1251, that he began the translation in 1291, the year in which he was made a canon of St. Peter's at Aire, and that he finished the book in 1294. In 1297, perhaps partly as a reward for his literary work, he was made dean of the same church. The popularity of Guiart des Moulins' work was very great, and manuscripts of it are found in many collections. It was revived in the fifteenth century by Jean de Rely, by order of Charles VIII, and printed in folio about 1496 by Antoine Verard in Paris. ❊

Old Age and Poverty

URING NEARLY three centuries, no single literary production (with the possible exception of the English poem about Piers Ploughman) enjoyed so great a popularity as the French poem entitled *Roman de la Rose* in French, and translated into English as *The Romance of the Rose*. This famous romance — discussed in great length in the following article — represents in an extravagant kind of allegory, the perils and hurt which the lover encounters in the pursuit of his object (a kind of Gothic *ars amandi*).

The Romance of the Rose was begun by a French poet named Guillaume de Lorris, who died in about the year 1260, and it was continued by Jean de Meun, a man of rank and fortune, as well as a poet of high reputation, who finished it in about 1305. Very little is known of the personal life or history of either of these writers.

While the work of de Lorris and de Meun frequently transgresses a strictly Victorian notion of delicacy, this was not considered its greatest fault in the age when it was most read. It is filled with bitter satire against the monks, and even contains some notions on politics which are more liberal than were then likely to be agreeable to everybody at the time. The consequence was, that the book was at times persecuted. One of the great pillars of the church said that he would no more condescend to pray for the soul of its author, than he would for that of Judas Iscariot who betrayed Christ. This poem is still interesting as a singularly curious monument of the literature of the Middle Ages.

It was translated into English partly by Geoffrey Chaucer, of whose version only a portion is preserved. Chaucer translated the political satire which was most objectionable in the thirteenth century and least objectionable in Victorian England. The indelicacies are lost, if they were ever translated.

It would be impossible to point out any miniature more beautiful than the illuminations which enrich the splendid 1480 edition of *The Romance of the Rose*, which is designated as Manuscript Number 4425 in the Harleian Library at the British Museum. The two illustrations on the facing page are considered as elegant illustrations of the Chaucer translation rather than of the French original.

The lover, falling asleep in the "merry month of May," dreams that he arises early and leaves the town for the country: "The sound of birds for to heare, That on the buskes singen cleare."

At length he arrives at a fair garden, enclosed by a strong wall, on the exterior of which are painted in compartments, the principal passions and troubles of life, including Hate, Covetousness, Sorrow and Envy. Among the rest, appeared Old Age in the form of an old woman, upon whom the lover comments:

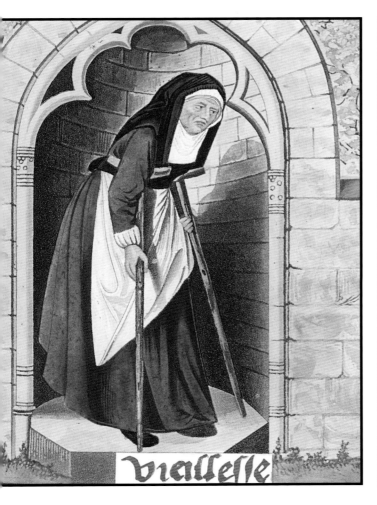

Viellesse

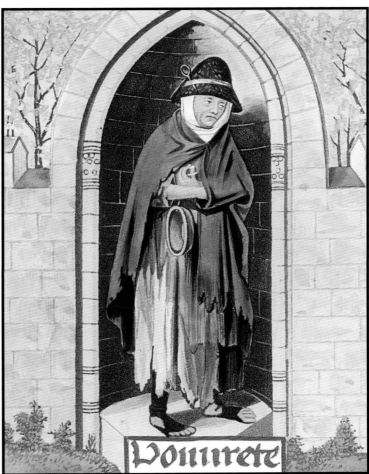

Pourrete

That shorter was a foot,
Than she was wont in her yonghede."
A foule for-welked thing was she,
That whilom round and soft had be;
Her heeres shoken fast withall,
As from her head they would fall;
Her face frounced and for-pined,
And both her honds lorne for-dwined.
So old she was that she ne went
A foot, but it were by potent [with a cane]

At the end of the passions and troubles, apart
from the rest, was a figure of poverty:
She ne had on but a straite old sacke,
And many a cloute on it there stacke;
This was her cote, and her mantel,

No more was there never a dele
To clothe her with; I undertake,
Great leaser had she to quake.
And she was put, that I of talke,
Ferre fro these other, up in an halke;
There lurked and there coured she,
For poore thyng, where so it be,
Is shamefast and despised aie.
Accursed may well be that die,
That poore man conceived is!

The initial letter D on the facing page — not
inappropriate in its design to the subject of gardens
and roses — is taken from a fifteenth century edition
of *The Offices of the Virgin*, which is among the
Douce Manuscripts at Oxford University . ❊

The Romance of the Rose

S DISCUSSED IN THE PRECEDING article, the richly allegorical French poem *Roman de la Rose* (translated into English as *The Romance of the Rose*) was one of the most popular and important works of European literature from the beginning of the fourteenth century until the beginning of the seventeenth.

Begun by the poet Guillaume de Lorris, who died in about the year 1260, *The Romance of the Rose* was initially published in 1305 by Jean de Meun, who also wrote much of the text. In the plot of the romance, the protagonist, known as "the Lover," is in a dream. After the scene described in the preceding article, the Lover finds the gate, which is opened to him by Idleness, the gate-keeper, and he enters a beautiful garden.

Here, Courtesy introduces the visitor to Pleasure, the proprietor of the garden, who was in the midst of his court. While the stranger is contemplating the beauty of the ladies in the court of Pleasure, he is pursued by Love, who is armed with five arrows. The fugitive then arrives at a fountain, beholds a beautiful rose tree, and is seized with the desire to pick a rose. At that moment, he becomes an easy conquest for his pursuer.

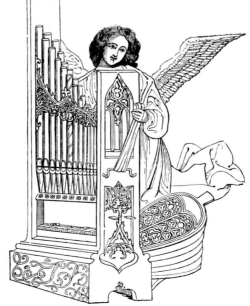

The rest of the poem relates the troubles and disappointments which the Lover experiences in his attempts to obtain the rose, on which he has set his desires. In the course of these attempts, one of his rudest opponents is Danger, and his most powerful opponent is Reason. A very large portion of the poem is taken up with the discourses of the latter.

As the story evolves, *Bel Acueil*, the ally and friend of the adventurous Lover, is seized and imprisoned in a tower by Jealousy. Both the Lover and his friend are befriended by Love and his mother Venus. Finally, the tower is stormed, and the Lover finally succeeds in his object.

Three of the figures represented on the opposite page — like those on the preceding page — are from the fifteenth century manuscript of *The Romance of the Rose*, which is designated as Manuscript Number 4425 in the Harleian Library. The figure in a riding dress (note the spurs) was taken from another manuscript from the same era.

These figures afford singularly curious examples of the court costume of the dandies of the latter half of the fifteenth century. The robe, with its "Sleeves blazing like unto a crane's wings," (as they are characterized by a contemporary satirist), reminds us of the form

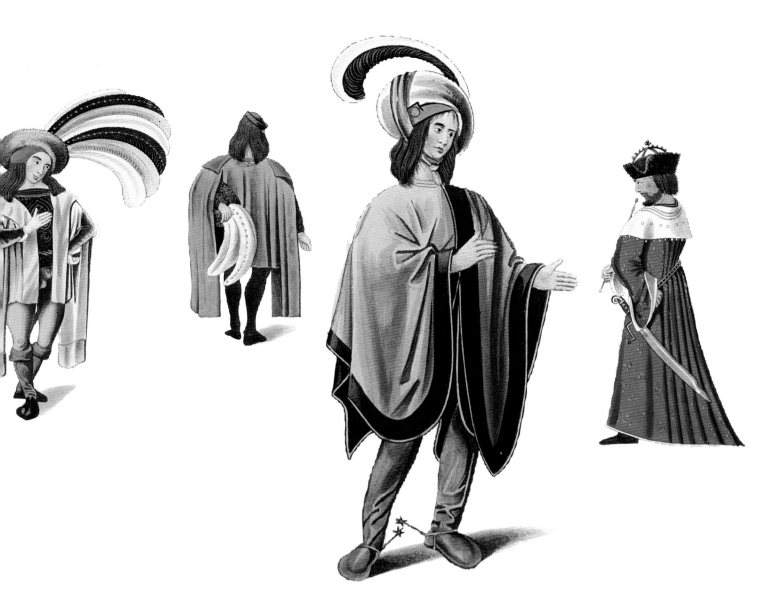

preserved in the gowns which were still worn in English universities in the nineteenth century. The different articles of a man's apparel as indicated in books of this time, are a shirt (often bordered with rich lace), " breech," a doublet, a long coat, a stomacher, stockings, socks, and shoes.

One of the most remarkable articles of dress of a gallant of this period was the large, plumed hat, which, as here represented, was generally slouched on one side, so as to expose to view part of an under cap of embroidered velvet or gold network.

The second figure on the plate carries his plumed hat in his hand, while he has a small cap perched on the top of his head. In some illuminations, the gallant, still having this little cap on his head, carries the plumed hat slung over his shoulders by means of a cord, in the same manner as the charity school boys of the nineteenth century, who were made to hang their hats around their necks with a string. This was done probably more for convenience than ornament. In the fifteenth century, the men's hair was worn very long, and it was the fashion to wear shoes which were very broad in front.

The woodcut on the facing page is a very fine representation of an organ and is taken from a painting of St. Cecilia by Lucas van Leyden. ❁

The Minstrels

N THE OPPOSITE PAGE is an illustration of a trio of minstrels taken from the 1480 edition of *The Romance of the Rose* at the Harleian Library at the British Museum, which provided the illustrations for the two preceding articles. This illumination represents the "karole," or dance, of "Sire Mirth." See page 186 for a full text of the lyrics to this song.

At the festivals of the fifteenth century, the minstrels sang, or repeated romances and tales, or other poetry. The jugglers performed different feats of skill, such as throwing pieces of wood into the air and catching them on their fingers. There were also dancing girls, many of whom were of the Middle and Far East heritage, who may have been brought to Europe by the Crusaders.

The minstrel, in the earlier ages of society, was a very important member of the community. With him was deposited the whole body of the national literature, the poetry which celebrated the ancient gods and heroes of the people, and which he sang to the harp for their entertainment. The poetry itself was not committed to writing, but merely handed by memory from one generation to another. With the refinement of civilization in the Middle Ages, the character of the minstrel underwent a gradual change, and the subjects which he sang of, as well as the instruments on which he played, became multiplied. In Anglo-Saxon manuscripts we have figures of many different kinds of musical instruments, some of them of a complicated description. Under the Anglo-Normans, his duties became still more varied. Every nobleman or great gentleman had his troupe of minstrels and "*jogelours*" (jugglers), but there were others who lived independently, and who wandered about attending tournaments, marriages, and other great ceremonies where they were always welcomed, with their share of the good cheer, and were dismissed with gifts of different kinds. There were still some minstrels who composed the poetry which they sang.

At the period when Chaucer wrote, the minstrels were still welcome to the halls of princes and barons, and were necessary to the celebration of all great festive ceremonies. They were always feasted with the best cheer, and rewarded with gifts of robes and other articles, and even with money. In the rolls and registers of the private expenditure of the princes and great families during that century, and even in the following, we find frequent entries of payments to the minstrels who attended their feasts.

In the illumination seen here, the minstrels are handsomely clad in brightly-colored garments, according to the manner of the time, and employ different kinds of instruments. The first has a harp, the second is performing on the flute, and the third is equipped with a pipe and tabor.

The initial letter is taken from a manuscript from the latter part of the fifteenth century. ✳

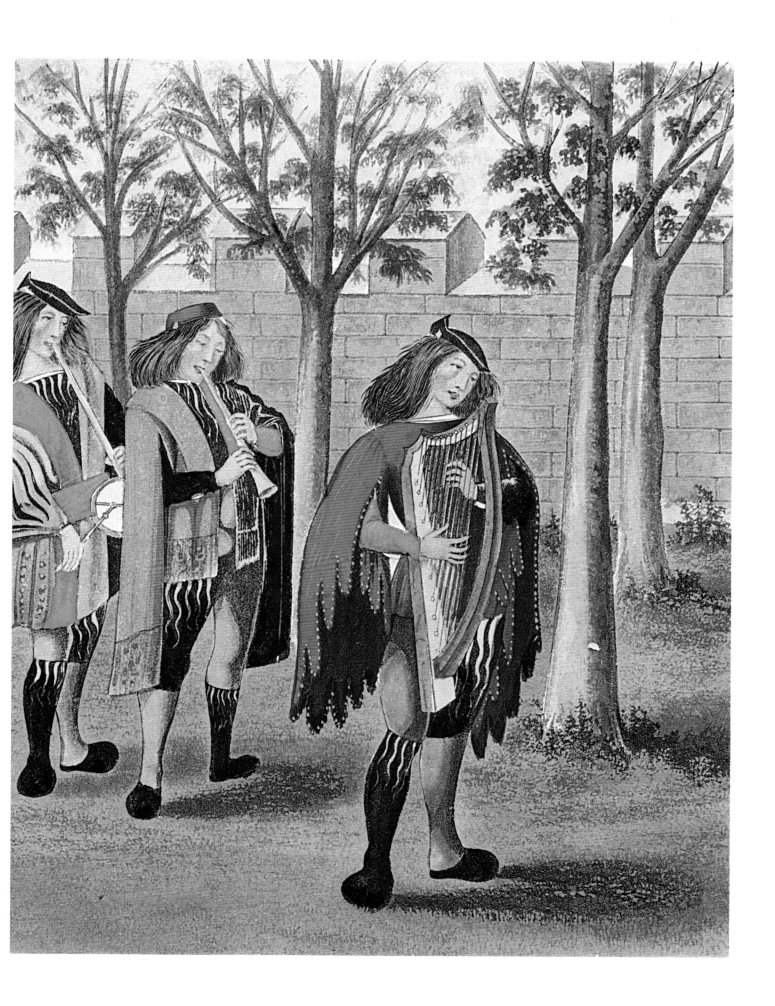

Margaret, Queen of Scotland

 ONSIDERING HER IMPORTANCE, it is strange that early nineteenth century writers recorded few incidents of the private life of the princess whose portrait forms the subject of the illustration on the facing pages. An amiable and virtuous woman, Margaret was the daughter of Christian I, King of Denmark. In 1469, she was married to James III, King of Scotland, at the age of 17. In her dowry, Scotland took possession of the Orkney and Shetland Islands, which had belonged to Denmark for six centuries.

In marrying the King of Scotland, Margaret became the queen of a country which was already distracted with civil dissensions. When James returned from Denmark with his bride, the first news that reached him was of plots and conspiracies. After a troubled 28-year reign, he was killed in 1488, while hiding in a peasant cottage after fleeing from Sauchieburn, where his army had just been defeated by his rebellious subjects.

Margaret died two years before him, in 1486. She is said to have been neglected by her husband, and her early death was probably caused as much by domestic afflictions as by anxiety at the troubles of James's reign. Fifteenth century writers praise her for her great beauty and piety.

The painting from which the picture is taken has been preserved at Hampton Court, but it was formerly in Kensington Palace. It is believed to have been executed between the years 1482 and 1484, and consists of three compartments. From its appeaarance it is supposed to have been intended for an altar piece, and was perhaps — as was suggested in the nineteenth century — painted for the magnificent royal chapel at Stirling, founded by King James III.

The engraving opposite represents the second compartment only. The queen has a singular, rich headdress, loaded with gold, precious stones, and pearls. Her coat is of cloth of gold. She is attended by a saint, supposed to be Canute, the patron saint of Denmark, and it has been imagined that his features

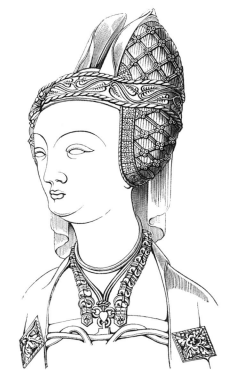

may be intended to represent those of her royal father, Christian. On the table or altar, before which she is kneeling, are seen the arms of Scotland and her native Denmark.

The illustration at the left, representing Lady Vernon, is described in the article on her husband, Sir Richard Vernon. The initial letter is taken from a splendidly illuminated missal, formerly in the collection at Strawberry Hill. ✳

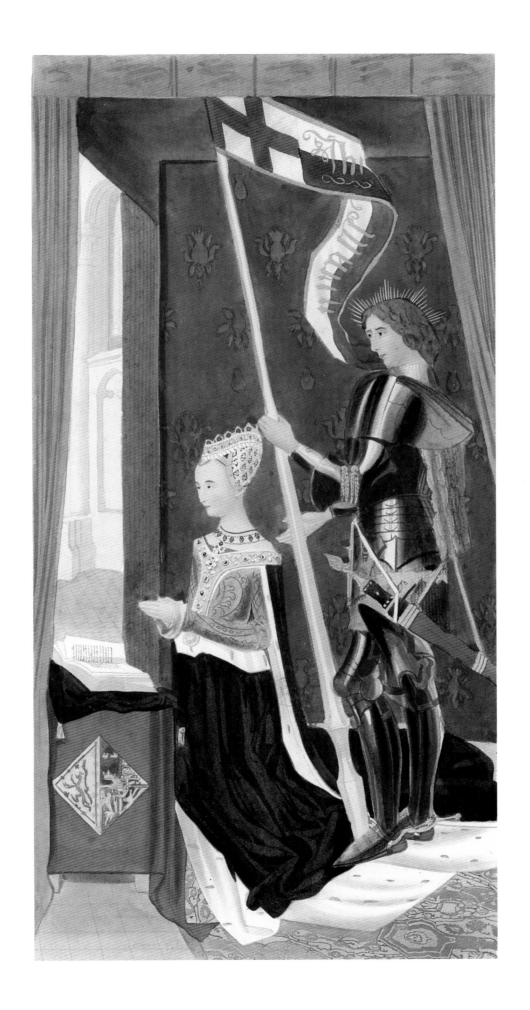

Fashions in the Times of Margaret and Isabella

TUDYING THE FASHIONS of the fifteenth century, one is struck by the abundance of ingenuity utilized in contriving a variety of fashions in ladies headdresses, which were at times carried to a wonderful extravagance. The variations appear to have alternated between raising the head high in the air or stretching it out sideways.

The former fashion, when confined within measure, had the appearance of a low hat, but it was often raised so high as to take the form of a steeple or spire, and then a long cape was thrown over it, which hung down to the ground. To hinder them from dragging the cape on the ground, the ladies in waiting carried the end of the cape over their arms. Sometimes they wore two of these towers, each being from half to three-quarters of a yard long, which, with the capes or kerchiefs, had the appearance of two wings, and satirical people, mocked them, calling them "butterflies."

The simplest form of the other system consisted of the hair being swelled out into the form of a caul on each side of the head, which was richly cased in net work of gold and covered in jewels. At times this was carried out sideways to a great length, and formed into the shape of a barrel. At others, instead of being carried out horizontally, it was raised upward, and this fashion, when carried to an extravagant point, bore a resemblance to two horns. These fashions appear to have been perpetually changing, each going out for a short period and then returning. Often they appeared simultaneously, so it is difficult to fix an exact period for each. References made by the poets and other popular writers prove that the horned headdresses were in use in the thirteenth and beginning of the fourteenth centuries. They were again an object of bitter satire at the end of the fourteenth, and during a considerable portion of the fifteenth.

The headdress of Scotland's Queen Margaret 1452-1486), whose portrait is shown opposite, provides the details of the ornaments. It is extremely elegant and partakes of none of the extremes.

The illustration on this page provides examples of headdresses from about a half century earlier. This figure of Isabella of Bavaria, Queen of France, is taken from a drawing in the Gaigneres Collection in the Bibliotheque du Roi in Paris.

Isabella was the daughter of Stephen II, Duke of Bavaria and Count Palatine, and was born in 1371. Her mother was one of the Visconti of Milan. At the early age of 14, Isabella was married, in

1385, to Charles VI, King of France, who had just succeeded to the throne of his father. Beautiful in person, and proud in her high position and powerful family connections, she first brought into France the extravagant love of finery, which, combined with her own profligacy, brought so many misfortunes on her adopted country.

Her criminal connection with the Duke of Orleans, at the beginning of the fifteenth century, long sustained his party in power, against the opposite party of the Duke of Burgundy. From that time, the disputes between these two families began to tear the country in pieces, and it also paved the way for the English invaders. In 1417, two years after the Battle of Agincourt, a term was put to her irregularities by the Dauphin, who had been entrusted with the government of the kingdom, and she was imprisoned at Tours. She immediately joined her former enemies, the Burgundians and the English Party, and Jean sans Peur, Duke of Burgundy, restored her to liberty. Yet another new civil war then followed — more cruel than those which had preceded — and Paris was depopulated by horrible massacres.

Her daughter was later married to Henry V of England, thus providing the English monarchs with new claims to the crown of France. At length, Isabella became an object of contempt to all parties. She died on September 30, 1435, neglected by all, and she was buried in the church of Notre Dame, with scarcely an attendant to mourn over her.

The initial letter on the opposite page is taken from the Burney Manuscript, Number 292. ❊

The Strange Masquerade of Charles VI, King of France

N THE ACCOMPANYING PLATE is represented one of the strangest, most celebrated and most fearsome of the numerous masquerades which characterized the reign of that unhappy lunatic, Charles VI, who ruled France from 1380-1422.

In 1393, the queen married off one of her ladies of honor, who was a widow. In that age it was customary to celebrate the marriage of widows with riotous and extravagant mirth. For example, everyone who was present at the festivities was allowed to do or say what he liked with the most unbounded freedom.

The weak king and his corrupt entourage were determined to make the 1393 event an occasion for exceeding even the licentiousness usual on such occasions. One of the king's favorite counselors in his pleasures, a wicked man named Hugh de Guisay, contrived an outlandish new scheme. He proposed that the king and five of his knights, including Hugh de Guisay himself, appear at the wedding celebration as satyrs. The king accepted the plan and they sewed themselves into vests of linen which fitted tightly the whole of their bodies, and which were covered externally with rosin and pitch, on which coarse flaxen fibers were attached to make the men look hairy like goats. On their heads, they wore hideous masks.

When the ladies of the court, and the newly married pair, with their friends, were celebrating their nuptials in the royal palace of St. Paul, on the night of January 29, the king and his five knights, thus disguised, rushed into the hall, howling like wolves, dancing and leaping about in an extravagant manner, and making uncouth and unbecoming gestures.

In the midst of the confusion that ensued, the Duke of Orleans (the king's brother) and the Comte de Bar, who had been passing the evening elsewhere, arrived. Wanting to heighten the merriment and frighten the ladies, they set fire to the hairy covering of some of the masqueraders. The pitch and rosin immediately caught the flames, and the satyrs became, in a few seconds, so many blazing fires. As the costumes had been sewed close to their bodies, it was impossible for them to escape, and the five knights, like living masses of fire, threw off their masks, and ran from one side of the hall to the other, in the most excruciating torments, and uttering the most terrible cries.

At the moment when this disaster took place, it happened that the king was apart from his companions, running after the young Duchess of Berry who, when she saw what had happened, held him fast and covered him with her robe, so that no spark could fall upon him, and he was thus saved. The queen and most of the other ladies fled in the utmost terror to a distant part of the house. One of the knights, with more presence of mind than his companions, rushed into the kitchen and threw himself into a large tub full of water, and thus saved himself. The other

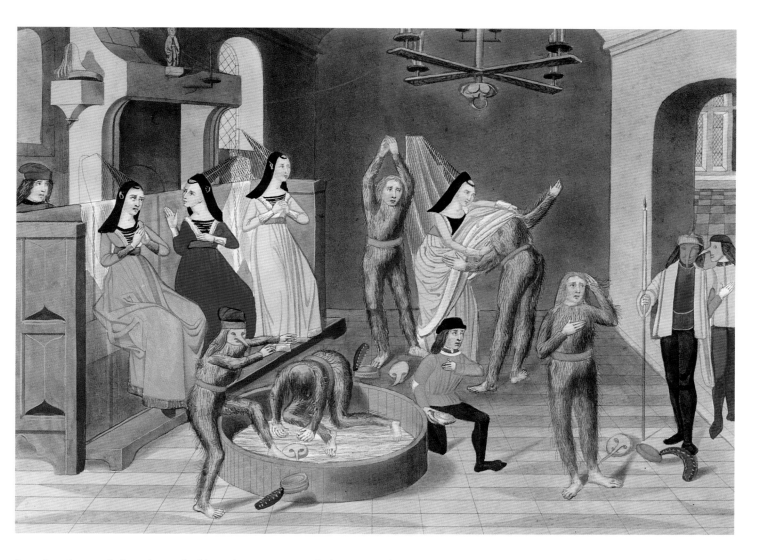

knights burned for about half an hour. One of them died on the spot, two died on the second day, and Hugh de Guisay, the contriver of this unfortunate masque, outlived the debacle by three days of extreme torment. The king, though he escaped the fate of his fellow masqueraders, was thrown by fright into a long fit of madness.

Hugh de Guisay was a proud, overbearing man, cruel and tyrannical in the extreme, and an object of general dislike. He was in the habit of treating the poor commoners, and his own servants, in the most brutal manner. He beat them like dogs, throwing them down and kicking them with his spurs, and forcing them to bark. His death created a general feeling of joy, and, as his funeral procession passed along the streets, people saluted him with the words he had so often used to others, "Bark, dog!"

The plate above is taken from a finely illuminated fifteenth century manuscript by Froissart that is preserved in the British Museum. It is a good specimen of the historical compositions of that period, and at the same time a very interesting illustration of costume. The ladies wear the "chimneys" on their heads which excited the indignation of the puritan preachers of the time, who complained that "The younger and more beautiful the ladies were, the higher were the chimneys which they carried."

The initial letter is taken from a printed book from the end of the fifteenth century, that is also preserved in the library of the British Museum. ✳

FINE MANUSCRIPT from John Lydgate's *Story of Thebes*, preserved in the British Museum, is the source for the beautiful illustration from the prologue to *The Canterbury Tales* that is seen on the opposite page. The Poet of Bury, as was well known to nineteenth century literati, composed the *Story of Thebes* as an addition, or sequel, to Geoffrey Chaucer's remarkable *Canterbury Tales*.

In the introductory lines, Lydgate pretends that after a fit of sickness he determined to make a pilgrimage to the shrine of St. Thomas at Canterbury, and that there he chanced to go to the same inn which harbored the host of the Tabard and his company. Lydgate describes himself as being clad:

> In a cope of black, and not of green,
> On a palfrey, slender, long, and lean,
> With rusty bridle, made not for the sale,
> My man to form with a void male.

The host of the Tabard receives him into the company, and then jokes with him about his lean, or slender, appearance:

> To be a monk slender is your koyse;
> Ye have been sick I dare mine head assure,
> Ore late fed in a faint pasture.
> Lift up your head, be glade, take no sorrow,
> And ye shale home ride with us tomorrow.

On the road, the poet is obliged to conform to the rule and to tell his tale, which is, of course, the tragedy of Thebes.

The history of Thebes, with that of Troy, the wanderings of Aeneas, and the conquests of Alexander, were the Four Stories of Antiquity which figure most among the medieval romances. The first three were considered as part of the same cycle. The prologue to a medieval French manuscript of the story of Thebes describes it as, "*li romans de Tiebes qui fu racine de Troie le grant.*"

It appeared early in French verse and in the thirteenth century, it was given in French prose in a book which was long popular, and of which the manuscripts are often richly illuminated. John Lydgate appears to have been the first, and perhaps the only one, who translated it into English in the Middle Ages. His poem, which is printed in some of the medieval folio editions of Chaucer, is often a favorable specimen of the talents of its author. Though it was popular in the Middle Ages, poetry of John Lydgate found few readers by the eighteenth and early nineteenth century.

The manuscript of Lydgate's *Story of Thebes*, from which the illustration is taken, appears to have been written toward the end of the fifteenth century. The illuminations were perhaps executed by a Flemish artist, who has not thought it necessary to follow every description of the pilgrims as given by Chaucer.

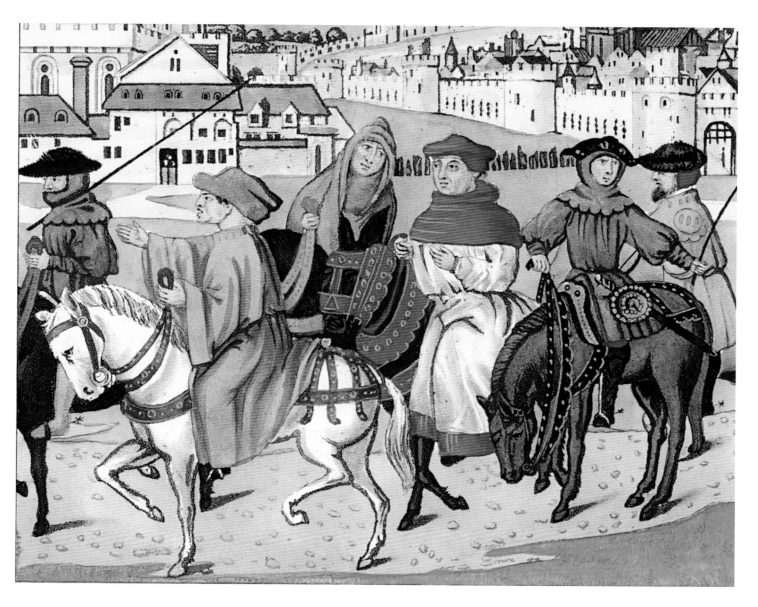

For example, it is a portly and well mounted monk who appears to be telling the same story as the "sclendire" monk in Lydgate's description.

It is not clear whether the rider on the right, or the one who carries a spear, is intended to represent the knight. Were it not that his horse seems too richly compared, and himself deficient in some of the characteristics mentioned in Chaucer, we might have taken him for the squire's yeoman, who carried, according to Chaucer:

by his side a sword and a bokeler,
And on that other side a decorated dagger,
Harnessed well, and sharp as point of spear.

Of course, the picture includes only a small portion of the number of the pilgrims. It is also a beautiful specimen of art in the fifteenth century. The monastic buildings, with the houses before them, and the walled city, are very interesting illustrations of ancient times.

It will be observed that the city, with its Flemish architecture, is enclosed by two lines of fortifications. The first encloses the buildings and between, it and the second encloses an open space for the army of defense — and of the cattle, and so forth, from the surrounding country — in cases of invasion. The outer wall is not surrounded by a moat. ✤

Shooting at the Butt

OPULAR TRADITIONS and the legendary ballads of the Middle Ages have contributed much toward keeping up an interest for the ancient practice of the bow. In the "times of the Edwards and the Henrys," an era spanning exactly four centuries from 1154 to 1553, "the might of the realm of England stood upon archers."

In fact, the pivotal battles of Crecy in 1346 and Agincourt in 1415, as well as many others, were decided by the legendary English longbows. Many laws on this subject show how anxious the successive monarchs were to make their subjects skillful in the use of this weapon. Many incidents mentioned by medieval historians show how powerful it was in their hands. The length of the bow seems generally to have been equal to the height of a man; the arrow measured generally "a cloth-yard."

The armor of the knights also shows how powerful it was in their hands. The armor of the knights was itself scarcely proof against the force of the English arrows. It was a law that a butt should be erected in every town. People were obliged to practice at them on Sundays and holy days, and were liable to fines for omitting to do so.

The use of the long-bow was common among the Anglo-Saxons, though it does not appear to have been of general and efficient use in war before the twelfth or even the thirteenth centuries. On the continent, the arbalest, or crossbow, was more in fashion, particularly among the Italians. The long-bow, however, was found to be the more formidable of the two, but it required more skill. Thus, by the fifteenth century, the crossbow began to supersede it in England. Ordinances were made to counteract this tendency; and the crossbow was sometimes forbidden except under certain restrictions.

The manuscript from which the opposite illustration is taken was written at the manor of Shene (Richmond) in 1496 and it may, therefore, be considered as exhibiting the costume and manners of the English at the end of the fifteenth century. We see the parish butt, and the archers engaged in shooting for the prize. They use the arbalest, or crossbow, and not the long-bow. One of them is engaged in preparing his weapon for shooting, which was done by drawing back the cord of the bow by means of a machine attached to the lock. The butt had a white circle in the middle, and the object of the archer was to place his arrow within the white. This picture illustrates a passage in the book where the different manners in which courtiers pursue their several objects is compared to the various modes practiced by the *arbalestriers* to aim with surety at the mark on the butt. The figure in the foreground of the picture presents a good specimen of the costume of the English peasant at this period.

In the reign of Elizabeth I, when the use of the gun superceded that of the bow, there was a controversy on their respective merits, and many asserted that the former weapon would never succeed in the general practice of warfare. One writer of that time, after discussing the question, concludes, "that there is no doubt but archers with their volleys of arrows, will wound, kill, and hurt above a hundred men and horses, for every one so to be done by the shot."

The following extract from a manuscript treatise on martial discipline provides an important description of the arrangement and accoutrement of the archers, at a time when they were still a key element of English military force:

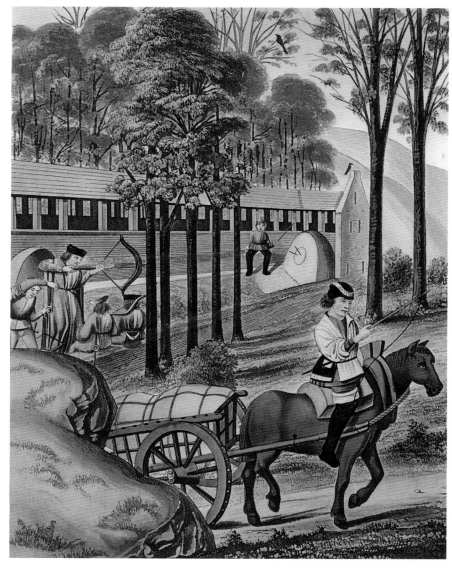

"Captains and officers should be skillful of that most noble weapon [the long-bow], and to see that their soldiers, according to their strength and drought, have good bows well knocked, well stringed, and every string whipped in the knock and in the middle rubbed over the wax, bracer and sutinge glove, some spare strings stringed as aforesaide, every man one sheaf of arrows, with case of leather, defensible against the rain; and in the same flower and 20 arrows, whereof eight of them should be faster than the residue, to gall or stone the enemies with hail shot of light arrows before they shall come within the danger of their arquebus shot.

"Let every man have a brigantine, or a little coat of plate, a skull or husken, a maul of lead of five foot long and a pike in the same hanging by his belt, with a hook and a dagger. Being thus furnished, teach them by musters to march, shot, and retire, keeping their faces upon their enemies, sometimes put them into great numbers as to a battell appertaineth, and thus to see them oftentimes practiced, until they be perfect, for those men in battell ne skirmish cannot be spared, none other weapon may compare with the same noble weapon." ❃

REAT DIFFICULTIES present themselves in attempting to give an exact date to the beautiful illumination represented in the opposite engraving. The original, which is in a private collection, is executed on vellum, in the most exquisite manner, and has evidently been cut out of a book, which is now lost, or, at least, of which nothing is known. The picture represents six of the principal sovereign monarchs of Europe, performing their devotions at the altar of St. George, the patron saint of England.

The armorial bearings leave no doubt as to the monarchs intended to be represented. The figure on the right hand side of the picture is the king of England. The person behind, next to the English monarch, is the king of Spain. Before the altar kneels the Holy Roman Emperor, and behind him are the king of the Romans and (further to the right) the archduke of Austria. At the side of the altar, on the left hand side of the picture, kneels the king of France.

It is of importance to know the date of this picture, because there can be little doubt that it furnishes a collection of portraits of contemporary monarchs. The style of painting and the figure of the English king point out the reign, from 1485 to 1509, of Henry VII. The intrigues of the monarch in the affairs of the continent ended in his being chosen as the apparent umpire in settling the disputes between the houses of Austria and France. A treaty between these parties was concluded in the year 1492, by the intermediation of our King Henry.

The monarchs represented here were all more or less involved in these intrigues, so it is possible that this picture may be from that period. It may have been intended to represent the parties in the 1492 treaty as acknowledging — in the person of St. George — the superiority of the English nation. This stroke of flattery would have been intended to soothe the popular discontent at the unwarlike conduct of their sovereign.

If this illustration may in fact be dated to the 1492 treaty, the aged emperor would be Frederick III, who had borne the imperial crown since 1440, and who died in 1493. The king of the Romans would be Maximilian I, who became Holy Roman Emperor in 1493 and who supported, with so much courage and activity, the cause of Anne of Brittany against the French king. The latter was Charles VIII, who

reigned from 1483 to 1498. He succeeded in making Anne of Brittany his queen, but after she had been affianced to Maximilian. If our conjecture be right, the other monarchs are Archduke Philip of Austria — who was also the Duke of Burgundy — and King Ferdinand of Spain, who, in the course of these disputes, had invaded the south of France in support of the cause of Anne and of Maximilian. Ferdinand was actually Ferdinand V of Castile and Leon and Ferdinand II of Castile, then separate, but all part of Spain since Ferdinand's rule, which lasted from 1474 (1479 in the case of Aragon, and 1492 in the case of Grenada) until his death in 1516. His claim to Aragon came by way of Henry VI, the brother of Ferdinand's wife, Isabella of Castile. It was she who convinced a skeptical Ferdinand to support the 1492 voyage on which Christopher Columbus reached America.

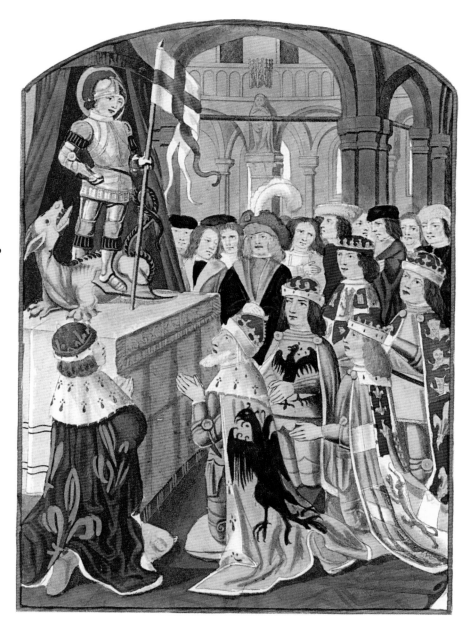

The illustration at the bottom of the opposite page is taken from a splendid "Blaison d'Armoiries", written in French in the year 1629. It shows a fifteenth or sixteenth century oil lamp which was in the collection of Monsinior Dugue of Paris in the early nineteenth century. Similar lamps of the same classic form — which appears to have been derived through a succession of ages from the Roman lamps — were still used in some parts of France in the nineteenth century. The branch with notches serves to raise the hinder part of the lamp as the oil diminishes, so as to throw it forward to the wick. The one end of the horizontal beam or rod was generally inserted into the side of a kind of wooden candlestick.

The initial letter opposite is taken from a fine manuscript of St. Augustine's *Treatise De Civitate Dei*, executed in Italy toward the end of the fifteenth century and now in the British Museum. ❋

O N THIS PAGE we see an illustration of a fifteenth century iron lock from Plessis les Tours, the castle of Louis XI, who ruled France from 1461 to 1483. One of the turrets moves by pressure on the pinnacle, and thus discovers the keyhole.

Louis XI was notable, among other things, for the cruel prisons that he had constructed. Meanwhile, he had his own castle, Plessis les Tours, encompassed with great bars of iron in the form of thick grating. At the four corners of the chateau, four massive iron crow's-nests, strong and thick, were built. The grates were outside the wall on the other side of the moat, and sunk to the bottom. Several spikes of iron were fastened into the wall, set as thick by one another as was possible, and each furnished with three or four points. He likewise placed ten bow-men in the moat to shoot at any man that approached the castle before the opening of the gates. He realized that this fortification was too weak to keep out an army or any great body of men, but he had no fear of such an attack. His

great apprehension was that some of the nobility of his kingdom might attempt to make themselves masters of the castle by night, intending to deprive him of the regal authority.

The gate of the Plessis was never opened, nor the drawbridge let down, before eight o'clock in the morning. At this time, the officers were let in, and the captains ordered their guards to their several posts, with pickets of archers in the middle of the court. No person was admitted except by the wicket and with the king's knowledge, unless it were the steward of his household, and such persons as were not admitted into the royal presence.

Writing of Louis XI, Philip de Commines (c. 1447-1511) asked rhetorically: "Is it possible then to keep a prince in a closer prison than he kept himself? The cages which were made for other people were about eight feet square; and he (though so great a monarch) had but a small court of the castle to walk in, and seldom made use of that, but generally kept himself in the gallery, out of which he went into the chambers on his way to mass, but never passed

through the court. Who can deny that he was a sufferer as well as his neighbors, considering how he was locked up and guarded, afraid of his own children and relations, and changing every day those very servants whom he had brought up and advanced; and though they owed all their preferment to him, yet he durst not trust any of them, but shut himself up in those strange chains and enclosures. If the place where he confined himself was larger than a common prison, was he also greater than common prisoners?"

On a completely opposite note, we see on this page, a fifteenth century Flemish engraving of the elevation of the host at the moment of consecration in the sacrifice of the mass. The subject is happily treated. It is a very interesting picture, with regard both to the subject and to the execution. It is probably taken from a splendid missal or service book.

The choir, raised upon a crypt, is approached by a double flight of steps. The priest standing at the altar is in the act of elevating the host (*hostia*), the consecrated bread for the celebration of the eucharist, while the deacon and subdeacon, on their knees, support the chasuble of the celebrant. The deacon wears the dalmatic, and the subdeacon the tunic. An acolyte, in his white surplice, kneels at each corner in front of the altar, bearing a torch.

Further down the choir stand two assistants, or cantors, with their choral books in their hands, and

habited in capes, red and gold, which are the colors of the suit of vestments.

On each side of the choir are the canons in their stalls, upon their knees, all in surplices, and, like the clergy at the altar, tonsured.

The antipendium, or frontal of the altar, is red and gold, and blue curtains hang at the sides. Over the altar is a tablet, in the center of which is represented the Virgin and Child. The priest's stalls and those of the canons are richly carved. In the nave of the church is a group of laity in the act of adoration, making a good foreground to the picture, which receives its light from the windows in the choir, as well as through the arch of the crypt, in which is seen another altar. ✺

A Censer Crafted by Martin Schongauer

N MEDIEVAL CATHOLICISM, the censer — whose use seems to have been derived from the ancient Jewish ceremonial — was one of the most important sacred utensils in the church. After the Reformation, this, as well as most of the other utensils of the older church ceremonies, was discarded. These then became articles of luxury in the houses of the rich. This latter usage was frequently alluded to by medieval dramatic writers.

The censer represented on the opposite page is not only of extreme beauty in itself, but it is remarkable on account of the person who originally designed and engraved it. Martin Schongauer (1445-1491?), a German goldsmith in Colmar, was one of the first two persons known to have practiced the art of engraving on copper, the other being his contemporary, Maso Finiguerra, of Florence. The engravings of Martin Schongauer are remarkable for their beauty, and are superior to those of any of his contemporaries, and are scarcely, if at all, excelled only by the best works of Albrecht Durer. He has left about 150 engravings, all of them rare, and much admired and sought after.

His two most important pieces are one representing the Bearing of the Cross, and one of St. Anthony carried into the air and tormented by the demons. The first of these plates is said to have been greatly admired by Michelangelo, who made a particular study of it in his youth. The temptations of St. Anthony formed a most prolific source of designs to the early painters and engravers. The plates of Martin Schongauer, like the one given here, are marked with the letters M.S., having a cross between them.

It is said that at the time of Schongauer's death, Albrecht Durer, then a youth, was on the point of being sent to Colmar by his father, to study under him. Durer was, if not a disciple, a warm admirer of the artist of Colmar. Martin was a painter as well as an engraver, and several of his works in the latter branch of art are still preserved.

The initial letter on this page is taken from a very large fifteenth century vellum manuscript of the *Confessio Amantis* by the poet John Gower (1325-1408) that is preserved in the British Museum. This manuscript, unfortunately not quite in perfect condition, is, however, one of the finest copies we have of the chief work of "moral Gower."

The *Confessio Amantis*, which is a singular monument of the poetry of the age, was written at the command of King Richard II, Gower's patron, and was first printed by William Caxton (1422-1491), the father of English printers. It is a kind of an allegorical work, written partly in imitation of the style of the famous Romance of the Rose, and is well worthy to be pursued by all who are desirous of becoming acquainted with early English literature. ✤

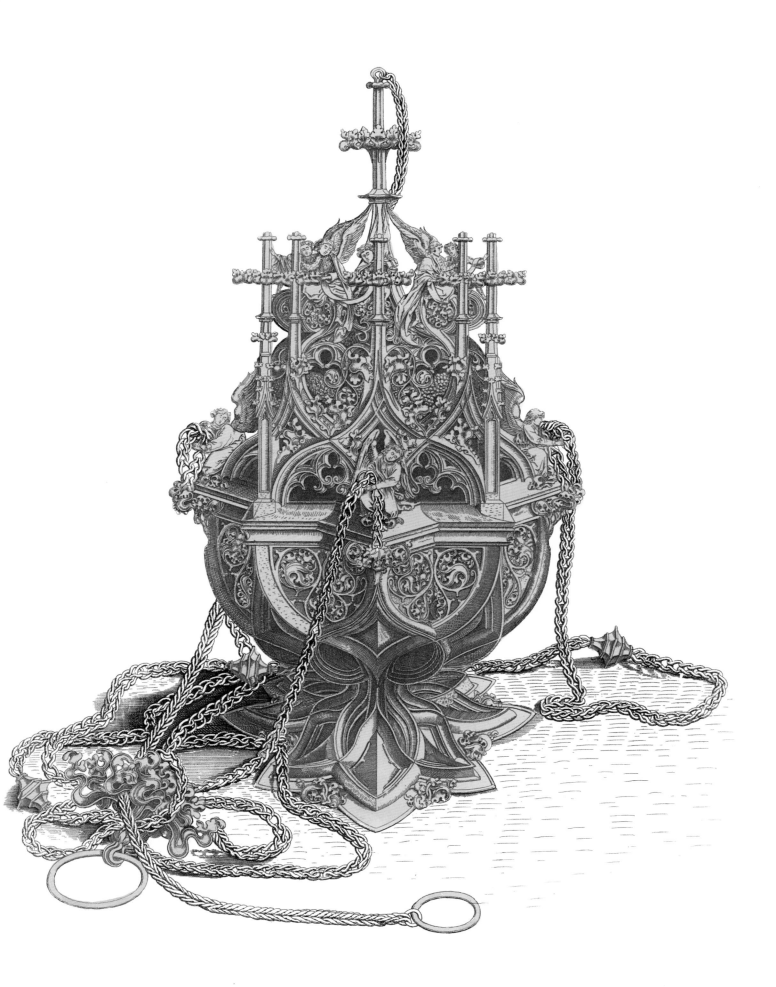

A Venetian Reliquary and an English Ink Case

HE BEAUTIFUL RELIQUARY pictured on the opposite page was acquired from a dealer in Venice by the noted nineteenth century scholar and collector Robert Curzon, Jr. The reliquaries were used in medieval Catholicism to contain the relics of saints, which were then objects of great reverence. It appears to be a work of the latter part of the fifteenth century, and is an interesting object, of which there are few, if any, other examples that resemble it.

This reliquary is a fine monument to the taste of the age in which it was made. It is of silver. The ornaments of the foot are elegantly worked in nielli; three of the departments are embellished with half-figures of saints. The boss from which the branches spring is picked-in with enamel. Each branch supports a little crystal box, in which the relics were deposited. The notched bar which runs across the supporting column appears also to have been intended to hold a box or other receptacle to contain a relic, perhaps of larger dimensions than those which were placed in the other boxes.

The ink case at the right is a curious relic of the bloody Wars of the Roses that belonged to Henry VI of England.

According to the tradition connected with it, when that unfortunate monarch wandered about Yorkshire seeking safety by concealment, after the fatal and bloody Battle of Towton (1460), he remained nine days at Bolton Hall, near Gisburn. He was then on his way to Waddington Hall, where he was discovered and made a prisoner. At Bolton Hall he left his boots, knife, fork, and spoon, and at Waddington his inkhorn. It later came into the possession of Edward Parker, of Brewsholme, and by his descendant Thomas Lister Parker, it was given to Robert Curzon.

This curious relic of a monarch who was truly fitted rather for the pen than the sword, seems to have been one of the last articles which he retained about his person after he had given up the utensils with which he took his meals — which medieval princes and nobles seem constantly to have carried about with them.

The ink case is made of leather, in the same style used up to the nineteenth century. It is ornamented with the arms of England and the rose of the House of Lancaster surmounted by the crown. Inside it are three compartments, one for the inkstand, the other two to hold pens. ❉

A Cup by Andrea Mantegna and a French Hanap

VERYONE WHO EXAMINES the pictures of the end of the fifteenth and beginning of the sixteenth centuries is struck with the elegance exhibited in the form and ornament of the cups and vases of that period. They were often designed by the finest artists of the day, and of these designs, some were perhaps never executed, while others were later reproduced by the engravers who had obtained the original drawings.

Such was the case with the fine cup shown on the opposite page. It was designed by Italian Renaissance master Andrea Mantegna (1431-1506) and engraved in 1643 by the Bohemian-born English engraver Wenceslaus Hollar (1607-1677), who found the drawing in the collection then existing at Arundel House. Mantegna was a painter and engraver living in Padua, in Italy, who enjoyed a great celebrity in the fifteenth century and who produced a great number of paintings and other works of art.

At the right is shown a figure of a cup from a splendidly illuminated manuscript from the fifteenth century, preserved in the Library of the Arsenal in Paris. It represents one of those goblets, or drinking vessels, which were formally designated by the name of a *hanap*. The derivation of this word is supposed to be taken from the Anglo-Saxon *hnaep*, like the modern German *napf*, describing a cup or goblet. The name in low Latin was *hanapus*, or *hanaphus*, and in old French *hanaps*. In the latter language we have *hanapee*, meaning a cupful and *hanapel*, a little cup. *Hanaper* (*hanaperium*) was the name given to the place in which these cups were preserved. In the English chancery, the fees which were paid for sealing charters, deeds, and so forth, were deposited in a large cup or vessel of this description, and the office in which this business was done was the *hanaper*. The person who transacted the business had the title of clerk of the *hanaper*.

Hanaps are frequently mentioned in old documents. An inventory of the goods of the Hospital of Wez in 1350 lists a *hanap* of silver, without foot, five *hanaps* of "madre" with silver feet, and 16 *hanaps* of "madre" without feet, the latter being "of small value." The material indicated by the name *madre* has been supposed to be a kind of stone used for making cups and the word itself has been synonymous with "cup."

The initial letter on this page is taken from a manuscript in the British Museum which is said to have been executed for Elizabeth of York, queen of Henry VII. ✳

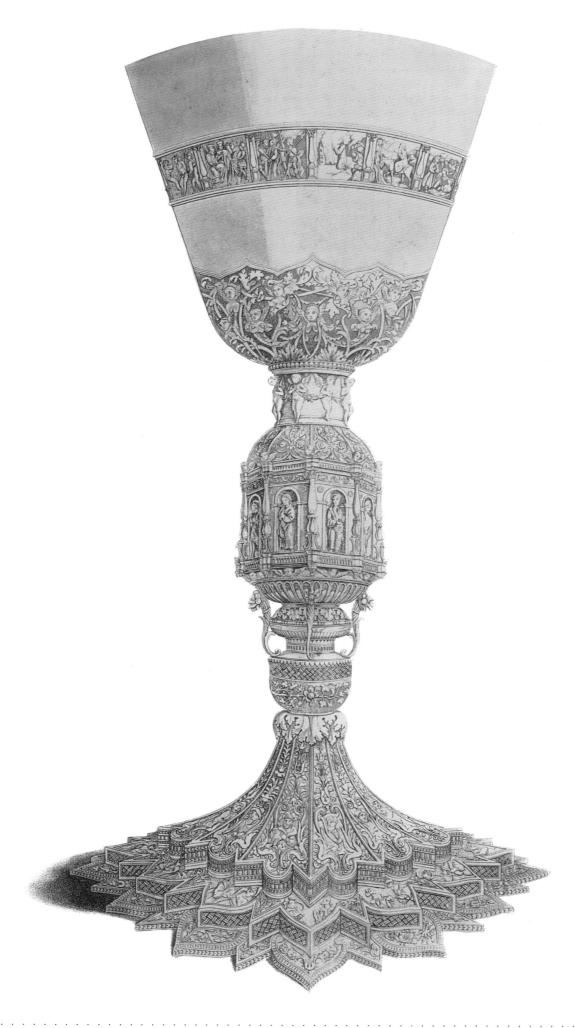

A Niello Cup

EFORE THE INTRODUCTION of printing from engraved plates, the art of engraving had been long practiced, although with a somewhat different object. Engraved ornaments are found of the highest antiquity. Instead of being embossed, they were covered with scroll-work, arabesques, or figures, cut into metal with a sharp instrument. The engraved lines were then filled up with a dark-colored substance called, in low Latin *nigellum*, from which appears to be derived the Italian word *niello*. The designs were scratched on the surface of the silver, in the manner of pen-and-ink drawings.

This art became very fashionable in Italy in the fifteenth century, where one of the principal artists was a man named Tommaso Finiguerra, best known as Maso. He was particularly eminent in this branch of art, and some of his most exquisite workmanship can still to be seen in the church of St. Giovanni in his native Florence. He made chiefly pixes, and other golden articles belonging to the service of the church.

Technically, the *niello* is said to have been composed of a mixture of silver, copper, lead, sulphur, and borax, fused and mixed, and later reduced to a powder. This was spread over the engraved parts, and then again fused by blowing over it the flame of a clear fire; the melted *niello*, in cooling, attached itself firmly to the rough parts of the engraved silver. When cold it was rubbed smooth with a pumice stone. The

niello in the engraved lines was all that remained, and the whole was then polished with the hand, or with leather. As no alteration could be made after the application of the *niello*, it became necessary to take proofs of the work before the lines were filled up, in order to examine its effect; this was sometimes done with dampened paper, the lines being filled up with a black substance transferred to the paper by passing a small roller over it. The effect of this impression on the paper is said to have suggested to Finiguerra the idea of making prints from engraved plates, and thus gave origin to the art of engraving on copper. Finiguerra himself executed many engravings of considerable merit, which are highly valued by collectors.

The beautiful *niello* cup represented in the engraving is supposed to have been executed about the end of the fifteenth century. It was formerly in the possession of the noble family of van Bekerhout, who presented it to Calonier, the celebrated sculptor of the statue of Jan van Eyck in Brugge (Bruges), Belgium. It was purchased from his widow by Henry Farrer, who sold it to the British Museum.

This cup is silver, the lower part, the ornamental rim of the lid, and the ornament at the top being gilt. It is 9.75 inches tall, with the diameter of the rim of the lid being 4.5 inches. The figure on the lid holds a shield, the device on which is understood to be merely ornamental and not the armorial bearings of the family to which the cup belonged. ❀

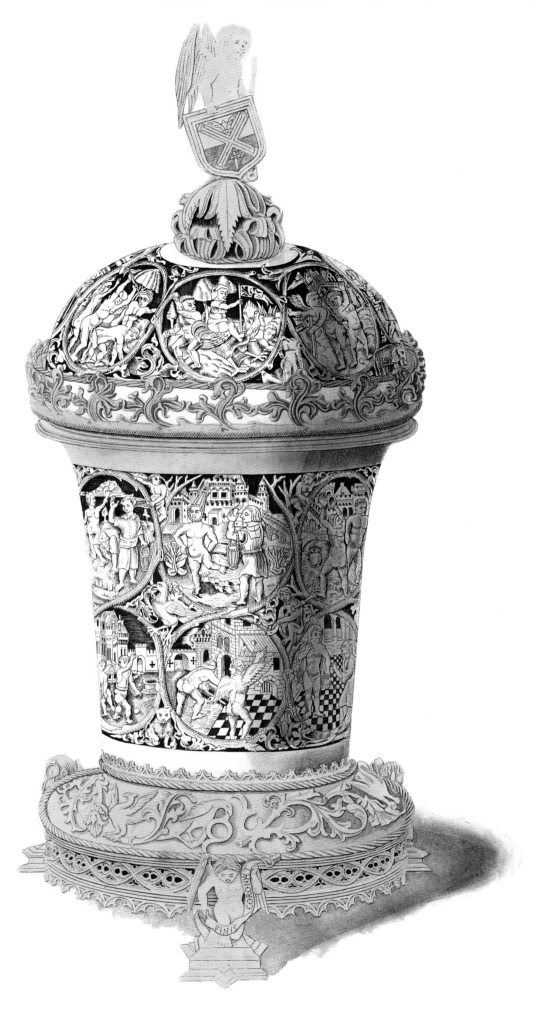

Heralds Announcing the Death of Charles VI, King of France

THE GREAT NUMBERS of illuminated manuscripts of ancient and modern chronicles and histories that began to appear in the fifteenth century demonstrate the great upsurge in interest in such subjects at that time. This in turn led to the great schools of art that distinguished the Middle Ages and the Renaissance.

The literary works which are most splendidly illustrated are generally written in French, but were frequently painted in Flanders, where the best illuminators were, although there were major centers in France and Italy that produced many noble manuscripts that have been preserved to enrich modern libraries. The manuscripts which are most distinguished by the richness of their embellishments are the *Grandes Chroniques* of St. Denis, and the annals of Froissart and Monstrelet.

The subject in the accompanying plate, which shows the costume of French heralds, is taken from a fine Monstrelet manuscript that is preserved in the Royal Library in Paris. The heralds were represented as carrying the pennon, or banner, of France, and announcing the death of Charles VI — known to his contemporaries by the appellation of "the well-beloved" — to his son and heir, the Duke of Touraine, who succeeded him as Charles VII. Charles died in the Hotel de St. Paul in Paris, on November 22, 1422, when his son was residing at the small castle called Espally, near Puy, in Languedoc.

At the bottom of this page is an illustration from the chronicles of St. Denis, written in the reign (1368-1422) of Charles VI, and preserved in the British Museum. No inappropriate companion to the opposite plate, it represents the monks of St. Denis bringing their relics from the monastery to cure Louis, the eldest son of Philip Auguste (Philip II), King of France. Philip Auguste ruled from 1180 to 1223, but Louis had been made regent in 1191, following his father's expedition to the East, where he was seized with a desperate illness in 1191. Louis became King as Louis VIII in 1223, but died three years later. ❉

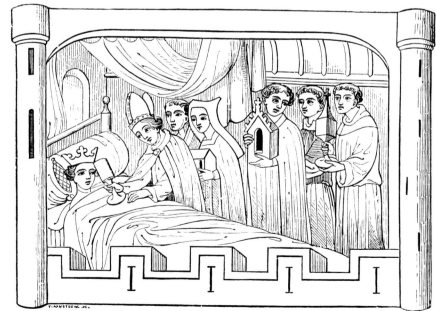

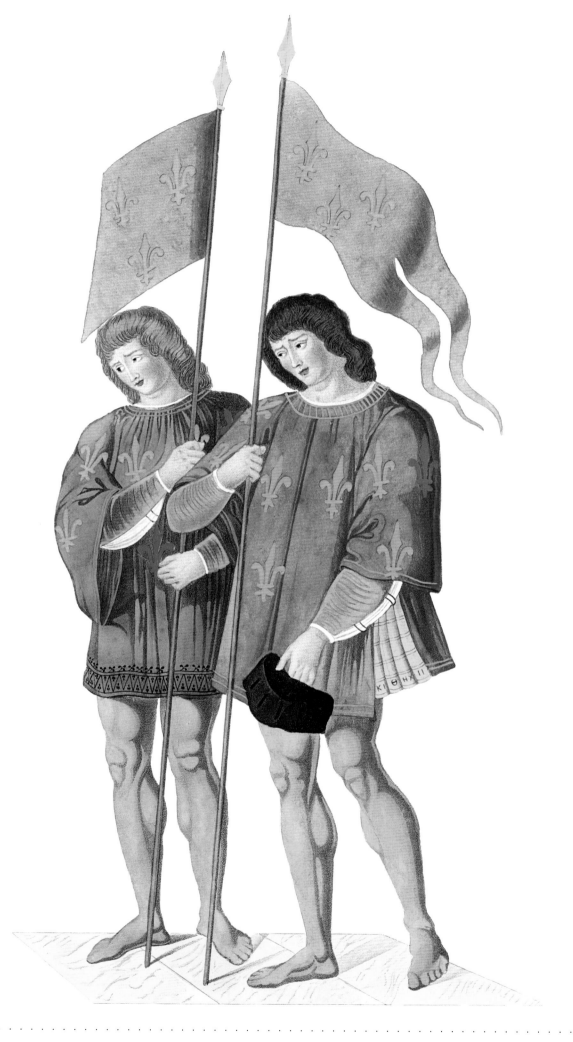

Arthur, Prince of Wales

EVERYTHING CONNECTED with the history of this amiable prince, whose virtues and accomplishments raised the expectations of his contemporaries — and whose untimely fate covered the whole kingdom with mourning — is of interest. Arthur was born in 1486, and at the age of 15 (in 1501) he was married to the celebrated Catherine of Aragon, who was then 18 years of age.

Medieval writers speak in warm terms of the magnificent pageants and the great public rejoicing which, in London, attended on this event, and they describe with enthusiasm "the rich arras, the costly tapestry, the fine clothes of both gold and silver, the curious velvettes, the beautiful satins, and the pleasant silks which did hang in every street," as well as "wine that ran continually out of the conduits," and "the goodly ballads, the sweet harmony, the musical instruments, which sounded with heavenly noyes on every side."

From London the youthful couple were carried to the noble castle of Ludlow, the residence of the prince. He died there in April of the following year, leaving the inheritance of the English crown, as well as his unfortunate wife, to his younger brother, later King Henry VIII. On his death, the body of Prince Arthur was carried in procession from Ludlow to Worcester, and was interred there in the cathedral church. The magnificent monument erected there to his memory is still preserved.

The picture of Prince Arthur seen opposite is taken from the beautiful painted glass in the window of the fine old church of Great Malvern, in Worcestershire. The window originally represented King Henry VII and his queen, with Prince Arthur, Sir Reginald Bray, John Savage, and Thomas Lovell.

The window was made immediately after Prince Arthur's marriage, and therefore when he was in his 16th year. The window itself was extensively damaged in the eighteenth century, having been be allowed to serve as a mark for the boys who played in the churchyard to aim stones at the different figures represented in them.

The sections containing the figures of the prince and of Sir Reginald Bray, one of the knights, are all that remain in tolerable preservation. Even these have received some damage and loss in the ornaments and border, and some of the pieces of glass have been placed the wrong way upward by workmen.

Enough, however, is left to allow an accurate restoration of these two sections.

The small illustration of a bagpiper at the left on this page is taken from a manuscript from the end of the fifteenth or beginning of the sixteenth century, preserved in the Royal Library in Paris. ✳

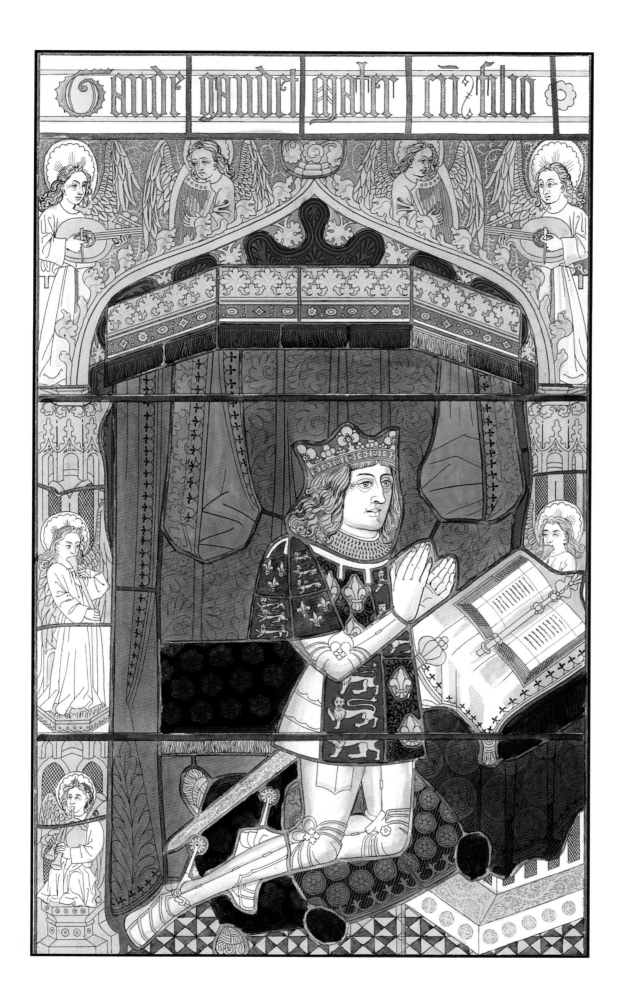

 HE REIGN (1509-1547) of Henry VIII is conspicuous in English history as a period of pompous and splendid pageants. One of the most gorgeous of these exhibitions is pictured in an illuminated roll, still preserved in the College of Arms, and known by the name of The Tournament Roll. This curious document is the source of the illustration on the opposite page.

The tournament represented on this roll was held at Westminster, in 1511 — the second year of the king's reign — in honor of Queen Catherine (formerly Catherine of Aragon) on the occasion of the birth of the king's first child, Prince Henry — who died a few days after these revels had been performed. The king, who entered heartily into the program, was one of the four knights, and bore the title of *Noble Cueur Loyal*. The other three were William, Earl of Devonshire, whose title was *Bon Vouloir*; Sir Edward Neville, who was *Vaillant Desyr*; and Sir Thomas Knevet. According to Hollingshed, who has given a detailed account of the exhibition, Knevet represented *Bon Espoir*, although the roll refers to him as *Joyeule Penser*.

The king rode under a pavilion of gold cloth and purple velvet, "powdered" with the letters H and R in fine gold. The other knights also rode under rich pavilions, and the pages and attendants were all in splendid costumes, many of them "powdered" in a

similar manner. There were 168 gentlemen following the pavilions on foot, and 12 "children of honor" came after them on rich coursers.

The roll represents the whole procession to the scene of these "solemn joustes," and furnishes us, no doubt, with an exact portraiture of the different costumes of the persons who figured at it. It is very long, and contains a great number of figures. The whole was engraved on a reduced scale, and published in the first volume of the *Vetusta Monumenta*. The figure is one of those entitled in the original, *Les Selles d'Armes*. If the drawings are not exaggerated, it must have been a splendid pageant, requiring an immense expenditure of money. At the conclusion, the spectators were allowed to strip the knights, and to scramble for the ornaments of their costumes.

Hollingshed tells us that "at this solemnity a shipman of London caught certain letters, which he sold to a goldsmith for three pounds, 14 shillings and eight pence; by reason whereof it appeared that the garments were of great value." Hall, the chronicler, speaking of the ceremonies at this king's coronation, observes very quaintly, "If I should declare what pain, labor, and diligence, the tailors, embroiderers, and goldsmiths took, both to make and devise garments, for lords, ladies, knights, and esquires, and also for decking, trapping, and adornyng of coursers, jenetes, and palffreis, it were too long to rehearse, but for a surety, more rich, nor more strange, nor more curi-

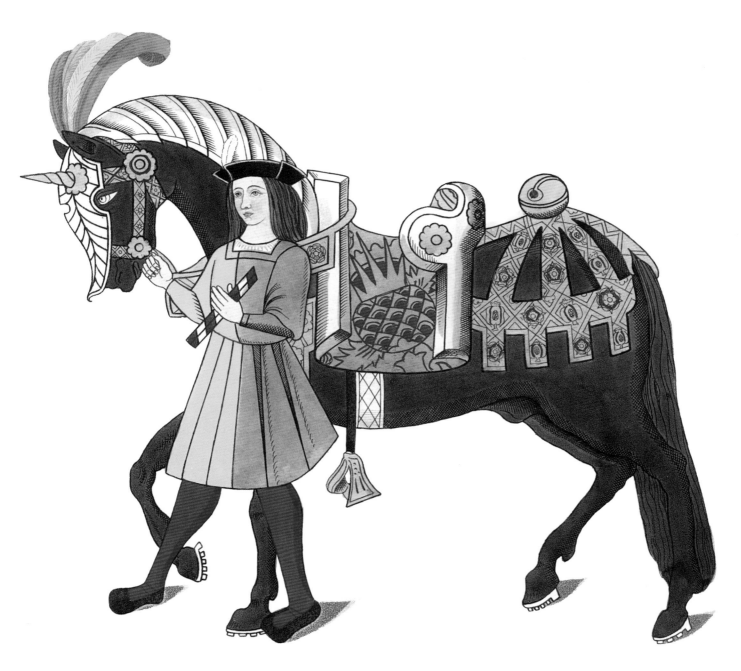

ous works hath not been seen, than were prepared against this coronation."

At one end of the roll is a copy of verses, in five stanzas, in praise of the king, beginning:

Our royal rose, now reigning rede and white,
Sure grafted is on ground of nobility,
In Harry the VIII, our joy and our delight,
Subduer of wrongs, maintainer of righteousness,
Fountain of honor, exemplar of largess;
Our clypsyd son now cleared is from the dark
By Harry our king, the flower of nature's work.

In the fourth stanza the king is put on a par with the nine worthies:

"Thou are to Ector in armes and honor!
Julius, Judas, nor duke Josewe,
In so short time their famous deed
 never more flower;
Not Charles of France, nor Arthur the worthy,
Alexander the Great, full of liberality;
David nor Godfras largess was not like thine:
Than why not thou the tenth,
 as well as they the nine? ❊

Troy the Great

HE ILLUSTRATION on the facing page is from a very splendid illumination on a large leaf of vellum that formed part of a volume executed in the reign (1498-1515) of Louis XII, King of France. The subject of the illumination is the rebuilding of the city of Troy — the legendary city of Homeric legend — by Priam after it had been sacked by Hercules. However, the architecture is from 1500 AD rather than 1500 BC.

Although as a whole, this picture is full of exaggeration and fancy, its parts are curious examples of French domestic architecture of the fourteenth century. The houses and shops are particularly interesting. The building in front is a richly embellished gateway. Beneath, the right hand side of the gateway appears to be occupied as a pharmacy. Under one arch is the pharmacist or apothecary weighing out his drugs, while another arch in the gateway shows his assistant pounding them in a mortar. The wares displayed for sale in the row of shops in the street are not so easily determined. One shop is occupied by a merchant who appears to be selling shoes and stockings, as well as hats or caps.

The history of "Troy the Great," as it is called in medieval romances, was remarkably popular from the twelfth century, not only for the interest attached to the feats of chivalry connected with it, but because most of the people of Western Europe had begun to lay claim to a fabulous origin from some of the Trojan chieftains who were supposed to have wandered across the world after the ruin of their country.

This history was, in general, founded on such myths as *Dares of Phrygia* and *Dictys of Crete*. These were adapted, by those who translated them, to the manners and notions of medieval chivalry. We frequently see anonymous accounts of the siege of Troy in medieval manuscripts, and in England in the twelfth and thirteenth centuries, Benoit de Sainte Maure, John Lydgate (see page 187) and Joseph of Exeter used it as the basis for long works.

In 1287, a new Latin history of the siege of Troy was written by an Italian writer named Guido de Columnis, or Delle Colonne. Many authors have erroneously stated this to be the earliest of the medieval books on this subject. However, Guido's work soon obtained a wide popularity, and, having thrown almost into oblivion the previous works on the same subject, became the groundwork of most of the similar works which appeared later.

In the fourteenth century, the Trojan legend was translated into French, or rather made the foundation of a French work, by Raoul Lefevre, chaplain of Philip the Good, Duke of Burgundy, who informs us that he composed it in 1464. The manuscripts of Lefevre's book, which are numerous, are, in general, richly illuminated. There are many copies in the Royal Library in Paris. ✳

OOKING at the costume of the sixteenth century, such as is seen overleaf on the following pages, we note that it is remarkably rich and expensive. Even the gowns of the wives of merchants are described as being "stuck full with silver pins;" and the inventories of the wardrobes of princes and nobles exceed all the previous ideas of splendid dresses.

English costume of the reign (1509-1547) of Henry VIII derived many of its characteristics from the Germans and from the Flemish. The figures on the illustrations opposite and overleaf appear to represent the German costume of the beginning of the sixteenth century, and are taken from a tapestry of that period that was located in the church of St. Germain l'Auxerrois in Paris during the early part of the nineteenth century.

The subject of the tapestry consists of allegorical representations of the seasons. The figures bear a strong resemblance to the English clothing worn during the reigns of Henry VIII and Edward VI (1547-1553), but they differ entirely from those of the earlier reign (1485-1509) of Henry VII, as represented in the illuminations of *The Romance of the Rose*.

The opening of the sixteenth century, in fact, formed a strongly-marked point of division between styles. One of the innovations was the close fitting silk stockings, which were worn by the rich, with the upper part of the leg coverings slashed, puffed, and embroidered distinctly from the lower part.

The men's shoes of the early sixteenth century were broad at the toes, and frequently slashed, so that their appearance was far from elegant. The lower part of the stockings was open, separate from the upper, and attached to it by buttons or strings, and the final separation gave origin to the later distinct articles of apparel such as stockings and knee-breeches. The upper part of the stockings was been confounded with the doublet. The wardrobe of a gentleman was, in general, especially rich in "pairs of sleeves."

As we see in the illustration overleaf, the ladies, as well as the men, wore little jackets. The sleeves were also very richly adorned, and were, in general, separate articles of clothing, that were attached to the shoulders of the vests that were worn by persons of both sexes.

Prior to the sixteenth century, the subjects represented on tapestries were generally taken from the numerous romance tales then in vogue, or from history. Very frequently, particularly in the tapestries

seen at the palaces of the ecclesiastics, the subjects were from Scripture.

A number of such subjects of different kinds, portrayed on formerly existing tapestries in England, are enumerated in Volume I of *Warton's History of English Poetry*. Some of these designs were also discussed in the large work on tapestries by Achille Jubinal, which was published at the beginning of the nineteenth century.

In the fifteenth century, a great taste for allegorical poems had arisen, and such subjects soon made their appearance on the tapestries. In a manuscript copy of some of John Lydgate's poems, that is in the Library of Trinity College, Cambridge, one of the poems has the comment, "Loo, sirs, the devise of a painted or embroidered cloth for a hall, a parlor, or a chamber, devised by John Lydgate, at the request of a worthy citizen of London."

The poem consists of speeches to be put in the mouths of two allegorical beasts called Bycorne and Chichevache. The former of these was said to eat good men and the latter of these was said to eat good women. The point of the legend was that Bycorne became very fat and Chichevache was equally lean.

The figures in the overleaf plate appear to represent masqueraders, who generally carried torches. Hall, the chronicler, in describing the festivities at the court at Greenwich in 1512, wrote: "After the banquet was done, these masqueraders came in, with six gentlemen disguised in silk, bearing staff-torches, and desired the ladies to dance. Some were content, and some refused; and after they had danced and communed together, as the fashion of the masque is, they took their leave and departed."

The initial letter on the opposite page represents a much earlier time, and is taken from an edition of the French *Life of Du Guesclin*. This book chronicles the life of Bertrand du Guesclin (1320-1380), the celebrated hero of the French wars of the fourteenth century, who was the legendary opponent of England's Black Prince. The man in armor is almost certainly intended to be du Guesclin himself. The book was printed at the beginning of the sixteenth century, and also contains the first edition of the *Mer des Hystoires*.

The illustration on this page represents a sack or bag of the same period, from a very splendid tapestry preserved in the treasury of the cathedral at Sens in France. ❋

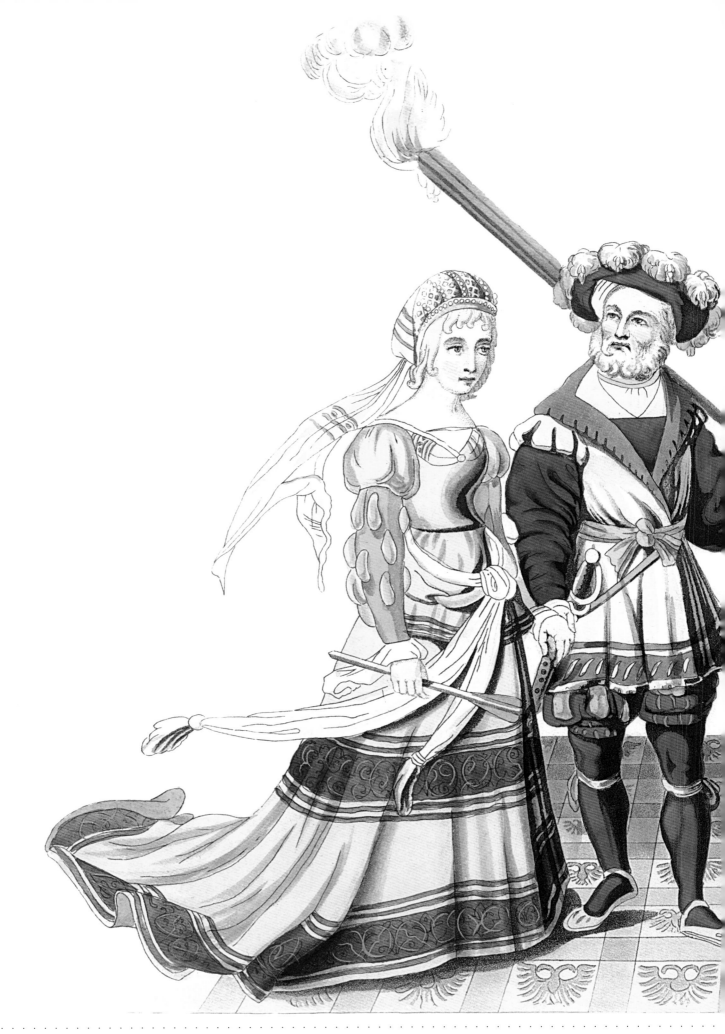

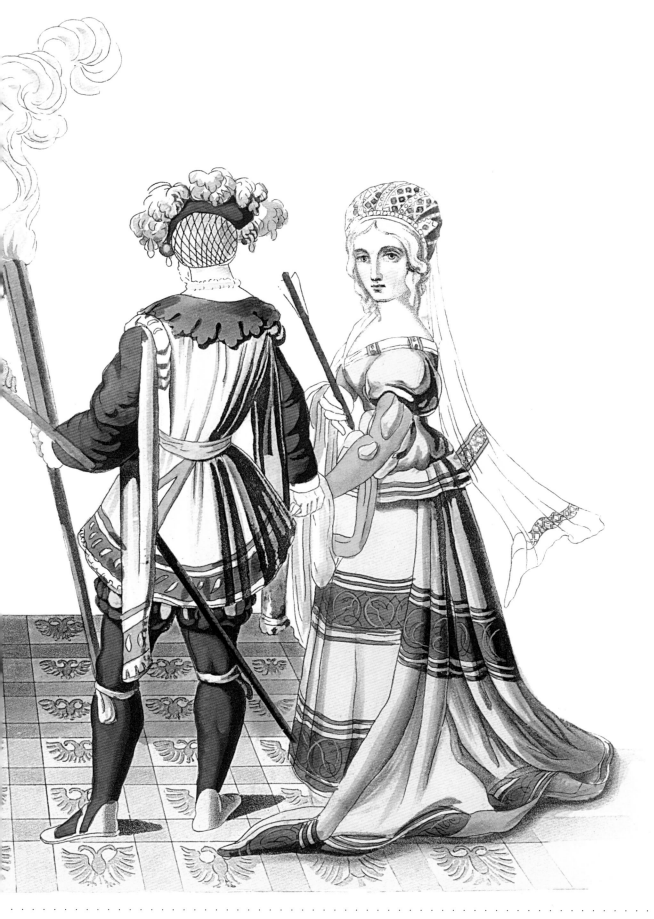

UITE CHARACTERISTIC of the earlier part and middle of the fourteenth century, to which the manuscript from which these figures are taken appears to belong, is the variety of ornament which they exhibit. At this period of our annals, almost every illuminated manuscript, or even each illumination of a manuscript, furnishes us with some new form of lady's headdress, whose colors vary scarcely less than their form. It can be added that this variety of shape and color in the costume of the time afforded a never failing subject of satire to contemporary writers.

The manuscript to which we refer appears to have been written and illuminated toward the south of France, during the reign (1364-1380) of Charles V. It was formerly in the Lamoignon Collection, from which it passed to the library of the Duke of Roxburghe, from whom it was subsequently purchased by the trustees of the British Museum for the sum of 200 pounds during the first decade of the nineteenth century. It is a fine manuscript on vellum, containing a copy of the French text of the *Romance of King Meliadus*. Meliadus, according to the leg-

ends of the Round Table, was the father of the famous Tristan, and his story was extremely popular in the fourteenth century. It was composed in the latter years of the thirteenth century by an Italian named Rusticien de Pisa, and is quite common in manuscript form. King Meliadus, one of Arthur's knights, was one of the *preux chevaliers* of romance. His story is a combined series of combats and hardy adventures, with comparatively little relief. It is truly characterized in the romance itself but differs from that of Tristan in that the latter is a tale of love and chivalry, while all the brave acts of Meliadus originated from no other stimulus than his own attachment to noble actions.

It is thus not at all surprising that the numerous illuminations of this manuscript consist chiefly of battle scenes, varied now and then with tournaments. The latter are always accompanied by numerous figures of ladies, as spectators, and have furnished us with the greater part of the subjects on the facing page. On this page, we see one of these battle scenes, representing a group of warriors carrying off the body of their king, who has been slain. The pictures in this volume are inter-

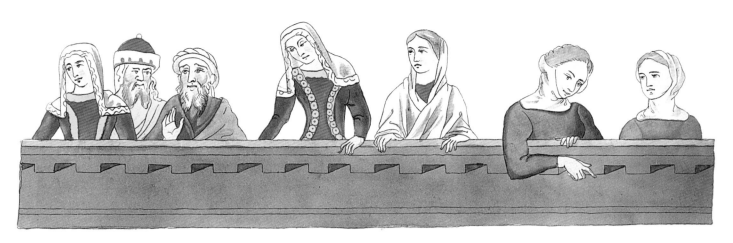

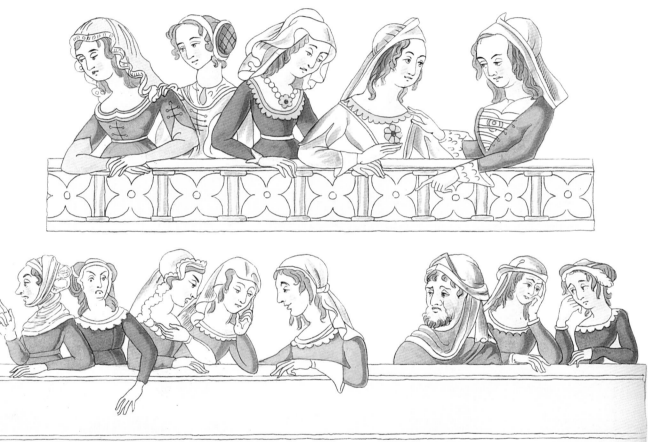

esting to the artist as being in various states of progress, some only half finished, while others are merely sketched in outline. This is not an uncommon occurrence in old illuminated manuscripts. Here and there other subjects of interest are represented, particularly some views of towns, and a curious group of card-players, which is of importance as being the earliest known drawing representing people playing at cards. We know from various authorities that they were in use at this time, as they are mentioned in conjunction with other games about, or soon after, the middle of the fourteenth century; but they cannot be traced, even by allusions in earlier writers, to an earlier period.

The initial letter opposite is from a fourteenth century manuscript in the British Museum. ✻

St. Agnes in Fifteenth Century Costume

GNES HOLDS A HIGH RANK among the saints of the Roman Catholic calendar, not less for her chastity and fortitude than for the extreme youth at which she is said to have embraced the Christian faith, and suffered martyrdom for her attachment to it.

The outline of her story seems to rest upon good authority, but the details of her legend are of very doubtful authenticity. She was a Roman virgin, and was only 13 years of age at the time of her death, in 304 or 305, soon after the beginning of the bloody persecution of Emperor Dioclesian. Her extreme beauty had attracted the attention of one of the persecutors, but after her refusal to countenance his proposals, he denounced her as a Christian. After having been exposed to every type of brutal insult, she was beheaded. Her festival, the anniversary of her martyrdom, is held on the 21st of January, and it was, before the sixteenth century, celebrated as a holiday for women in England.

The figure of this saint seen in the engraving opposite is copied from a painting by Lucas van Leyden, the friend of Albrecht Durer. The original painting forms the central panel of a large triptych, which was formerly in the palace of

Schleissheim, but which was later moved to the Bavarian Royal Gallery in Munich. Lucas van Leyden, one of the most celebrated of the Dutch painters of the beginning of the sixteenth century, and who was famous for the precocity of his genius, died in 1533 at the early age of 39, leaving behind him a great number of paintings and engravings.

The saint is remarkable for the richness of her dress, which, with the hangings behind, reminds us rather of the magnificence and splendor of the Middle Ages. Even the book, by the little we can see of the upper border of the leaves, seems to be intended for an illuminated missal. Her glove, according to the custom of the age of van Leyden, has an opening in the finger to show the richness of the jewel which adorns her ring.

The lamb, which the artist has introduced here, is emblematical of her name. The monks were very partial to these punning explanations of the names of their saints, and the puns were taken from different languages. They observed that the name of this virgin martyr in Latin represented a lamb (*agna*), and that she was "humble and debonair as a lamb."

The small illustration at the left, representing a domestic altar, was furnished by a manuscript that is in the Bodleian Library at Oxford. ❖

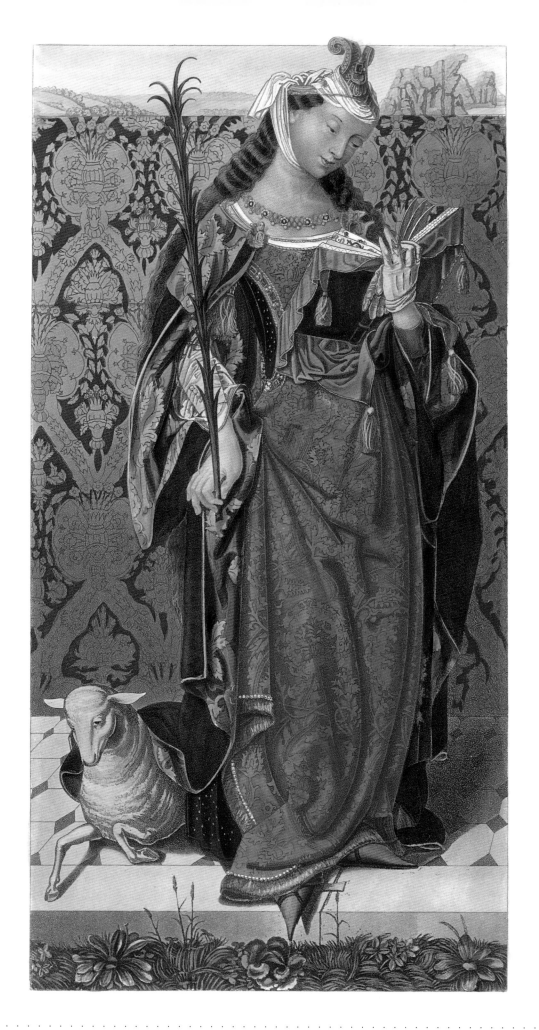

Constancia, Duchess of Lancaster

 MONG THE MOST BEAUTIFUL specimens of illuminated manuscripts preserved in the British Museum is the one which includes the engraving seen opposite. The work is a richly illuminated genealogy relating to the regal house of Portugal, and appears to have been executed by Flemish artists during the reign (1493-1519) of the Holy Roman Emperor Maximilian.

The portrait seen opposite is of Constancia, the Castilian Spanish second wife of John of Gaunt (1340-1399), who was Duke of Lancaster and the fourth son of England's King Edward III. The horned headdress, and other parts of her costume, are hardly that of the period at which it was painted, but were perhaps copied from an older picture. Over the lady's head, in the original, is a scroll, bearing the inscription: *Dunquesta Dona Constanca de Ingraterra*.

The first wife of John of Gaunt had been Blanche Plantagenet, the great heiress of the Duchy of Lancaster, which he inherited through her. After her death, he wed Constancia, who was the elder daughter and co-heiress of Pedro of Castile, in whose right John assumed the title of King of Castile and Leon, although he had never actually visited this kingdom. During the reign (1377-1399) of Richard II, John conceived the idea of possessing himself by force of his distant kingdom, and invaded Spain with a well-equipped army. At Compostella, he was met by King John I (Johann I) of Portugal, to whom he gave his daughter Philippa (by his first wife) in marriage.

From Compostella, John of Gaunt marched into Castile, but he laid aside his idea of conquest and concluded a treaty of peace with the prince who occupied the throne he claimed. By this treaty, the Duke of Lancaster abandoned all his claim to the Spanish crown. He also received a large sum of money, and Henry, Prince of the Auturias, married Lady Catherine, his only daughter by his wife Constancia.

Thus two of the daughters of John of Gaunt became queens, and in 1399 — a few months after his death — his son Henry of Bolingbroke ascended the throne of England as Henry IV.

After the death of Constancia, the Duke of Lancaster made another and lowlier marriage, his third wife being Catherine de Swynford, widow of Sir Otho de Swynford, and daughter of Sir Payn Roet (or Green), king at arms.

After the death of John of Gaunt, his property was seized by King Richard II, which was the catalyst which led to Henry Bolingbroke's deposing him as king and thus establishing the Lancaster dynasty that would remain on the English throne until the end of the fifteenth century.

The initial letter on this page is taken from an illuminated missal that was in the possession of F.A. Beck in the early nineteenth century. ✳

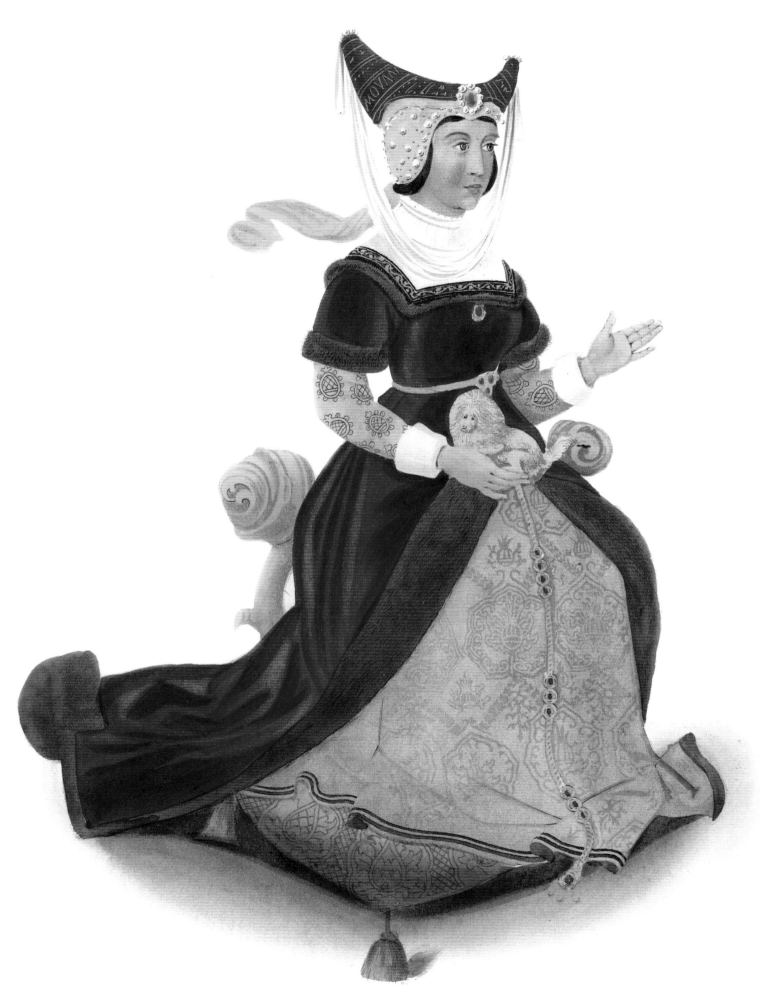

Philippa, Queen of Portugal

N THE OPPOSITE page is seen a portrait of Philippa, daughter of John of Gaunt, the fourth son of England's King Edward III and Blanche Plantagenet, the heiress of the Duchy of Lancaster. This illustration is taken from the same splendid Portuguese manuscript as the portrait on the previous page of Constancia, the second wife of John of Gaunt.

That prince's eldest daughter, Philippa became the Queen of John I (Johann I), King of Portugal, whom she wed in 1387. From then, until her death in 1415, Portugal was in a period of international alliance that was one of the most splendid in that nation's history. This and the next generation would be marked by those great discoveries and conquests that contributed to Portugal's greatness in the eyes of European history. It would seem as though Queen Philippa had transferred into the royal blood of Portugal a portion of the enterprising spirit of her own countrymen.

Philippa bore King Johann eight children, of whom the eldest, Alfonso, died young, and the second (named Edward, in honor of his great-grandfather, King Edward III of England) succeeded to his father's throne. The third son, Peter, Duke of Coimbra, was distinguished by his love of science and travel.

Peter visited many different parts of Africa and Eastern Europe, and even some of the remotest corners of Asia. When, after a long absence, he returned to Portugal, it is said that his countrymen looked upon his reappearance as miraculous, and supposed that he had dropped down from heaven. The fourth son of John and Philippa was the legendary Henry the Navigator (1394-1460), Duke of Visco, who made many discoveries and conquests on the distant coasts of Africa and who was one of the leading figures of the Age of Discovery. The other four children were John, Ferdinand, Blanche, and Isabella, who eventually was married to Philip the Good, the Duke of Burgundy.

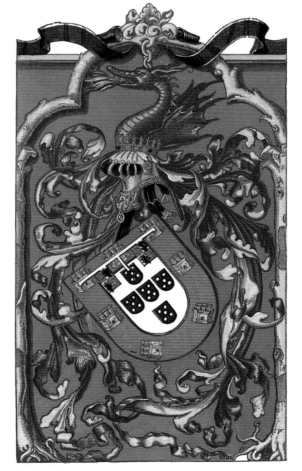

The coat of arms on this page is that of the prince for whom the manuscript which furnished the engraving was originally made. ❋

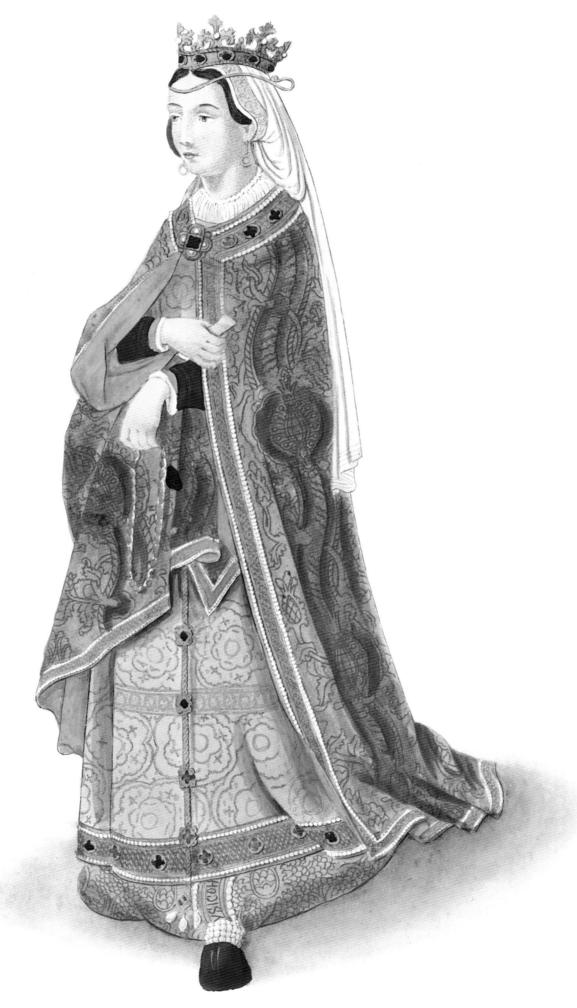

ONTINUING THE SELECTIONS from the series of Portuguese genealogical illuminations given in the two preceding articles, three royal figures of the early sixteenth century are pictured on these pages. Their costumes are good examples of the styles — especially in regard to the headdresses — of that which was worn by the royalty at the beginning of the sixteenth century.

In England, the hats worn at this period by men varied much in shape and character, but we have examples of nearly the same form as that given to King John II of Portugal. The costume of the two queens is much in the style of the beginning of the sixteenth century. Each is seen with their corresponding coats of arms, and Queen Johanna appears to hold a kind of fan in her hand.

John II of Portugal — known as John the Perfect — who reigned from 1481 to 1495, was king at a unique time in Portuguese history. We passed up an opportunity to employ Christopher Columbus, but saw the beginning of Portuguese influence in the Western Hemisphere. He launched Diogo Cam and Bartolomew Diaz on their great voyages of discovery, and was on the throne when Diaz returned from the first voyage by a European around the tip of Africa. It was John II who renamed the Cape of Storms — as Diaz had called it — as the Cape of Good Hope,

an appellation which survives until this day. The equally brave, but less celebrated Cam began service under Alphonso V, but it was under the flag of John the Perfect that the great sailor discovered Africa's Congo River in 1484

Johanna I of Castile, seen at top right on the facing page, was known as "Johanna the Mad" for her eccentricity. In 1506, when she was 27 and he was 28, she married the Flanders-born Philip the Fair, eldest son of Emperor Maximilian I and Mary of Burgundy, in 1506, making him king consort of Castile. He died the same year, but Johanna the Mad lived until 1555, when she died at Tordesillas.

Seen at the bottom of the facing page, the young Leonora of Aragon, the wife of Ercole I — the Duke of Ferrara from 1471 to 1505 — was a legendary beauty. It is said that Pietro Riario, the young Cardinal Archbishop of Florence (rumored to be the son of Sixtus IV) once received Leonora in a pavilion of white and crimson silk, filled with nymphs and centaurs. When she died, there was great mourning. The great Italian poet Ludovico Ariosto (1474-1533) wrote: "This death had given Ferrara a blow which it would not get over for years: Its beneacits benefactress was now its advocate in heaven, since earth was not worthy of her. Truly, the angel of death had not come to her, as with us common mortals, with blood-stained scythe, but fair to behold, and with so kind a face that every fear was allayed." ✻

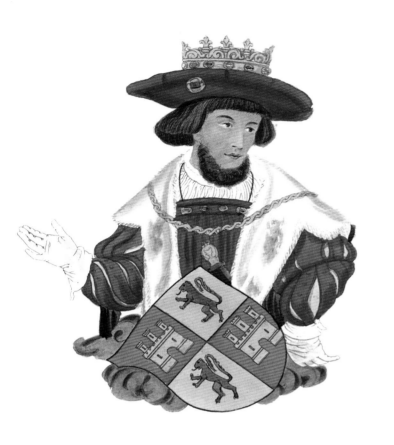

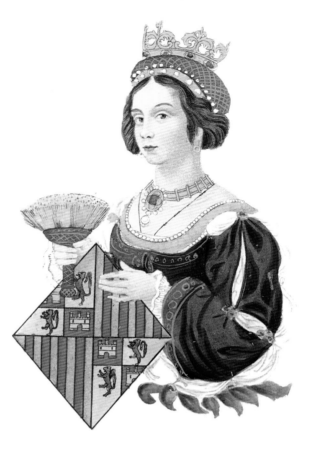

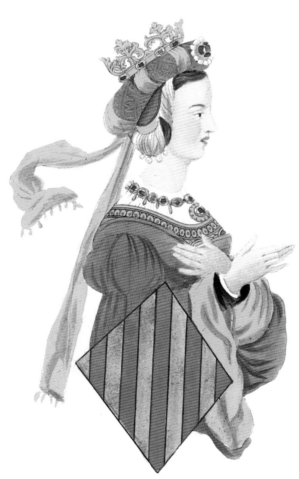

Richard de Beauchamp Engaged in a Tournament

THE ILLUSTRATION on the opposite page is taken from an interesting series of drawings executed in the latter part of the fifteenth century by the celebrated English antiquary John Rouse of Warwick, and preserved in the Cottonian Manuscript, Julius E.IV, in the British Museum. These drawings, executed in a superior style, illustrate the romantic adventures of Richard de Beauchamp, Earl of Warwick.

Richard de Beauchamp was one of the most chivalrous knights of the reigns of Henry IV and V. In his younger days he distinguished himself against the Welsh, and was made a Knight of the Garter after the memorable Battle of Shrewsbury. In 1408, at he age of 27 years, he set out on a journey to the Holy Land. As he was passing through Lombardy on his way, he was met by a herald of Sir Pandulf Malacet, who had heard of his fame. The herald told the Earl of Warwick that Sir Pandulf wished to challenge him to certain feats of arms, and requested a tournament at Verona in the presence of Sir Galaot of Mantua.

Richard de Beauchamp accepted the challenge, and

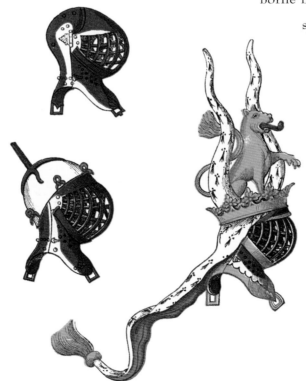

agreed to meet the knight in Verona after he had completed a visit to perform his pilgrimage there. Having done this, he returned to Verona, where he met his challenger.

On a day assigned, Richard de Beauchamp met Sir Pandulf Malacet. First, they commenced to joust with spears. Next they fought fight with axes, then with arming swords, and finally with sharp daggers. The opposite illustration represents the hand-to-hand combat with axes, and gives an accurate idea of the arms and armor of the fifteenth century, and of the mode of using those formidable weapons.

"At the place and day assigned," reads a contemporary account, "Sir Pandulf entered the place, spears borne before him. Then thacte of spears to therle Richard worshipfully finished, after went they together with axes, and if the Lord Galaot had not the sooner cried peace, Sir Pandulf sore wounded on the left shoulder had been utterly slain in the field."

In the porter's lodge at Warwick Castle there is preserved the head and upper part of an axe, which bears so much resemblance to those represented here,

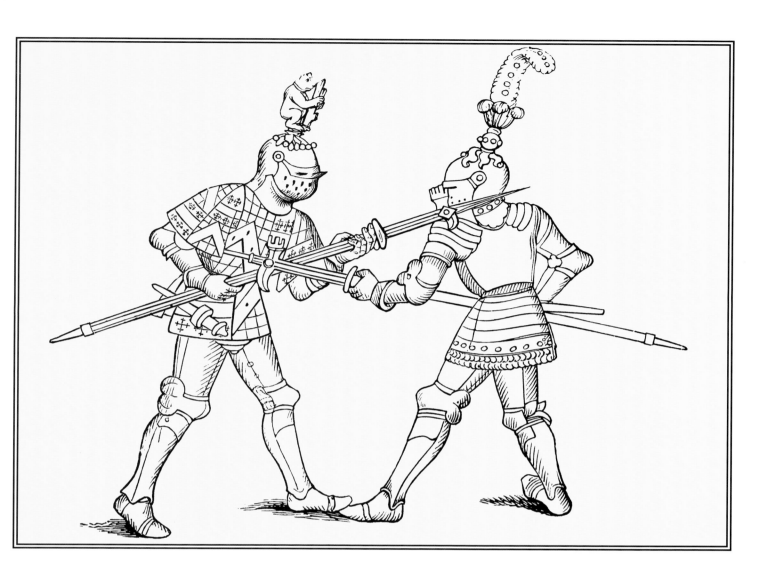

that one might fairly surmise that it had been wielded by Earl Richard at Verona.

Richard de Beauchamp subsequently continued his journey to Jerusalem, where he made his offerings at the Holy Sepulcher. After his return to England, he increased his fame by the valor he displayed in several encounters similar to that related above; and it is said that, when attending the English prelates at the Council of Constance, he slew "a great duke" in a jousting tournament.

He displayed great courage and activity in the French wars of Henry V, who made him governor of the castle of Caen. Later, by his will, he appointed him guardian of his infant son Henry VI, who was born in 1421, the year before the death of Henry V. The younger monarch appointed Richard de Beauchamp lieutenant general of the whole realm of France and the Duchy of Normandy, on the death of the Duke of Bedford.

Earl Richard de Beauchamp died in the enjoyment of that title at the Castle of Rouen, on April 30, 1439. His stately monument still remains in the chapel founded by him on the south side of the collegiate church of St. Mary at Warwick.

The illustration on the opposite page is taken from a splendid "Blaison d'Armoiries," written in French in the year 1629. It shows the manner of placing the mantling on the helmet. ✳

Thomas Pownder, Merchant, and his Wife

THE MONUMENTAL memorial brass represented on the opposite page is a tribute to Thomas Pownder, a merchant and bailiff in Ipswich in England. Located in the Chancel of St. Mary Key, this interesting monument bears, at first sight, the stamp of Flemish workmanship. By comparison with brasses in the churches of Brugge (Bruges), in Belgium, such a close similarity appears in the ornamental details, and the peculiar and flowery character used in the inscription. Such characteristics have been interpreted — as was the fashion in the early nineteenth century — as being implicit of a Middle Eastern influence. Thus the root of the term arabesque. This notion would serve to justify the opinion that this plate was executed in one of the great cities of Flanders, Brabant or the Netherlands, with which the commercial relations of the Middle East afforded very ready communication.

The plate is now detached. It is of unusual weight and thickness, and appears to have been affixed by resin melted into the casement (which was in turn, chiseled out to receive it) on the face of a marble slab, which was observed in 1843 to be lying under the altar table.

Of the individual represented, nothing has been ascertained beyond the bare fact stated in the inscription. The figures of the merchant and his wife are placed, apparently, at the richly decorated entrance of an oratory, or other chamber, closed by a hanging.

A broad fringe just apparent between the figures. From the elegant arabesque work forming a sort of the arch above, are suspended three scutcheons. Also seen are the arms of the Merchants Adventurers' or Hambrough Merchants, incorporated 1296, a bearing of very common occurrence on tombs of merchants in the eastern counties. In the center, in default of any personal bearing, is found the merchant's mark. In this context, it should be pointed out, "Hambrough" is a reference to the English spelling of the great German/Hanseatic trading city of Hamburg, rather than to the English village of Hambrough that is near Kempsford in Gloucestershire.

The merchant wears a loose and wide-sleeved gown, very similar to that worn by Henry VIII, as represented on his return from the Tournament of 1512, in the Tournament Roll in the College of Arms. The close-fitting, but full-sleeved, garment, with puckered bases, worn by the merchant's younger son, occurs frequently in the same roll. The headdresses of the daughters deserve notice; they appear to be a combination of the pendant lappets with the crespine. In the design of this tasteful brass plate, it is remarkable that nothing is found partaking of the style termed "Gothic," with the exception of the quatrefoils at the corners, containing the emblems of the four evangelists. Its character is almost wholly that of the revival of the classical style, as introduced from Italy early in the sixteenth century. ❋

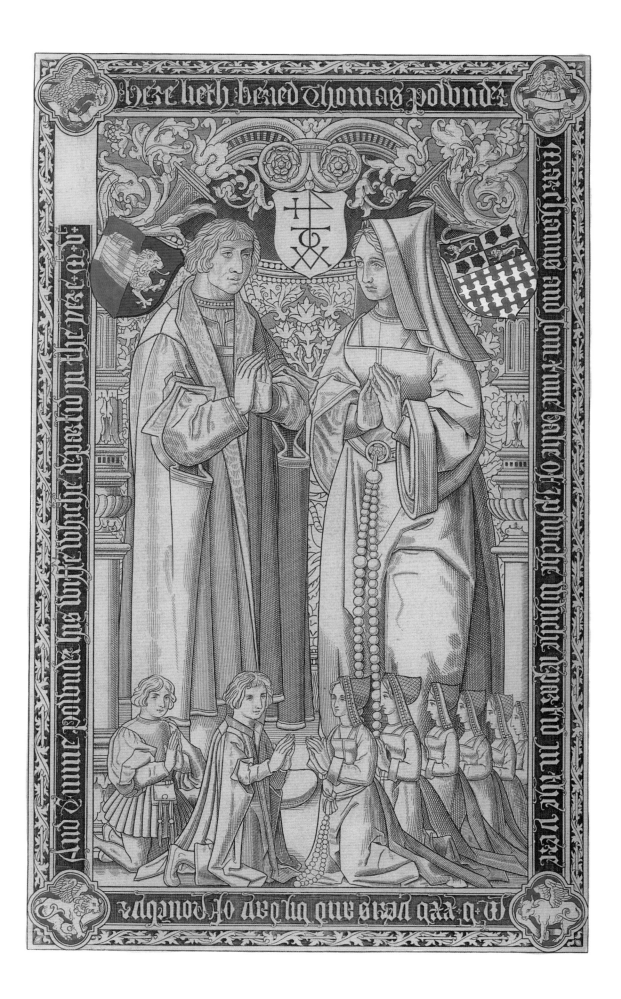

Francis I, King of France

Y HIS CONTEMPORARIES, no less than by the historians of subsequent times, a place among the greater monarchs who have contributed to the civilization of mankind has been accorded to Francis I. As the patron of science and literature, or as the brave warrior (the companion of Bayard, the "preux chevalier"), he commands our respect. The age in which he lived saw the establishment of the Reformation and the Renaissance.

Francis was born in 1494, and, in his youth, showed equal ardor in the pursuit of study and in the practice of martial exercises. At an early age, he frequented the tournaments, which were then so much in fashion, and frequently carried off the prize. He succeeded to the throne of France at age 21, and immediately found himself involved in the Italian War, which had started under his father-in-law, Louis XII. His arms made rapid progress in Italy, and his valor in the obstinate Battle of Marignan covered him with glory. The magnificence exhibited at his celebrated conversation with England's Henry VIII in the camp of the Cloth of Gold, forms one of the brilliant episodes of English history. In 1521, he became involved in the fatal war with Charles V, which ended in his defeat and capture at the Battle of Pavia. After a long and cruel captivity, he regained his throne, and subsequently turned his thoughts almost entirely to the cultivation of the arts and elegancies of peace,

although he was, in his latter years, again involved in war with Charles V. Francis died, after a reign of 32 years, on the last day of March 1547.

Few monarchs have been so distinguished by their avidity for knowledge and instruction as Francis. He spent an immense sum of money collecting manuscripts from Italy and Greece, and was in frequent correspondence with the most learned men of his age. It was he who first introduced into France a taste for the study of natural history, which has since been followed with so much success among his countrymen. He was the founder of the College Royal, and contributed in many other ways to the extension of sound instruction among his countrymen. He showed his taste for poetry and literature of a lighter and more festive character by patronizing such men as Rabelais. Marguerite, Queen of Navarre, was his sister. Francis bought, at high prices, foreign paintings to enrich his palaces, and at the same time used his utmost endeavors to encourage native art. Benvenuto Cellini was employed at his court, and he was the last patron of Leonardo da Vinci. Francis I began the Louvre, and he also built Fontainebleau and other noble palaces. Yet in spite of all his genius and liberality, it was in his reign that the cruel persecutions of the Protestants began, which were continued with so much barbarity under his immediate successors.

The initial letter at the beginning of this article is taken from a beautifully illuminated missal. �֍

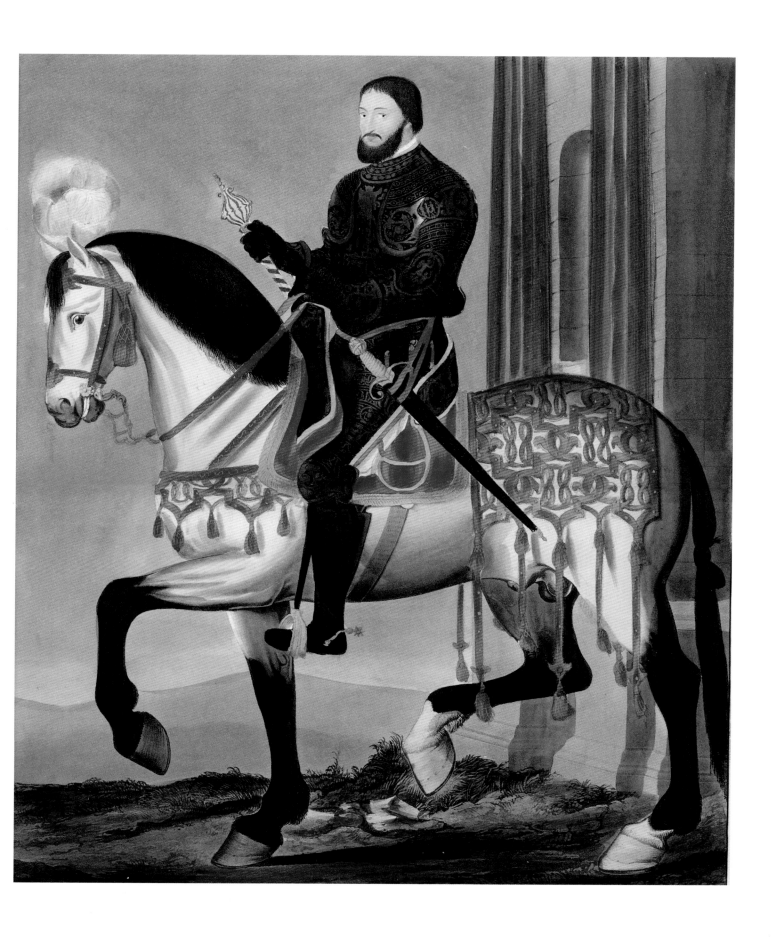

Henry Howard, Earl of Surrey

UAINTNESS OF expression was the peculiar characteristic of the poetry of the early sixteenth century. The change which subsequently took place, and which was perfected in Spenser and Shakespeare, had its origin with Surrey and Wyat. Amid the heap of doggerel verses composed during the reign of Henry VIII, we are surprised at the delicacy and beauty of the productions of these two poets. It was the second, and permanent, importation of the influence of Italian taste.

Henry Howard was born in 1517, and was given his title by courtesy in 1524 on the passing away of his grandfather, Thomas, Earl of Surrey. Henry Howard was one of the first of England's *noble* poets, and, with Sir Thomas Wyat, one of her first two sonneteers. In his youth he distinguished himself by his talents and accomplishments, both literary and military; but he was proud and headstrong, and his imprudence not infrequently brought him into disgrace. It was the fashion of this age for the young nobles to despise the wealthy merchants of London, and both Surrey and Wyat were imprisoned for having walked about the streets at night in a "lewd and unseemly manner," breaking citizens' windows with stones thrown from a bow. In prison, Surrey penned a satire on the vices which he, at least, attributed to them, and he pretended that he broke their windows in order to warn them of their sins:

In secret silence of the night
This made me, with a reckless breast,
To wake thy sluggards with my bow:
A figure of the Lord's behest;
Whose scourge for sin the scriptures show.
That as the fearful thunder's clap
By sudden flame at hand we know;
Of pebble stones the soundless rap,
The dreadful plague might make thee see
Of God's wrath that does thee enwrap.

After his release, he served with the army in France, and was made Marshal of the Army. In 1545 he was appointed Commander of Boulogne. Here he distinguished himself by his vigor and courage, but he was defeated. Having lost the king's favor, he was recalled and superseded. After his return to England, he irritated his enemies by his expressions of discontent. Early in 1547, Henry VIII decided to eliminate the Howards, and he had Surrey and his father imprisoned in the Tower of London for high treason. The chief article of accusation was a pretended assumption of the royal arms. Both father and son were condemned to lose their heads. Surrey was executed on January 21, and the life of the duke was saved only by the death of the king. The Earl of Surrey was only 30 years of age. Our portrait of this talented nobleman is taken from a fine painting by Holbein, preserved in the palace of Hampton Court. ❋

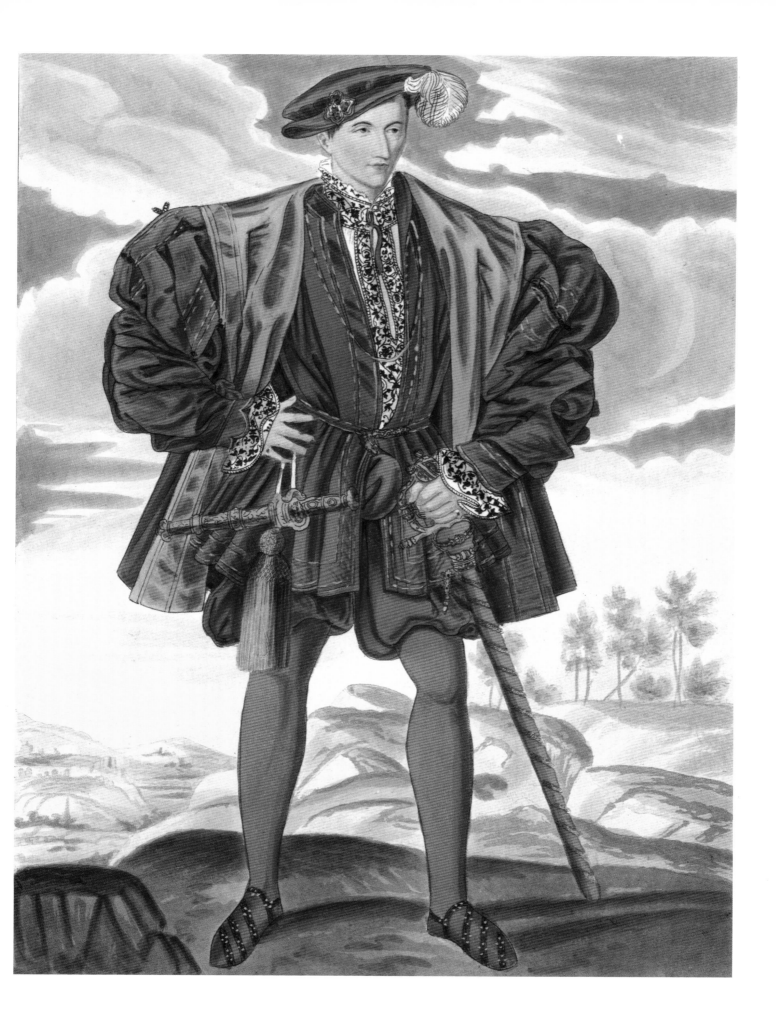

Tharlton, a Clown in the Time of Elizabeth I of England

HE PICTURE HERE set down within this letter T.,
Aright both show the form and
shape of Tharlton unto thee.
When he in pleasant wise the counterfeit expressed
Of clown, with cote of russet hew, and stirrups with the rest.
Who merry many made, when he appeard in sight;
The grave and wise, as well as rude, at him did take delight.
The party now is gone, and closely clad in clay;
Of all the jesters in the land he bore the praise away.
Now hath he plaid his part; and sure he is of this,
If he in Christ did die, to live with him in lasting bliss.

Such are the lines which, in the manuscript from which we have taken it, accompany our initial letter. There is every reason for believing that it is an accurate portrait of this mysterious actor. We know from contemporary sources that Tharlton was remarkable for his flat nose and the "squint of his eyes," which are exhibited in the picture.

The part which Tharlton acted with most success on the stage, was that of the clown, and he excelled especially in the "jig," a sort of humorous performance consisting of singing and recitation, accompanied by the sound of the pipe and tabor.

A work published soon after his death describes him when on the stage in nearly the same words as the verses given above, and in the costume represented in his picture "in russet, with a buttoned cap on his head, a great bag by his side, and a strong bat in his hand, artificially attired for a clown."

Payne Collier, in his *Bibliographical Catalogue of the Library at Bridgewater House*, has shown from "a scene in the old play of 'The Three Lords and The Three Ladies of London,' (1590,) that an engraving of Tharlton, doubtless on wood, was then current, and what is given above is very possibly, if not probably, a copy of the old print."

We are able to confirm Mr. Collier's conjecture; for we have seen in the Ashmolean Museum at Oxford, an old woodcut of Tharlton, closely resembling the above, printed with a blackletter ballad. The volume from which our drawing is taken consists of an alphabet of ornamental letters, drawn in the latter years of the sixteenth century, probably very soon after Tharlton's death in the year 1588, a little more than a month after the defeat of the Spanish Armada by the navy of Elizabeth I.

Many of these letters are remarkably bold and fantastic, but in general they are not accompanied with drawings, like this of Tharlton, or with verses. The presence of these adjuncts in the case of the letter T show the great reputation of Tharlton's name at the period when the manuscript was executed, and this is confirmed by the numerous allusions to him in popular publications for some years later.

Tharlton was known as a writer of ballads, as well as an actor, and his ballads were probably composed

before he eventually became famous on the stage.

Tharlton was, although in a low station, one of the remarkable persons of the reign of Elizabeth I. Indeed, it was in this era that the the English stage took its rise. William Shakespeare composed most of his greatest works during her reign, thus changing the history of drama irrevocably and forever.

As for Tharlton, when he died, the great bard was only just beginning his career in London. It is possible, indeed probable, that they knew one another, for they would have moved in the same circles. It is a pity though, that Tharlton never had a chance to act in one of the great Shakespeare comedies that came later.

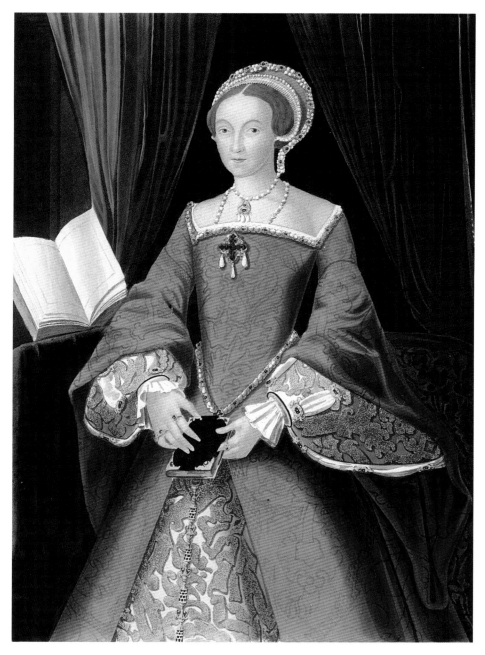

The picture above is taken from a portrait of Princess Elizabeth at age 12 by Hans Holbein. It was done in 1545, the year in which James V of Scotland died broken-hearted because of his defeat by the English at Solway Moss, thus leaving his infant daughter Mary — Elizabeth's future rival — as an orphan.

It was, in many other respects, a critical period, for this year may be considered the one in which the Reformation in England was finally determined. At the accession of her sister Mary to the throne of England, Elizabeth had reached her 20th year. During the greater part of Mary's reign she was virtually a prisoner, and only obtained her freedom with her crown. There can, indeed, be little doubt that her life was in danger during this period.

A youth filled with troubles and perils perhaps contributed a great deal toward forming that powerful greatness of character which would later distinguish the remarkable Elizabeth I. �֎

A Sixteenth Century Room at Schleissheim

IKE MANY OF THE ARTISTS who were his contemporaries, John Schoreel was distinguished chiefly by his paintings of pious or religious subjects. He took his name from a village near Alkmaar, where he was born in 1493, and lived a roving life full of adventures. He travelled over a great part of Europe, and even to Jerusalem, to find opportunities of perfecting himself in his art. He died in 1560, leaving behind him a great number of paintings. Many of them, unfortunately, were destroyed in the unrest which desolated the Low Countries during the sixteenth century. Schoreel justly claims a place among the first of the early Dutch painters.

The engraving on the opposite page is a detail from a fine picture by Schoreel that represents the death of the Virgin. It was formerly in the collection at the King of Bavaria's palace at Schleissheim, but later moved to the Alt Pinakothek in Munich. The detail here is intended to give an idea of the interior of a room at the beginning of the sixteenth century, and of some of the principal religious utensils then in use. The brush leaning against the wall was used for sprinkling holy water, and was called an *aspersorium*, or sprinkler. The bishop would use this utensil in the consecration of a church. In the opposite picture, the little vase near the *aspersorium* is the holy water vat, a name which sufficiently explains its use. The book lying open on the table is a Psalter. The long, hanging cover of this book, called a *forrel* (*forrellum*), was generally made of leather, and not only served to protect the book from injury, but when it was closed, people might carry it by the ball at the end. The string of beads is a rosary. Over the cupboard, and hanging behind the candlesticks, stands a folding altar table, represented here as shut, but which, if unfolded, would offer three compartments, each with a picture. The ornaments above the recess in the corner, as well as other details in parts of the original painting not introduced here, are in Renaissance style. The round glazing of the windows is also worthy of notice, and at this day is not infrequently found in houses in some of the older towns in the Netherlands and Germany.

The small illustration represents a very elegant design for a saltcellar, engraved in 1645 by Wenceslaus Hollar (1607-1677) after a drawing by Hans Holbein (1497-1543). Holbein, as is well known, was long the favorite painter at the court of Henry VIII, and his paintings grace many of our native collections. Besides painting portraits of many members of the English nobility and a variety of other subjects then in fashion, he appears, like his contemporary, Albrecht Durer, to have furnished designs for ornamental plate and furniture. ✳

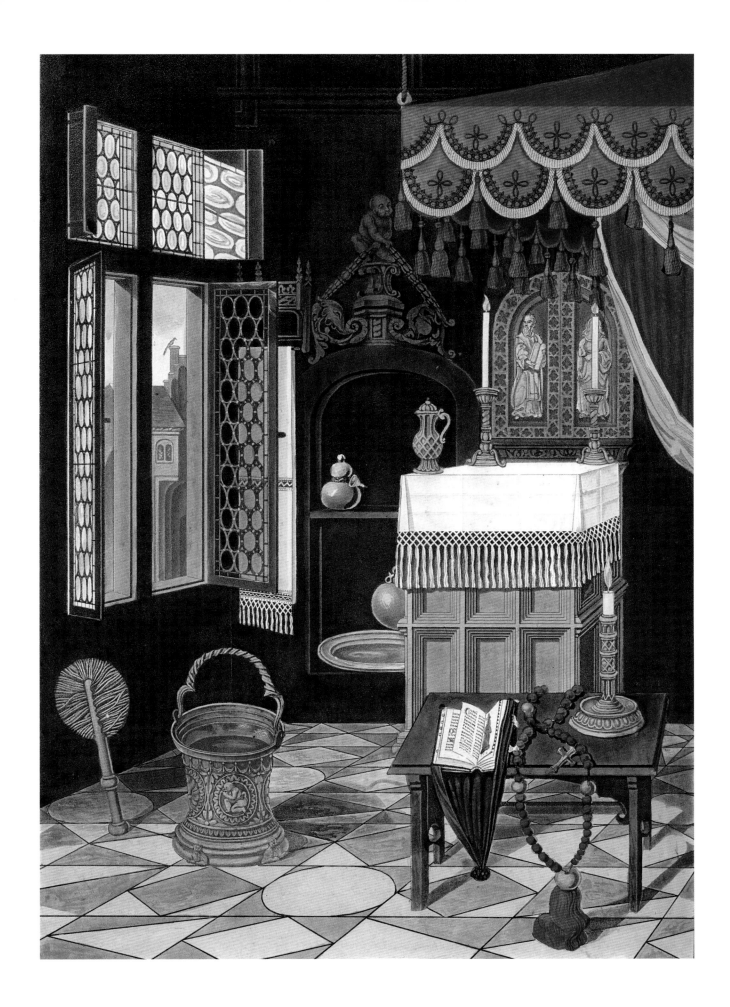

Fifteenth Century Glaive, Catch-Pole, Sword and Dagger

DURING THE LATTER HALF of the fifteenth century and the first half of the sixteenth, the elegance which entered into every branch of art was especially conspicuous in the arms and armor of princes. The opposite illustration represents the ornamental parts of a superb dagger and of a sword, both designed by Hans Holbein in the earlier part of the sixteenth century.

The illustration at right is of a *glaive* preserved in the Tower of London. The *glaive* was a weapon of common use during the Middle Ages, and is mentioned by contemporary historians in describing the wars in Europe at different periods. The origin of the word was the old French word for this instrument, *glaives*, or *gleves*, which again was itself formed from the purer Latin *gladius*. Factories for the production of these weapons were established in Wales, and we often read of "*Welsh glaives*." The glaive consisted of a long cutting blade, placed at the end of a staff. Shown here are the upper and lower parts of the staff. The former, which is engraved with figured ornaments, is 28.5 inches in length. The staff is covered with crimson velvet, with silk tassels, and studded with brass headed nails. A passage in the fourteenth century story of Guy of Warwick describes the efficiency of these weapons in battle, as the warriors gave each other such blows with glaives that "their shields were not worth a glove to them."

The use of the catch-pole was used to take horsemen in battle by the neck and drag them from their horses. The upper part of the instrument is peculiarly well designed for this purpose. The two bars in the middle form springs, which are strengthened by the moveable side-bolts. The person who held the staff pushed the instrument straight forward against the man's neck. It opened until the neck had passed into the aperture, and then closed again. The catch-pole man could easily pull the rider, thus caught, to the ground. If much resistance was made, he had only to give the weapon a twist, and the curved spike under the staff would render him *hors de combat*. The staff of the catch-pole is between seven and eight feet long, and is, like that of the glaive, covered with bright crimson velvet and studded with brass nails. ✳

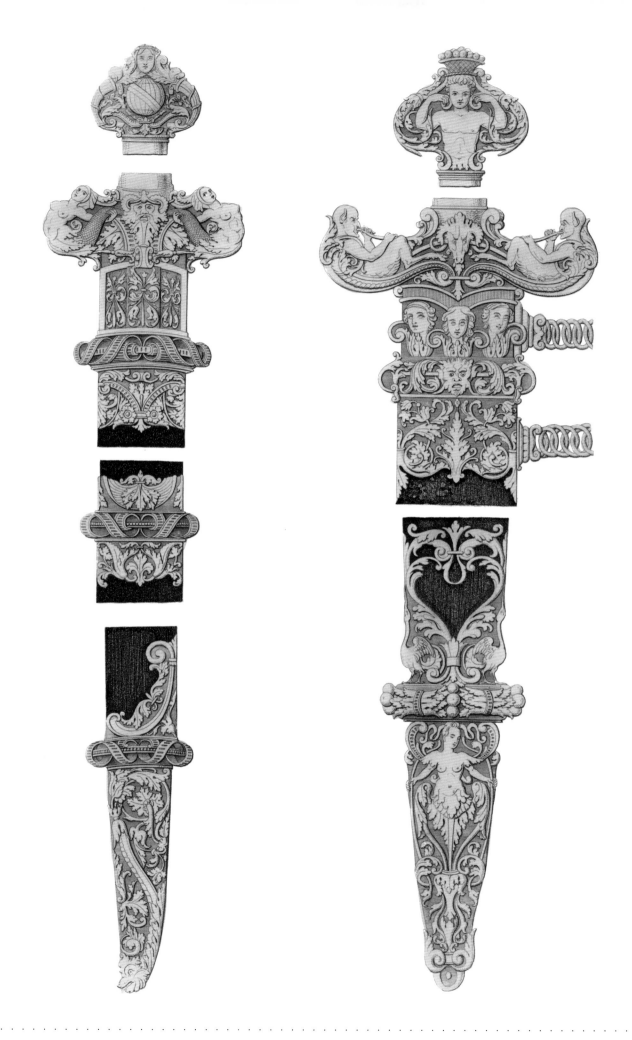

MONG THE NUMEROUS rich specimens of ancient *bijouterie* which have been preserved from the ravages of time, we know of few more elegant than the clasp represented on the opposite page. It was made for the celebrated Holy Roman Emperor Charles V, who ruled from 1519 to 1556, when he abdicated two years before his death. The son of Philip of Austria and Johanna of Spain, he became King of Spain, Naples, Sicily and the Netherlands two years before being crowned emperor.

His clasp is ornamented with the Austrian eagle and a mass of precious stones. The breast of the eagle is covered with rubies, the wings are ornamented with rubies, and pearls hang from the tail, beak, and legs. The head is covered with a pearl, and the neck and thighs with small rubies. The eagle, which is placed on a gilt and ornamented ground, is enclosed within a lozenge formed of a line of sapphires, pearls, amethysts, and emeralds. The outer border of the clasp is adorned with tiny reliquaries containing small relics of saints. These are decorated in white, red, and green enamel. Trimmed in pink ribbon, they also bear the names of the saints: Martini, Andreae, Margaritae, Nicolai, Sancti Petri, Ypoliti, Constanti and Laurentii.

The illustration on this page is taken from an early folio edition of the comic poet Terence, printed at Strasbourg in 1496 by John Gruninger. This image is boldly engraved on a block which is the full size of the folio page.

At the foot is printed the word "Theatrum." It is intended to exhibit the stage of a theater, but it is not known whether it is a fanciful design for an ancient Roman theater or a representation of a theater which existed at the time it was engraved.

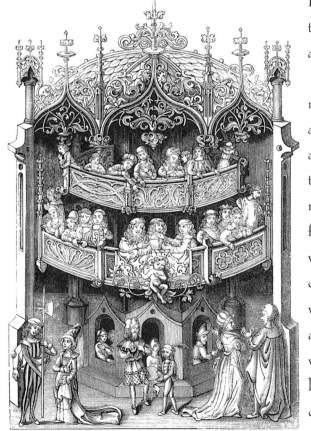

In the Western and northern parts of Europe, theatrical exhibitions were still of a very primitive character, and they included mysteries and miracle plays, which were performed in the open air on wooden scaffolds, or in the churches and monasteries as well as pageants, for which also the place of performance was built only for the occasion like a nineteenth century country fair. ✳

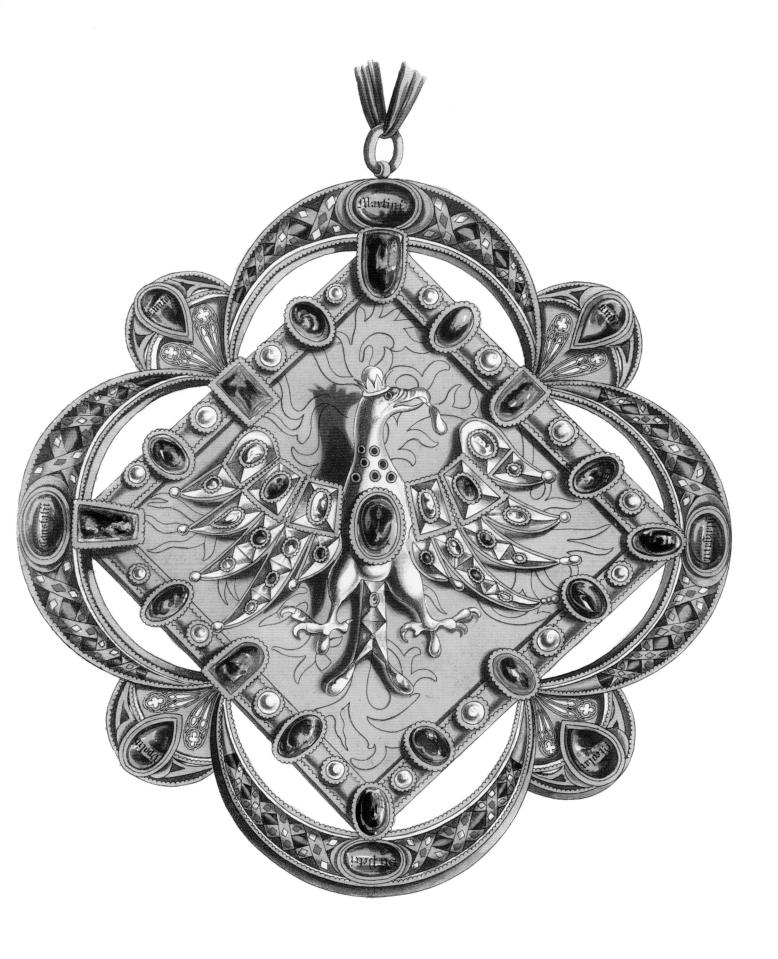

A Sixteenth Century Funeral Pall

CERTAIN OF THE merchant companies of the city of London still possess rich monuments of the arts of former days. The accompanying plate represents a superb pall, which remains still in the possession of the Sadlers' Company, which appears to have been made about the beginning of the sixteenth century. It is made of a rich, crimson velvet, the head, foot, and sides being embroidered with the arms of the company, between which are the figures of four angels, surrounding the letters IHS.

A broad gold and crimson fringe hangs from it. On one side of the pall is embroidered in raised work of gold thread the words *"In te, Domine, Speramuo."* Perhaps this last word was intended for *Speramus*. On the other side, in a similar style of embroidery, is the inscription *"Ne me confined in eternitum."*

It appears that it was formerly a custom with the city companies to lend not only their halls and chapels, but even their regalia and other articles, for the celebration of public ceremonies. In the curious article "On City Funerals," by Thomas Adderly in *The Gentleman's Magazine* for January 1813, many examples are quoted to show that the city livery halls were commonly let out for funerals up to the nineteenth century. The pall here represented was perhaps lent for such purposes on many occasions.

The subject of funerals naturally leads to that of epitaphs, and the writer of the article in *The Gen-tleman's Magazine* has there preserved one on a humble individual, which, besides its quaintness, is so curiously connected with a locality interesting to every reader of Shakespeare, that we shall perhaps not be blamed for reproducing it here:

"Here lies the body of Robert Preston, late Drawer of the Boar's Head Tavern in Great East-Cheap, who departed this life on March 16, 1730 aged 27 years.

Bacchus, to give the toping world surprise,
Produced one sober son, and here he lies;
Though nursed among full hogsheads, he defy'd
The charms of Wine, and ev'ry vice deny'd.
O Reader! if to justice thou art inclin'd,
Keep honest Preston daily in thy mind.
He drew good Wine, took care to fill his pots;
Had sundry virtues that outweigh'd his faults.
You that on Bacchus have the like dependence,
Pray copy Bob in measure and attendance."

The Sadlers' Company is the oldest of all the city livery companies, having originated out of the ancient *Gilda Sellariorum*, which is believed to have existed in London in the remote ages of Anglo-Saxon history. Most of the other companies are known to also have possessed ornamental funeral palls in former times. In 1652, the merchant tailors had no less than three palls. In the year 1572, John Cawood, the well-known printer, left to the Stationers' Company a pall

which is described in his will as "a
horse cloth, of cloth of gold, pow-
dered with blew velvet, and bordered
abought with black velvet, embroi-
dered and stained with blew, yellow,
red and green."

The Company of Fishmongers
still possesses a very superb pall,
resembling in general form that of
the Sadlers' Company, and, like it,
is supposed to be from the reign of
Henry VII or of that of Henry VIII.
This pall, of which the ornaments
are exceedingly elaborate, is a fine
specimen of ancient art. The pall
has, in the middle, a richly worked
picture of St. Peter, which is sur-
rounded by numerous other figures.
The whole is bordered with a broad
fringe of gold and purple thread.

The initial letter has been fur-
nished by a printed book from the
end of the fifteenth century. In the
earlier ages of printing and publish-
ing with movable type, it was cus-
tomary to leave a square space for
the initial letters, which were later inserted, according
to the will of the possessor of the book, by the same
illuminators who ornamented the manuscripts. ✻

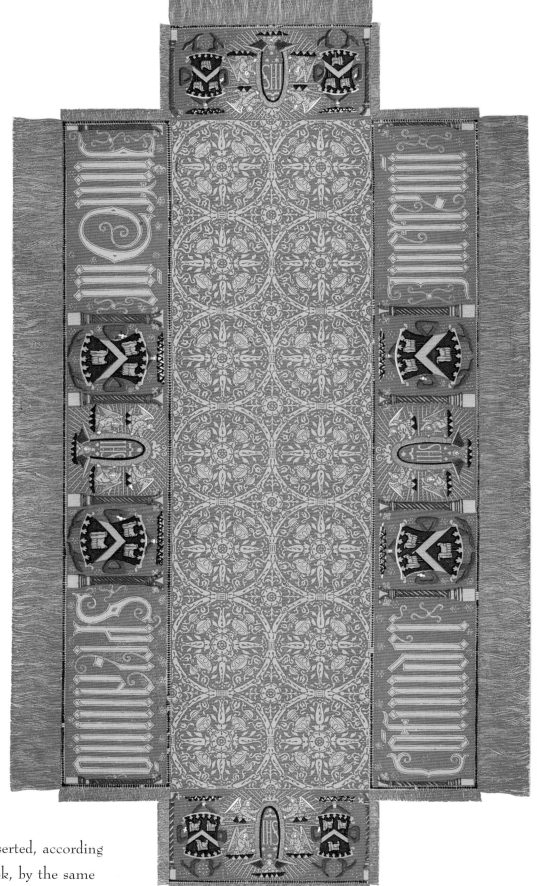

A Clock Presented by Henry VIII to Anne Boleyn

OME NINETEENTH century writers erroneously stated that house clocks were "of late invention." That they were in use several centuries before is shown by the number of allusions to them found in the works of earlier writers. Sir Samuel Ayrick, in his well-researched and instructive introduction to *The Specimens of Ancient Furniture*, has shown that they were in use in Italy in the thirteenth century, when they are mentioned by Dante.

The *Romance of the Rose*, composed at the beginning of the fourteenth century, mentions house clocks as then well known in France, and describes them as being made "with wheels very subtly contrived with a continuous movement."

The Dutch were celebrated as especially skillful clockmakers during the fourteenth century, and clocks like the one in the large illustration are even now called Dutch clocks.

The English name *clock* is supposed to be derived from the French *cloche*, a bell. Several clocks of the same period are still preserved in England.

The medieval word for all kinds of clocks was the French term *horloge*, but as early as the reign (1377-1399) of Richard II, Geoffrey Chaucer seems to apply the name "clock" to small house clocks, to distinguish them from the larger clocks or horloges of the abbeys and churches. He writes of a cock: "Full

sikerer was his crowing in his loge, As is a clock or any abbey horloge."

These early clocks went by weights, without pendulums. The pendulum clocks were invented toward the middle of the seventeenth century.

The clock represented in the opposite engraving is interesting, both for its singularity and for its connection with English history. It was presented by King Henry VIII to his second wife, the accomplished Anne Boleyn, on the occasion of their marriage in 1533. Three years later, the king had her beheaded, but for reasons not having to do with the clock. We know nothing further of its history, until it was given to Horace Walpole by Lady Elizabeth Germaine, and was among the curiosities of his villa at Strawberry Hill until sold, at the rent sale of his collection, to the Keeper of the National Gallery.

This clock is made of silver gilt, richly chased and engraved. It is ornamented with fleurs-de-lys, miniature heads, etc. On the top sits a lion, bearing the arms of England, which are also on the sides. On the weights are the initial letters of Henry and Anne — ironically with true-lovers' knots. On the band above is the royal motto, and on the one below, the equally ironic "The most happy."

The initial letter on this page is from a collection of sixteenth century drawings and illuminations in the possession of William Howard of Hartley House in Devon. ❉

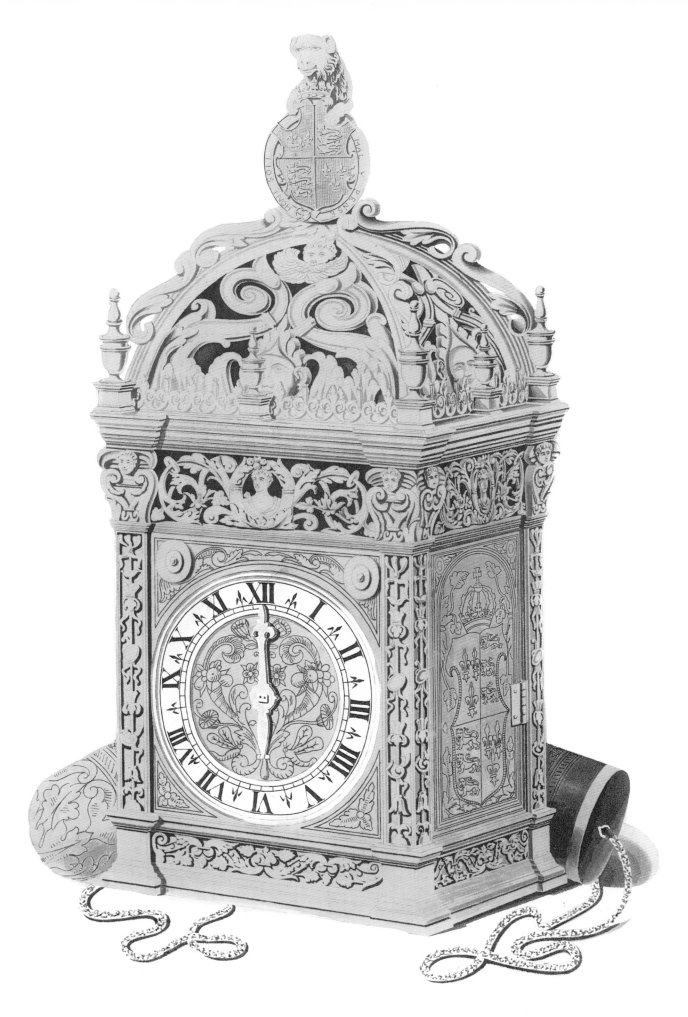

A Cup Designed by Benvenuto Cellini

THE BEAUTIFUL CUP represented in the accompanying large illustration was purchased by the firm of Rundell & Bridge, at the sale of the effects of Wanstead House in 1822, and sold by them to King George IV. It is now preserved in the Gold Plate Room at Windsor Castle. The bowl is formed of a nautilus shell, mounted on a stand of silver gilt, with a cover of the same material, the silver being left in its natural color to represent the flesh of the figures, and the rows of beads in various parts of the cup and the lid. The height of the whole is one foot, eight inches.

John G. Bridge of Rundell & Bridge, to whom we are indebted for the account of this cup, stated that it was frequently seen by the late John Flaxman of the Royal Academy, who expressed his opinion that it was a work of the great Italian Renaissance master, Benvenuto Cellini (1500-1571). If so, it was probably executed at the time when that artist was in France working for the court of Francis I, who reigned from 1515 to 1547. This supposition is strengthened by the presence of the figure of Jupiter bearing a close resemblance to the profile of that monarch.

According to *The Biographie Universelle*, a silver cup, beautifully

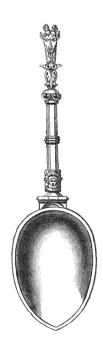

chiselled by the same artist, was bought in 1774 by an English collector traveling in Italy.

Born in Florence, Cellini was famous as a sculptor, and wrote a treatise on sculpture and the art of goldsmithery published in 1568. He apprenticed at ateliers in Florence, Siena, and Pisa before moving to Rome in 1519. In 1540, he travelled to France, where he would work for the court of Francis I and create many memorable works in bronze as well as in gold and enamel. He returned to Florence in 1545.

The two spoons represented on this page are preserved in the collection of M. Sauvasgeot in Paris, and are both from the sixteenth century. The larger one, made of silver gilt, and probably intended to be carried in a small case or in the pocket, consists of three parts which join together and which may be made to serve three different purposes. The handle of the spoon is a fork, the prongs of which fit into the back of the bowl. The end of the fork unscrews, and, when taken off, presents a toothpick.

The handle has a joint just above the point where the bifurcation of the fork commences, and by which, on removing a ring which covers it, the whole may be folded up so as to occupy the least possible room. ✽

A Cup Presented to Charles I, King of England

VARIOUS CIRCUMSTANCES connected with this handsome cup combine to make it of interest to the mind of the historian as well as to that of the lover of art. It is said to have belonged once to the merriest of English monarchs, Charles II, who reigned 1660 to 1685, following the restoration of the Stuart monarchy. The cup itself is entirely made of silver gilt, except the filigree work, which is left in plain silver. It is 22.5 inches tall overall.

The cup was presented by him to a master of Queen's College, Oxford, who had rendered important services to his unfortunate father, Charles I, amid the troubles of civil contention which signalized his reign, and which led to Charles I being deposed by the English Parliament and executed in 1649.

The cup remained in the possession of the House of Stuart until their altered circumstances induced one of Charles' descendants to part with it in the early nineteenth century. It was purchased privately by the firm of Rundell & Bridge, who sold it

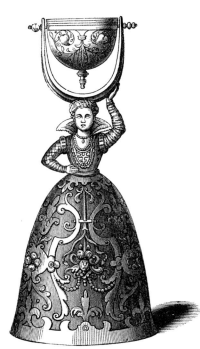

to King George IV of the House of Hanover, who reigned from 1820 to 1830. It was subsequently placed in the collection of gold and silver wares that is held at Windsor Castle.

The top illustration on this page represents a portion of the rim of a very elegant dish of an enameled pottery, which was invented by the celebrated Bernard Palissy, in the eighteenth century, now preserved in the Du Sommerard Collection in Paris. It was made early in the seventeenth century and contains, in the center, a picture representing Henri IV of France and his family.

The bottom illustration is a bell-like silver "puzzle cup" preserved in a collection of antiquities in Paris. The idea of the cup was that wine should be drunk from both vessels without spilling either. This was done by reversing the figure, filling both when upright and drinking from the larger cup first. The smaller cup would be suspended horizontally from the arch on which it swings. The wine from it could then be taken by bending down the figure to this position seen here. ✻

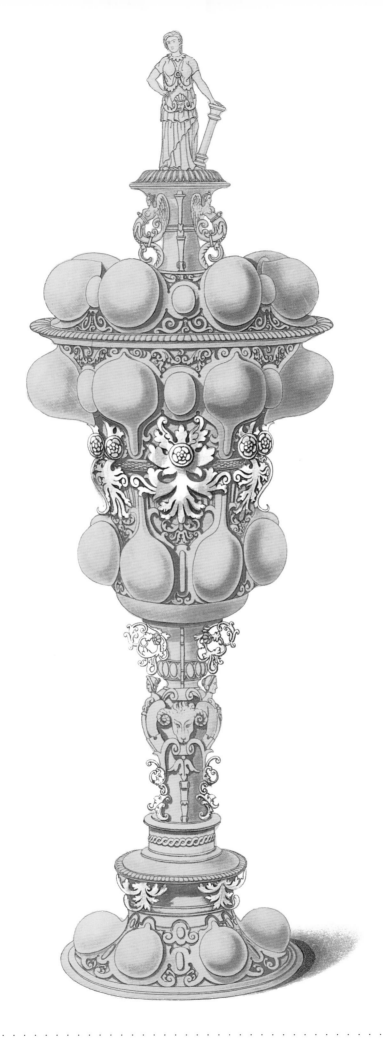

A Cup Belonging to the Company of the Goldsmiths

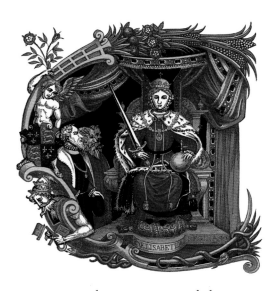

IRCUMSTANCES of some interest are connected with the traditional history of the handsome cup represented on the facing page. In the 1840s it was in the possession of the Company of the Goldsmiths, one of the most ancient and wealthy of the city companies in London. The cup is said to have been presented by Queen Elizabeth I to Sir Martin Bowes, a member of this company and lord-mayor of London in 1558, the year of her accession to the throne. As such, it was probably one of the first presents that she gave as Queen of England.

Sir Martin Bowes was one of the most distinguished men to have been a member of the Company of the Goldsmiths. He was also remembered as a great benefactor to its charities. Bowes flourished during the reign (1509-1547) of Henry VIII and the reign (1547-1553) of Edward VI. He served as lord mayor six times, specifically in the years 1546, 1547, 1553, 1554, 1555, and 1558. It was, of course, in the latter year that Elizabeth became queen.

Bowes died in 1566, and was buried in the church of St. Mary Woolnoth in London, where he had founded a lecture. Sir Martin resided "against" Abchurch Lane, in that parish, which is remembered as being the part of London where the goldsmiths traditionally had their shops.

As we could logically surmise, and which is confirmed in Herbert's *History of the City Companies*, the Company of Goldsmiths was very rich in gold ware, which was then referred to as "plate." This was especially true prior to and during Bowes' life, but in 1667, a considerable portion of it was sold, being considered superfluous. The cup of Sir Martin Bowes, however, escaped this fate.

This cup is of silver gilt, studded with crystals, and it measures 19.5 inches high, with its greatest diameter being 7.6 inches. The figure on the cover holds a shield bearing the coat of arms of Sir Martin Bowes. The arms include an ermine, three longbows erect in fess gules, and a swan between two leopards' faces. His crest was a demi-lion rampant gardant or holding a sheaf of arrows.

The initial letter on this page is taken from a fine woodcut used by John Daye, the printer, first in the original edition of *Foxe's Book of Martyrs*, which he printed in 1563, and later in an edition of John Dee's *General and Rare Memorials, Pertaining to the Perfect Art of Navigation*, published in 1577. It represents Queen Elizabeth, sitting in state, and attended probably by three members of her privy council. They were, without doubt, intended to be portraits, but it is not now easy to identify them. ❋

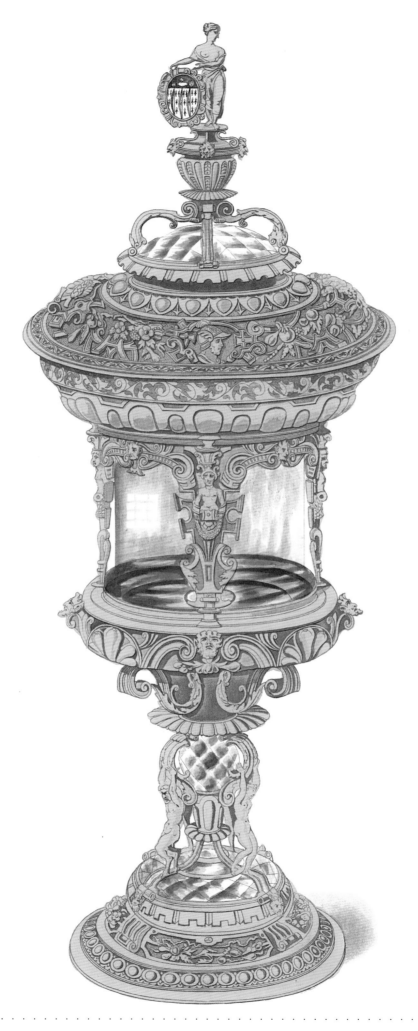

A Sixteenth Century Hourglass

MANY NOTICES of the use of hourglasses during the sixteenth and part of the seventeenth centuries can be gathered from contemporary writers. At that time, preachers were in the habit of measuring their sermons by the hour, so the hourglass was a piece of furniture found in the pulpit. It was placed beside the preacher, who regulated his sermon by the motion of the sand. It seems to have been used equally by the Catholics and Protestants. In the account of the fall of the house in the Blackfriars in 1623, where a party of Romanists were assembled to hear one of their preachers, he is described as "being attended by a man that brought after him his book and *hourglass*."

In the preface to *The Bishops' Bible*, printed by John Daye in 1569, Archbishop Parker is represented with an hourglass at his right hand. In the eighteenth century, Daniel Burgess was a celebrated nonconformist, known for the length of his sermons and the quaintness of his illustrations. On one occasion he was declaiming with great vehemence against drunkenness, and having exhausted the usual time to which the length of the sermon was limited, he turned the hourglass and said, "Brethren, I have somewhat more to say on the nature and consequences of drunkenness, so let us have the other glass."

Hour glasses were often very elegantly formed, and of rich materials. The one represented on the facing page is richly enameled and set with jewels. Several churches in London are known to have possessed famous hourglasses. We note in the tract on the fall of the house in Blackfriars mentioned above, that the frame of an hourglass preserved in old St. Dunstan's Church on Fleet Street was of massive silver, and that it was melted down and made into two staff heads for the parish beadles.

The figure in the lower right on the opposite page represents a bracket for supporting an hourglass. In 1840, it was still attached to the pulpit of the church at Hurst in Berkshire. It is made of iron, painted and gilt. St. Alban's Church on Wood Street in London once had a stand and hourglass that were placed in a square box, supported by a spiral column, all made of brass. The glass itself was fitted in a very elegant square frame, also of brass. At Waltham in Leicestershire there is, or was, an iron frame for an hourglass, mounted on three high wooden brackets. We learn from parish accounts that in 1579, the church at Lambeth paid one shilling and fourpence "for the frame in which the hour stands." In 1615, six shillings and eightpence was "paid for an iron hourglass."

Numerous examples of the use of this instrument in preaching may be cited. The reader of Samuel Butler's satirical poem *Hudibras* (1726) will recall the phrase about "gifted brethren, preaching by a carnal hourglass." ✸

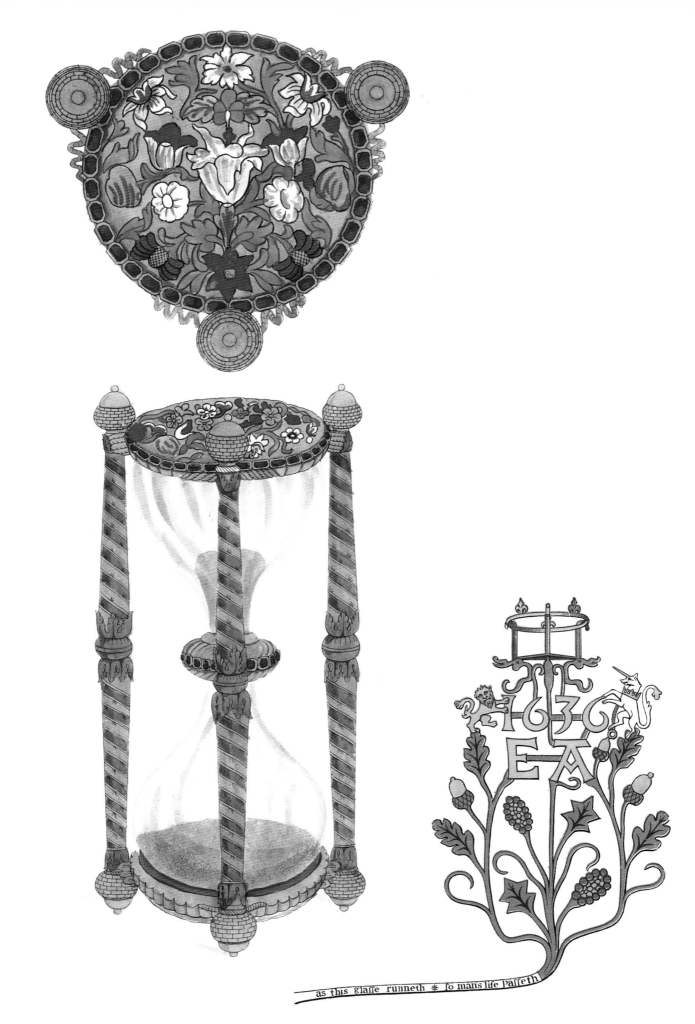

as this glasse runneth ✳ so mans life passeth

Original Texts of Sire Mirth, and of Commentaries in Verse on Homer by Benoit de Sainte Maure and John Lydgate

O N PAGE 112, we discuss a trio of minstrels that are seen in an illumination from the 1480 edition of *The Romance of the Rose* at the Harleian Library at the British Museum. This illumination represents the "karole," or dance, of "Sire Mirth," which is herewith reproduced in its entirety:

> These folk, of which I tell you so,
> Upon a karole went tho;
> a lady karoled hem, that night
> Gladness the blissful and the light.
> Well could she sing and lustily,
> None half so well and semily.

This dance was, in turn, attended by other minstrels and "jogelours":

> Tho might thou karollis seen,
> And folk dance, and merry ben,
> And make many a faire turning
> Upon the green grass springing.
> There might thou see these flutours,
> Minstrels, and eke jogelours,
> That well to sing did there pain;
> Some songen songis of Lorraine,
> For in Lorraine there notis be
> Full swetir than in this country.
> There was many a timbestere,
> And sailors, that I dare well swear
> Their craft full parfitly,

> The timbris up full subtilely
> They casten, and hent them full oft
> Upon a finger faire and soft,
> That they ne failed never mo.
> Full fetis damsels two,
> Right young, and full of semelyhede,
> In kirtils, and none other wede,
> And faire tressed every tress,
> Had Mirth done for his noblesse
> Amidde the carole for to dance,
> But hereof lies no remembrance
> How that they danced quietly;
> That one would come all privily
> Agen that other, and when they were
> Together almoste, they threw afar
> There mouths so, that through their play
> It seemed as they kissed alwaie."

The above lines afford us an exact description of the class of persons who attended festivals and ceremonies to afford entertainment to the company. The minstrel sang, or repeated romances and tales, or other poetry. The jugglers performed different feats of skill, such as throwing pieces of wood into the air, and catching them on their fingers. Because the two "damsels" remind us strongly of the traditional dancing girls of the Middle and Far East, we might suppose that the custom was brought to Europe from the East by the Crusaders.

The minstrel, as we have noted, was a very important member of the community. With him was deposited the whole body of the national literature, the poetry which celebrated the ancient gods and heroes of the people, and which he sang to the harp at their entertainments.

DURING THE MIDDLE AGES, as we have noted in the article on page 142, the subject of the seige of Troy was one of the most popular and most retold of the classical tales. Often, these were written in verse. In the fourteenth century it was translated into French, or rather made the foundation of a French work, by Raoul Lefevre, chaplain of Philip the Good, Duke of Burgundy. However, the earliest of these was probably that written by Benoit de Sainte Maure.

After telling us that Homer was a "marvelous clerk," de Sainte Maure assures us that, living more than 100 years after the Trojan Wars, Homer could not possibly know much about them. He then relates a curious anecdote of the reception which Homer's "history" met with among the Athenians:

When he had made his book about it,
And had published it at Athens,
There was a strange contention:
They rightly wished to condemn it:
Because he had made the gods

Fight with carnal men,
And the goddesses, in like manner,
He made to combat with the people.
And when they recited his book,
Many for that reason refused it;
But Homer had so great a reputation,
And he exerted himself so much, as I find,
That his book was at last received
And held for authority.

Such was the distorted point of view in which the people of the Middle Ages regarded the works of the ancients.

The earliest English poem we know on the Trojan War is John Lydgate's *Troy-Book*. It is one of the best of that poet's works, and it contains prose as well as poetry. Lydgate began it in 1414 at the command of King Henry IV, but it was not finished until 1420, in the reign of his successor, Henry V, to whom it was dedicated. Lydgate also repudiates Homer, because he was too favorable to the Greeks:

"One said that Omere made lies
And feigning in his poetry:
And was to the Greeks favorable,
And therefore held he it but fable.

In the Bodleian Library, there is another long English poem on the war of Troy, supposed to be of the time of Henry VI. �֍

Index

Index

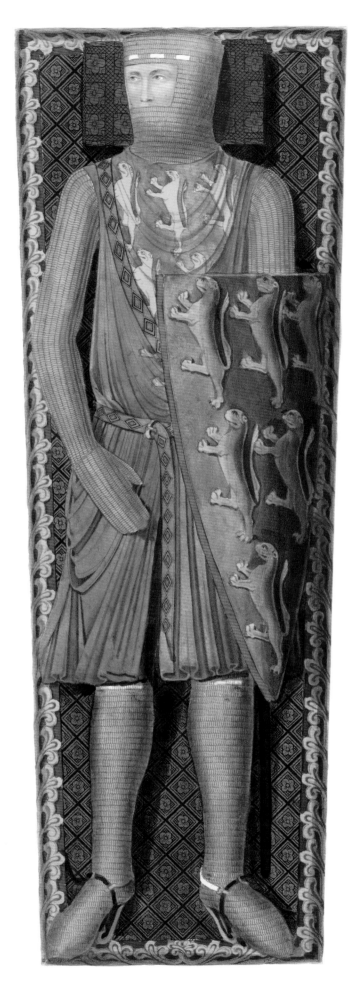

Right: William Longuespee,
First Earl of Salisbury (see page 44)